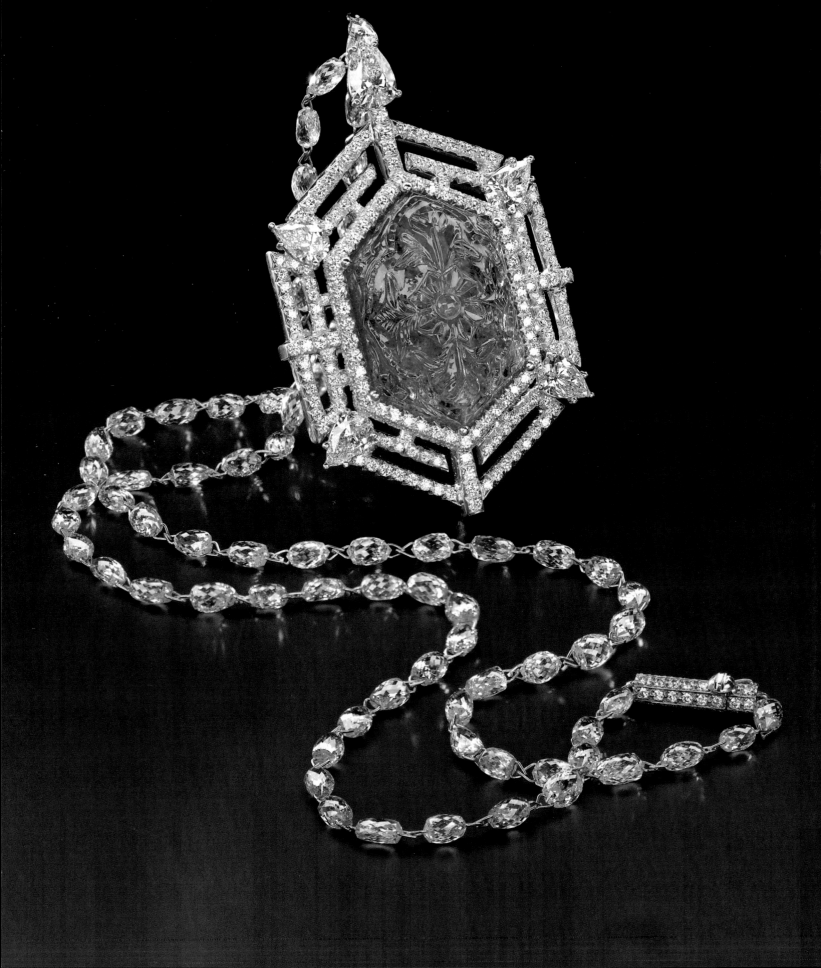

HENRY DUNAY

A PRECIOUS LIFE

Foreword by Henry Dunay
Introduction by Stephen Magner

Essays by Penny Proddow and Marion Fasel,
George E. Harlow, and Jeryl Brunner

Principal Photography by John Parrish

ABRAMS, NEW YORK

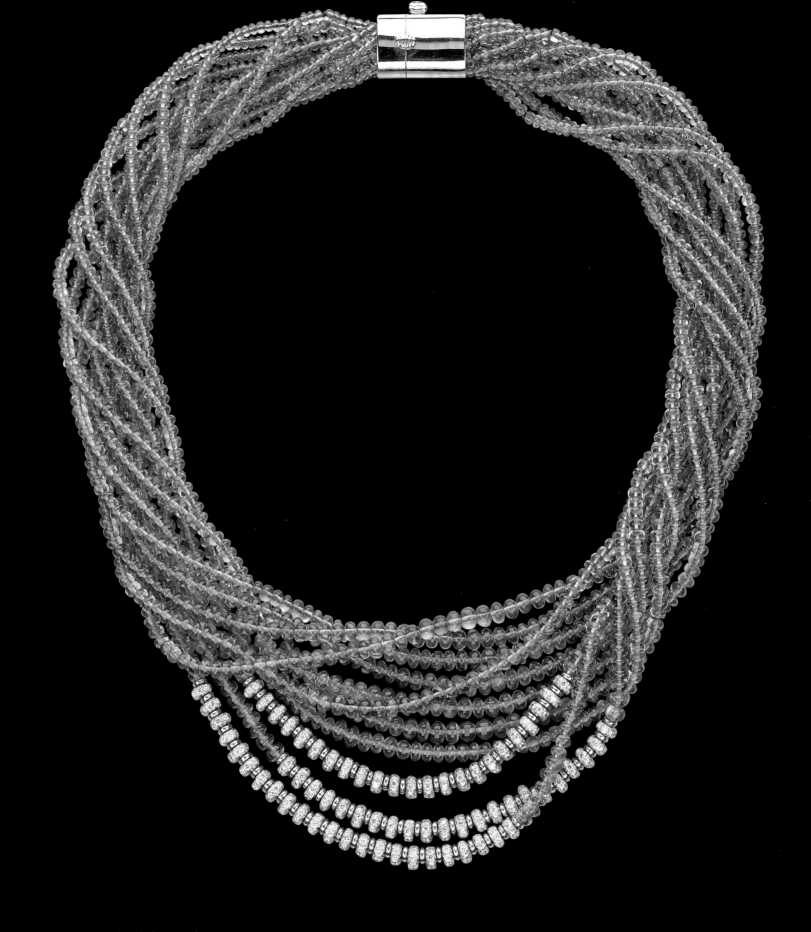

ABOVE Diamond and platinum discs
highlight an aquamarine bead necklace.
OPPOSITE A design for aquamarine,
diamond, and platinum earrings.

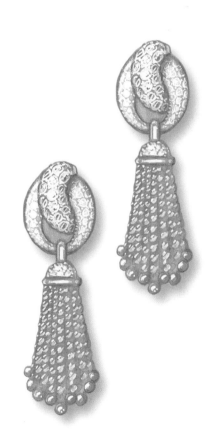

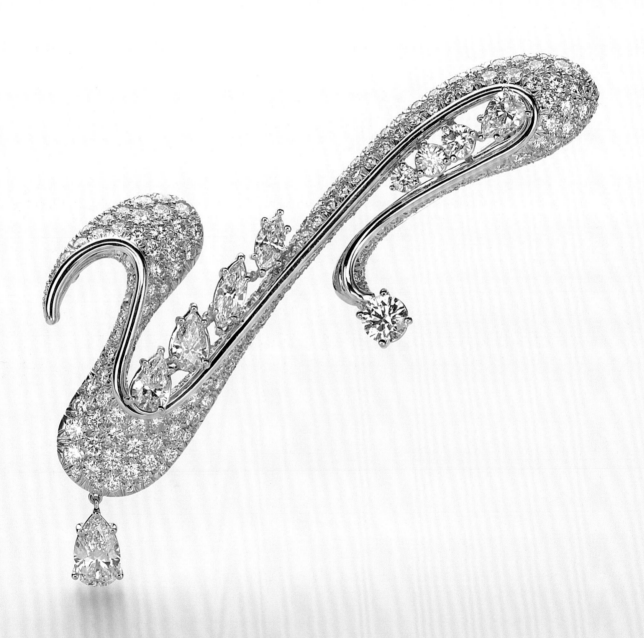

FOREWORD Fifty years is a long time in anyone's life. It is how long I have been creating jewelry. Yet the time has gone by very quickly. My passion for my work is the reason. It is also the reason I wanted to share the experience with a book. Reviewing the changes I have made over the years, the places I have seen, and the designs that have come from it, the gems I mounted in jewelry and objects have made me appreciate my life in design more than ever before. Jewelry is art. My hope is for young people to read this book and get inspired from it.

Countless people helped me over the last fifty years. Gem dealers who brought me treasures made it possible for me to execute my designs. I would like to single out Hans-Jürgen Henn. He has guided me for decades and given his time generously to this project. I am grateful to all the talented bench people I have worked with, particularly my longtime friend, model maker, and confidant Osvaldo Blasoni, my foreman, Edgar Albert, who started with me when he was eighteen years old, and my head model maker, Farah Farah. A heartfelt thanks to everyone at the Dunay office who all make the business run smoothly and rose to the occasion of this project, especially my controller, Mary Ellen DeThomasis. I appreciate the salesmen who spread the word of Dunay, chiefly Don Santander and Tom Bake. I would like to thank Linda Goldstein, who found imaginative ways to publicize my work over the years. Neiman Marcus has been integral to my career almost since the beginning. I am grateful to the department store and its executives Burt Tansky, Karen Katz, Lisa Kazor, Larry Pelzel, Eric Ford, and Marnie Mika. I appreciate Steve Magner's generous introduction and loyal friendship. A thank-you to Frinette Simon: She is my next fifty years of inspiration.

It has taken three years to assemble this volume. I could not have done it without the visionary work of my photographer for over twenty years, John Parrish. A very special thanks to the contributing essayists Penny Proddow and Marion Fasel, Dr. George Harlow, and Jeryl Brunner. I would like to express my gratitude to Carol Dunay Kriet for sharing old family photos and Carl Scheffel for his jewelry and art photography. I am obliged to designer Russell Hassell, who assembled all the parts into a jewel of a book. At Abrams I would like to thank editor in chief Eric Himmel, executive managing editor Andrea Colvin, and senior editor Eva Prinz for their thoughtful approach to the project.

Henry Dunay

OPPOSITE A whiplash of diamonds makes a dynamic brooch.

7

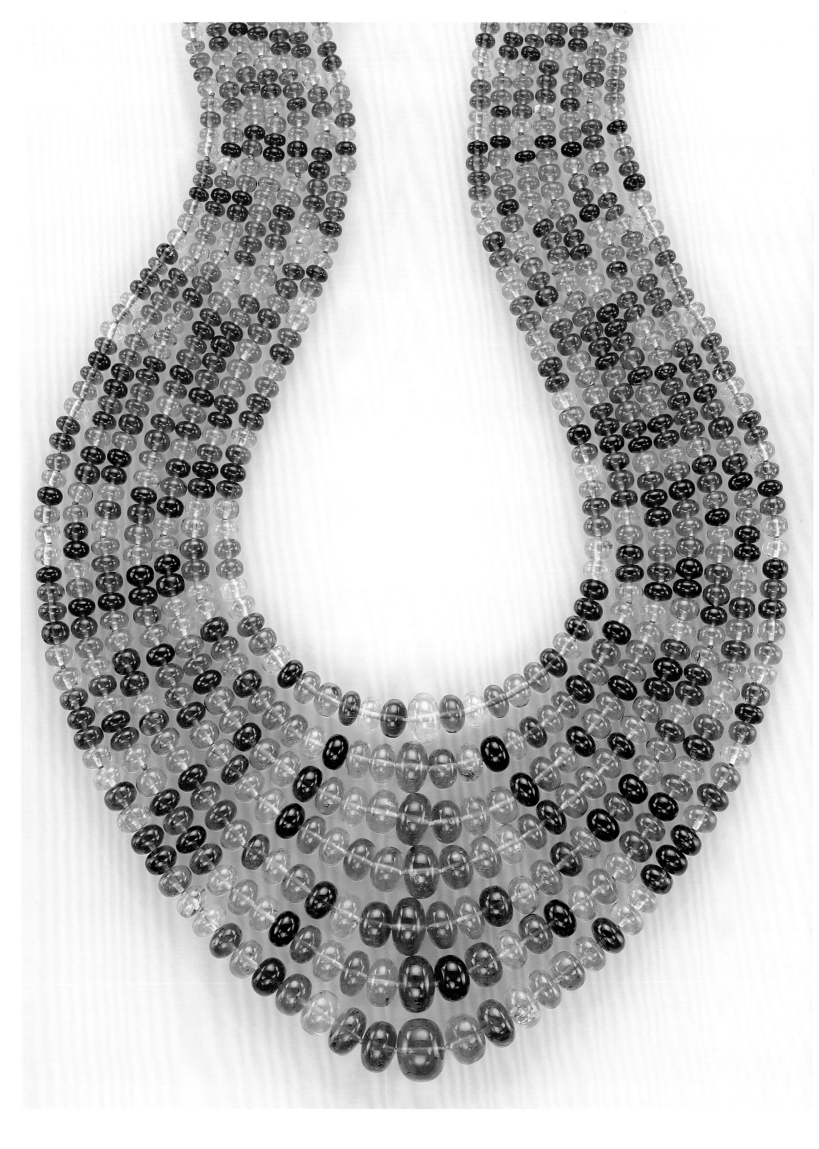

INTRODUCTION There is no greater reward to a merchant than to seek out a product or entity he deems special and have the clientele agree via enthusiastic purchase. In the world of luxury, this is no easy task. With the ultimate purchaser being most discerning and exposed to practically everything new, finding the unique is indeed a challenge. One must utilize every bit of one's knowledge, experience, intuition, and personal taste to weigh the merits of design, quality, value, and salability. Every once in a great while a rainbow falls right in your lap. This was our case with Mr. Henry Dunay; his creations were exactly Neiman Marcus Precious Jewels.

Henry makes "big girl's jewelry," which is what we are all about. The women who favor our stores for the greatest names in apparel demand an equally robust statement in their jewelry. The Dunay collection began and continues with all the correct criteria. It is a different color, a different texture, a different look, an escalated quality, readily identifiable and undoubtedly beautiful.

Over the last thirty years Henry's collections have grown and evolved in many different ways. From the start, we had people voting yes, but that was only the tip of the iceberg, as they say. Through time the designs became even more refined. Through the endless public appearances, conversations with his followers, as well as his vast travel experience in sourcing materials, the collections came to truly reflect Henry's heart, soul, and personality. The successes we enjoyed allowed Henry to expand the designs from their gold and diamond beginnings to a magical use of colored stones. With a remarkable eye for color, and superb cutting expertise, he surprised us with dreamscapes including peridot, tanzanite, and moonstone. He adorned our catalogues with magnificent emeralds, rubies, and sapphires. All fabulous, all Dunay.

Henry's jewelry is Henry's passion. Although his talents have gained him awards and fame, I know his greatest prize is to see the smile that pops up when someone receives a Dunay creation. We thank Henry for being the great designer, bench-man manufacturer, and friend to Neiman Marcus that he is. He certainly makes our job easier!

Stephen Magner

Neiman Marcus, Vice President Precious Jewels, Divisional Merchandise Manager (1984–2005)

OPPOSITE Bright pink, yellow, and green are among the many shades of tourmaline beads in a multistrand necklace.

9

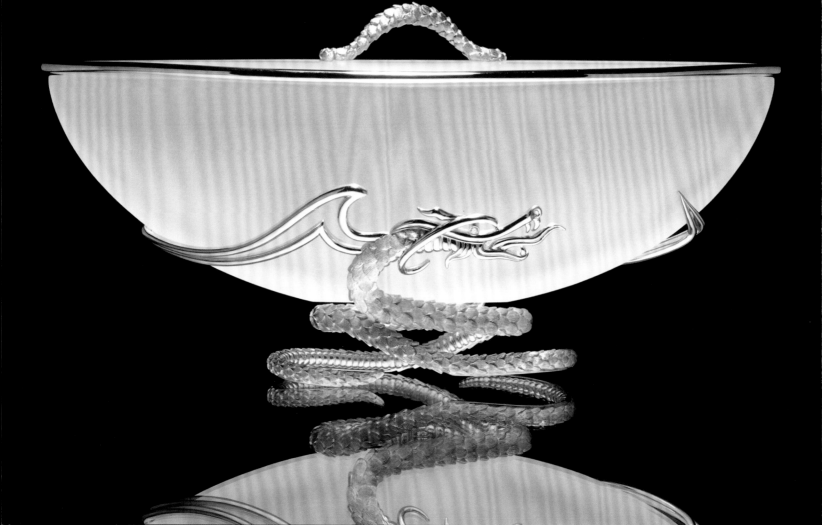

OPPOSITE Two intertwined gold dragons cradle the carved quartz bowl.

ABOVE A 2,035-carat carved smoky quartz, gold, and diamond dragon breaking the chains of captivity is called Freedom.

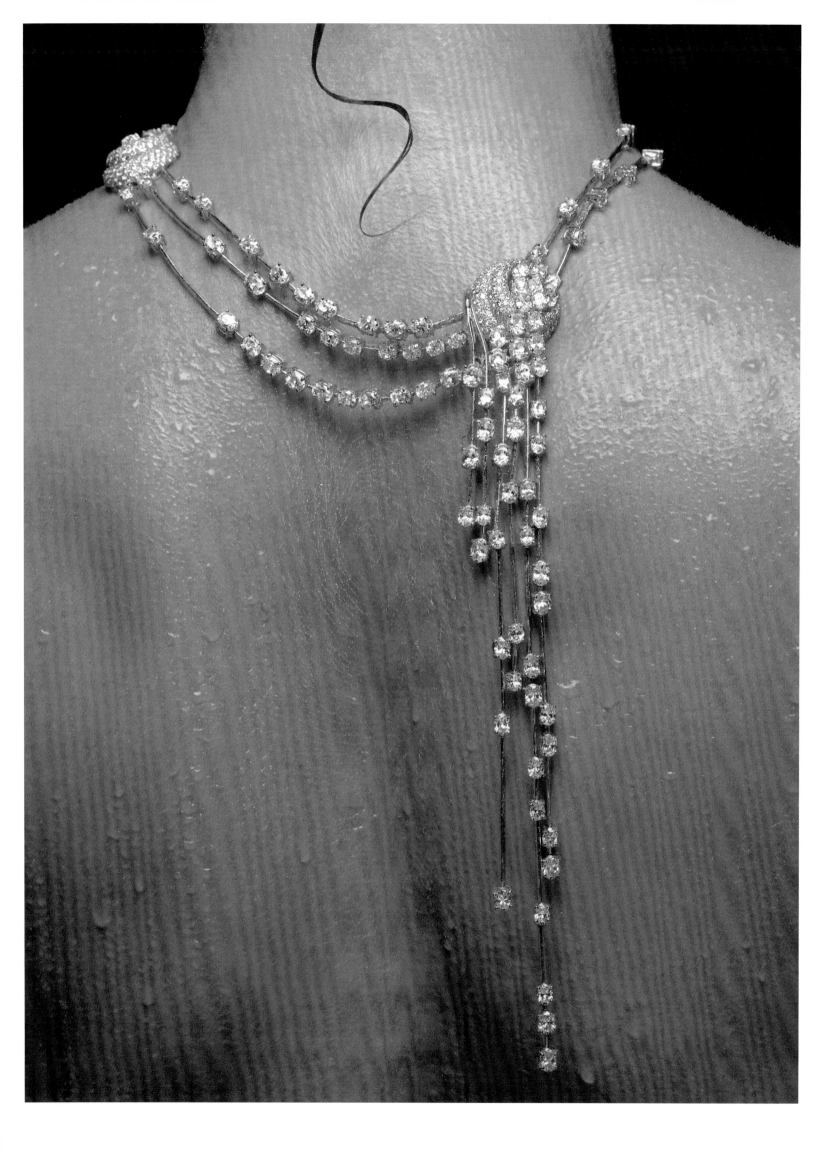

Henry Dunay: A Precious Life

By Penny Proddow and Marion Fasel

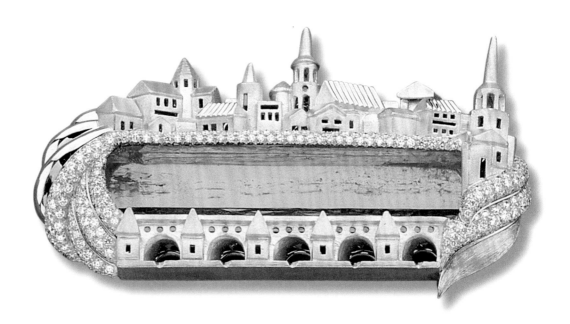

THE OPULENT SETTING FOR THE 1982 DIAMONDS INTERNATIONAL AWARDS
fit the occasion. Venice, Italy, the jewel of the Adriatic, hosted the highly stylish
and fiercely competitive prize that attracted jewelers from all over the globe.
Among the glitterati descending on the Grand Canal for the event was the
American Henry Dunay. The tall, slim, soft-spoken master jeweler knew exactly
what it took to dazzle the sharp-eyed judges. An entry had to be fantastical,
something worthy of a modern-day glamour goddess. The designer delivered the
goods with a necklace named Liberation.

It had more than four hundred round and oval diamonds sporadically set
along slender yellow-gold wires. In a truly high-wire act of craftsmanship, the
multiple strands swept up, whirled around, and cascaded down, way down, the
front, just left of center. Liberation blew away the age-old notion of straight-laced
symmetry, not to mention stiffness, in jewelry. The entire piece was flexible. When
a model put it on, the jewel skimmed lightly over the body, enhancing the figure.
As if this weren't enough, the top half could be detached and worn as a headband.
Diamonds draped over the forehead, creating a modern-day tiara. "It was liberated
from tradition," explains Henry. "That is why I called it Liberation."

After the Diamonds International Awards were over, Henry took home a
grand prize and Liberation went on a worldwide tour. De Beers, the sponsor of the

PREVIOUS Henry's award-winning
Liberation necklace was draped down
a model's back for a national
advertising campaign promoting
diamond jewelry with the tag line,
"Diamonds that shatter all the rules."

ABOVE An aquamarine
represents the Danube river
in the diamond and gold
Budapest brooch.

awards and the tour, took it to a photographer's studio in New York for its close-up. No standard still life, the necklace was shot shining against a model's bare, wet back. The sexy image added even more panache to the piece. Countless newspaper and magazine editors gave the photograph of the award-winner prime coverage. De Beers also ran the necklace in a national ad with the tag line, "Diamonds that shatter all the rules." The publicity climax was a segment on *The Merv Griffin Show*, where the popular host *ooh*ed and *ah*ed over Liberation's glory.

Viewers were surely mesmerized by Liberation, but one woman watching in Portland, Oregon, knew she couldn't live without it. Through De Beers, she tracked down Henry, who was halfway around the world in Tokyo, Japan, making a personal appearance. Thrilled at the chance to sell the important necklace, the designer immediately hopped a plane to Los Angeles where he picked up the necklace at the American Airlines Club from a De Beers representative, then flew directly to Portland and drove to the designated rendezvous point—a parking lot in front of a jewelry store where he waited for his admirer, a modern-day glamour goddess and liberation personified. The lady in question flew herself into the parking lot in her own helicopter. "Before I could clasp it in the back," Dunay remembers, "she said, 'It is mine!'"

THE DIAMONDS, HELICOPTERS, AND GLAMOUR GODDESS hovering around the Liberation necklace were a long way from Henry Dunay's humble beginnings. He was born on May 1, 1935, in the industrial town of Jersey City, New Jersey. And his last name was not Dunay. It was Loniewski like his father, Henry, who was second generation Polish American and a captain of a Lehigh Valley line tugboat on the Hudson River. His mother, Helen, worked at the American Can Factory. Henry had two brothers, Edward, who was three years older, and Richard, who was six years younger. "There was a lot of love in the family," remembers Henry. "But we had to work for anything we wanted."

As a child, Henry was industrious and precocious. He had newspaper and shoe-polishing routes. Around Christmas he earned extra money to buy gifts for his family by selling pretzels in the center of town at Journal Square where there were bustling crowds for the three movie theaters, the State, the Stanley, and

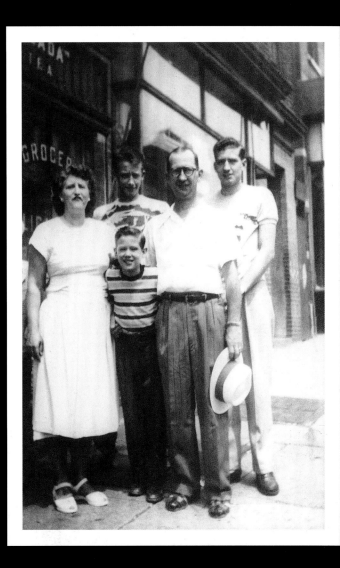

OPPOSITE, CLOCKWISE FROM TOP LEFT Henry's grandmother sits next to his mother at her first communion. Henry's father (left) stands beside his uncle at their first communion. Family and friends surround Henry's parents, Henry Loniewski and Helen Dunay, on their wedding day.

ABOVE LEFT Henry (left) poses with his mother and brother Edward on the Jersey Shore.

ABOVE RIGHT A family picture shows Henry (center back) standing with his mother, father, and brothers Richard (second from left in front) and Edward (right) in Jersey City.

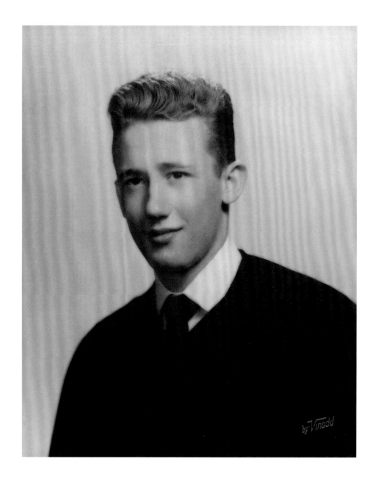

Loews. In his free time, Henry enjoyed taking apart clocks and putting them back together. "You have eyes in your fingers," his mother was forever declaring about his talent for tinkering.

During his junior year at William L. Dickinson High School, Henry began a part-time job working as a messenger across the Hudson River at Rudolph Cacioli's New York City jewelry workshop. It was a nickel subway ride to the job in lower Manhattan that would change his life. "A friend recommended me to Mr. Cacioli," remembers Henry. "The interview was pretty quick. He took one look at me and realized he could trust me. In those days the jewelry industry was all about trust. Someone would hand over diamonds to a jeweler with a piece to mount them on; there was no paperwork, nothing to sign. It was all about trust and Mr. Cacioli knew he could trust me from day one."

In his free time Henry swam competitively, eventually winning a medal at the Pan American Games in the butterfly stroke. "I was always going to the

ABOVE Henry's 1952 high school graduation picture from the William L. Dickinson High School.

OPPOSITE Coral punctuates a gold and diamond leaf brooch.

American Athletic Union office at Broadway and Nassau Street in Manhattan to check out what meets were available." The swimming gave Henry exercise, discipline, and on one memorable occasion a great life lesson. "I went to a night meet at an outdoor fifty-meter pool," remembers Henry. "I wasn't used to that size of pool or swimming outdoors so I looked up and down the line when we got on the blocks to check out my competition," says Henry. "I had beaten four of them and the other guy had one leg. I thought to myself, great—I am a shoo-in. Well, the guy with one leg beat the pants off of me and from that race on I have never assumed anything. I always give every situation my all. The swimming and that meet in particular taught me about tenacity."

It was Henry's drive and hard work ethic that got him a promotion from messenger to jeweler's apprentice in a matter of a few months at Mr. Cacioli's. "I didn't know if I could sit on a little stool and work on a jeweler's bench," says Henry. "I had been studying to be a cabinetmaker in school, but I realized Mr. Cacioli, a classically trained jeweler from Lake Como, Italy, was giving me a great opportunity to learn a trade on the job."

The first thing an apprentice learned at Mr. Cacioli's was how to work metal with a penny. He filed down the front and back. Then he drilled holes and set zircons or white spinels (a very inexpensive colored stone) in the cavity. Finally he raised small beads of metal to hold the gem in place.

For six months, Henry toiled over these tasks with pennies. When he became adept with the copper, Mr. Cacioli moved Henry onto gold. "If I screwed up," recalls Henry, "it was back to the penny." Slowly but surely, Mr. Cacioli patiently taught his student how to set diamonds. "The first time I broke a stone, he said, 'Whenever you break a diamond, throw it to the end of the bench and leave it there—get it out of your mind and start all over again,'" remembers Henry. "He was a great human being."

The satisfying work, nurturing atmosphere, and excitement of being in the heart of Manhattan's jewelry district in the pivotal 1950s made Henry decide to work at Mr. Cacioli's full time after graduation from high school in 1952. Located at the intersection of Bowery and Canal Street, Mr. Cacioli's office windows overlooked the Manhattan Bridge. Outside its door, the sidewalk teemed with

jewelers, gem dealers, manufacturers, and customers. There were a handful of big diamond dealers in the district. M. Fabrikant & Sons, established in 1895, was the oldest and most important of them all. It drew Frank Sinatra and Ava Gardner to the Bowery for an engagement ring in 1951. "Everyone went out on the sidewalk to see the stars," remembers Henry. "It was wonderful."

Side by side with the splendor on the Bowery existed generic diamond jewelry —nondescript circle brooches, domed rings, and button earrings. "It seemed like there were 4,000 pieces in every window. And it all looked alike," says Henry. "I studied the windows and I thought to myself, 'How will I make jewelry that will stand out from everything here?'"

Henry worked long days, from seven o'clock in the morning until seven at night, honing his craft. He became very good at every aspect of diamond setting: filing metal, mounting gems, polishing, and finishing. Every once in a while, Mr. Cacioli gave Henry extra incentive to excel. He pulled a precious treasure out of his safe—a small Fabergé watch fob—for his protégé to examine. "Now this is art," Mr. Cacioli would say. "Look at it closely. This is what real jewelry is about."

Even though this was Henry's initial exposure to a master jeweler, the excellence of the craftsmanship was something he could see at a glance. Soon Henry would learn more about the history of the great nineteenth-century Russian court jeweler. He would come to appreciate the exquisite Easter eggs that the czar gave the czarina at holidays and the custom objects—bejeweled lilies in little flower-pots and farm animals—made from chunks of colored stones found in the Ural Mountains. In fact, Henry would base his whole career on the Fabergé ideal of creating something in every category of the jeweled arts: jewelry, objects, and watches. But for the moment, it was the deft setting with a myriad of tiny old mine-cut diamonds on the watch fob, one of the famous jeweler's most humble objects, that the apprentice looked at rapturously for inspiration.

Henry squeezed every lesson of craftsmanship out of the fabled Russian jeweler's work. There was something else he realized about the piece, something he couldn't let go. The jeweler's name was inscribed proudly into the metal. This signature ignited a dream for Henry of one day signing his own original designs.

When he was eighteen years old, Henry took a major step toward becoming a designer name by changing his own. He analyzed the contemporary designers he admired, David Webb and Harry Winston, and noticed the number of letters in their last names. "Webb had four letters and Winston had seven," says Dunay. Loniewski was simply too long. Henry changed his last name to his mother's elegant, Hungarian, five-letter maiden name, Dunay. The teenager hired a lawyer and, without telling his parents, made the switch legal. "They were disappointed but I knew it had to be done," Henry recalls. "I had found my calling." He treated the new name to a stylish presentation, gold letters with a few flourishes to the H, E, D, N, and the Ys in sweeping script. The logo was ready for signage and his signature.

Three years after the personal name change, Henry Dunay the business was born. Eager to follow his own path, the young jeweler gave notice to Mr. Cacioli and moved next door to 82 Bowery, taking a ground-level booth at the jeweler's exchange. The building was a hub of activity. Every aspect of the trade was there under one roof, including manufacturers, pearl stringers, tool suppliers, and gem, gold, platinum, and jewelry dealers.

Henry wasn't concerned about the risk of starting his own business. He had total confidence in his skills and ability to work—and he was thrilled to be independent. "Mr. Cacioli had a certain kind of customer and a certain kind of jewelry—mainly engagement rings," says Henry. "Moving downstairs I saw a different kind of jewelry that I didn't see at Cacioli's. My business gave me a place to be able to see what was going on in the world. I could disappear for fifteen or twenty minutes to look in store windows. I couldn't do that with Mr. Cacioli."

In his small digs, Henry was basically a one-man show, performing all the functions for his jewelry-manufacturing and diamond-setting company. Whatever had to be done, he did it, from generating business to personally handling clients and actually executing the work on the jeweler's bench. "I think my flaw was I didn't say no to any job," says Henry. At one famous jeweler's, M. S. Nelkin's, Henry joined the line with other fine-gem dealers and manufacturers as early as six in the morning. "It was the only moment in the day he could concentrate on the jewelry and gems," says Henry. "Once the phone started ringing, he couldn't do it."

Henry designed his own logo
with flourishes on the letters at
the beginning of his career.

Henry was forced to stop working his round-the-clock schedule when Uncle Sam called. Due to the Korean War, the army had reinstated the draft with the 1951 Universal Military and Training Service Act. As the sole proprietor of a business, Henry had the choice of serving in the regular armed forces for two years or enlisting in the reserves, which required six months of active duty, meetings once a month, and a commitment of two weeks annually. Henry shut down his business on the Bowery and joined the reserves. After basic training, he attended survey school in Oklahoma, and then he trained officers for night missions. The evening duty gave him days free and he started designing jewelry for the first time.

"I was so into jewelry and I was missing it," remembers Henry. "I looked at magazines, it excited me, and I began drawing brooches and earrings. They were easier for me to handle than rings and necklaces which are generally more sculptural."

Since age fourteen Henry had been working nonstop in the jewelry industry. The breaks he experienced in the reserves were the only chance he had ever had to concentrate seriously on his own ideas. "If I hadn't had the time to look at the magazines while I was in the army, it is possible I would have stayed a benchman forever churning out the work. The six months in the service gave me time to think about design."

ABOVE LEFT Henry shines his shoes while serving in the Army Reserves at Fort Sill, Oklahoma.

ABOVE RIGHT Henry smiles for the camera while shaving outside in Fort Sill.

WHEN HENRY RETURNED TO NEW JERSEY and reopened on the Bowery he had to put his designing on hold in order to build his business, not to mention his savings. He needed capital to invest in the materials to make his own jewelry. Being at the busy exchange proved to be a real benefit. Gradually, a buzz about Henry's expertise—the speed and excellence of his work—spread through the chitchat of the building. Then it spread beyond, all the way to midtown, to one of the great American jewelers, Harry Winston.

Nicknamed "The King of Diamonds," Winston reigned supreme during the mid-twentieth century. One of his most impressive feats was assembling a historic collection of sensational gems and jewels, called the Court of Jewels, and touring it as far afield as Europe, Cuba, and the Texas State Fair. The 44.5-carat Hope Diamond—made famous by its curse, inky blue color, and royal French provenance—along with the 44.63- and 44.18-carat Indore Pears—two diamonds of exactly the same color and almost exactly the same size from the Maharaja of Indore's personal jewelry box—were the headliners in the collection. Winston also made his name on jewels with huge total-carat weights presented in his signature holly wreath setting of marquise-, pear-, and brilliant-cut diamonds.

The day a representative from Winston arrived at Henry's office, they asked for his father. This encounter paralleled Winston's early experience; as a wunderkind dealer he used to travel with a dapper older man to give himself legitimacy. After Henry identified himself as the jeweler, they couldn't believe someone so young was doing such well-respected work. They left him with a diamond-setting job to assess his ability. "It was not an easy job," remembers Henry. A flower brooch had to be set with four hundred and fifty diamonds. The difficulty was not the number of gems but the fact that the petals opened and closed on the stem and the whole thing was completely *ajoured*—a French jewelry term for making the opening of each hole perfect for the shape and size of every diamond. "It is an extremely labor-intensive technique," explains Henry. "As much work goes into the back as the front when you *ajoure*—it is the definition of a fine piece of jewelry."

As soon as he saw the results of the flower, Winston sent work regularly to the little shop on the Bowery and Henry began to blossom. "The work coming to

ABOVE A pen-and-ink drawing
depicts Henry in his thirties.

me from Winston was very different from what I had been doing," remembers Dunay. "I had been mounting diamonds in cast settings which are a bit thick. The settings from Winston were all elegant, handmade, and thin."

Winston imported many of these settings from France because during the 1950s they were considered the finest in the world. Soon Winston entrusted Henry—who had moved into a larger office space at 82 Bowery and hired four bench workers—with putting these settings together as well as mounting them with diamonds. Assembling a jewel came easily. His wizardry, what his mother had called "eyes in his fingers" while he tinkered around with clocks as a child, truly kicked in.

Life was very full for Henry. At 82 Bowery business was steady. On the home front, he married his high-school sweetheart, Carol Restivo, in 1955. And it wasn't long before children arrived, a daughter, Valerie, and a son, Paul. They bought a house in Jersey City and occasionally entertained there. One regular guest was Mr. Cacioli, a widower, who came every Wednesday night for dinner with a big bag of groceries from the specialty shops in Little Italy. Over the spread, which frequently included salami and stuffed artichokes, the two jewelers talked shop. "He would give me little tidbits, tips," says Henry. "It was an education for me that continued."

IN 1963, AFTER MANY YEARS ON THE BOWERY, Henry decided to relocate. He wanted to get away from jewelry for the masses on the Bowery to the classier new jewelry district growing in midtown. The post–World War II economic boom propelled jewelers uptown to be close to and compete for the work coming from the big-name retail jewelers on Fifth Avenue such as Harry Winston, Van Cleef & Arpels, and Tiffany & Co. Jewelers settled on and around Forty-seventh Street between Fifth and Sixth Avenues, a district that would eventually become known as Diamond and Jewelry Way. Henry moved into a mini loft–style office with three windows at 1200 Sixth Avenue, a building filled with jewelers. Unfortunately things didn't work out exactly according to plan.

"It was the worst year of my life," recalls Henry. "There were clients on Forty-seventh Street who said they would give me work if I moved, but they didn't."

OPPOSITE A design shows
five ways the diamond cluster
could be positioned in a gold
circle brooch.

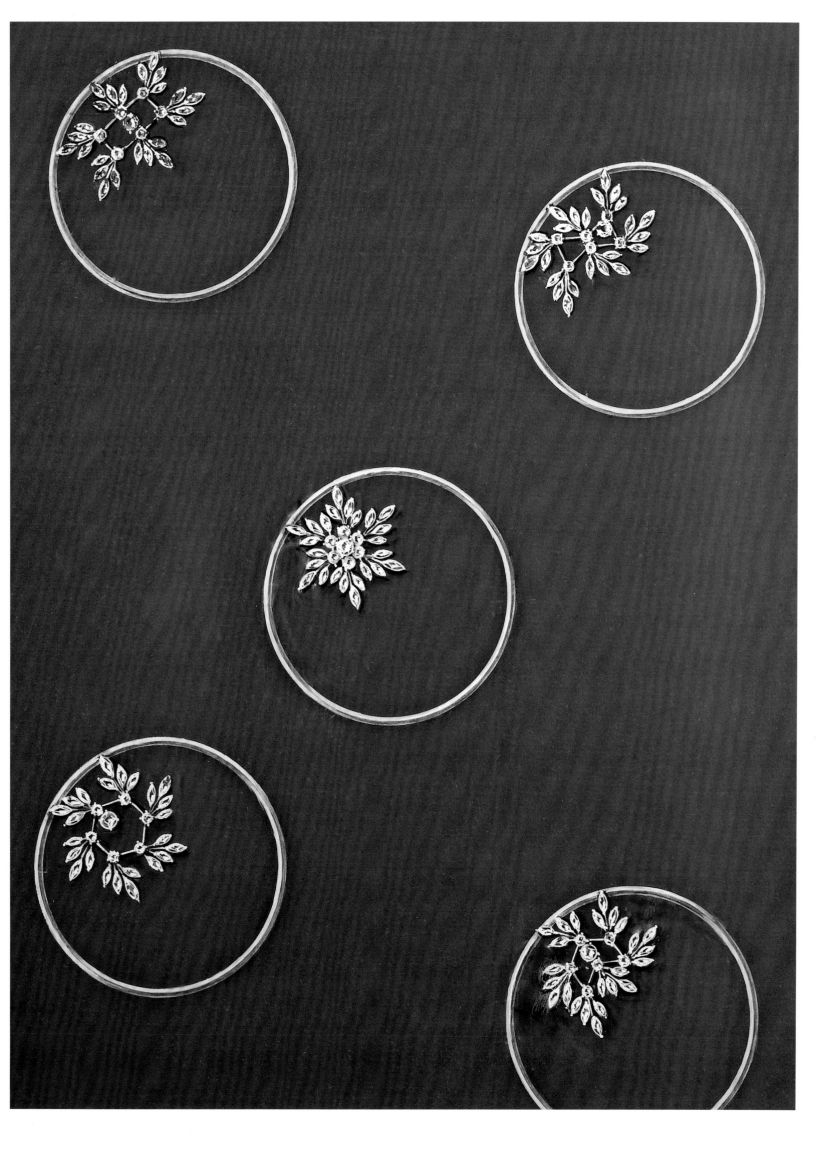

Instead, he had to make regular runs back and forth to the Bowery to pick up and drop off jobs, a twenty- to thirty-minute subway ride each way. "It took almost exactly a year for me to get the work I was looking for uptown," he recalls.

Once the business stabilized, Henry felt ready to start making his own jewelry. A lot of expertise goes into a piece of fine jewelry. One key element is the ink and gouache design. Generally, jewelers have an artist on staff who specializes in the detailed watercolor technique. Thinking big—although his company was very small—Henry hired just such an artist, Peggy Bernroth, to work part time. The designer had a desk in the little office where she worked every day from ten in the morning until three in the afternoon. "She made very classic things for some of her own clients on Fifth Avenue," says Henry. "Together she and I made more adventurous pieces. She said I gave her thinking a sharper edge."

Henry came up with countless designs with Bernroth at his side, but he could only afford to produce ten pieces a year, more than that was too expensive. "I had to take the risk of investing in and doing my own jewelry," says Henry. "There was a hole in my chest; creating my own jewelry made the hole get smaller."

Henry has maintained a jeweler-renderer on his staff continuously. Watercolor designs enable his craftsmen to carry out the work without difficulty. There were a couple of people after Bernroth. Then Henry met Myrna Wax, a classically trained artist, who came from Van Cleef & Arpels. The duo has been together for over twenty years. "She lives in Rhode Island and comes into the office one day a week," says Henry. "She understands me; we communicate easily."

WHEN HENRY BEGAN DESIGNING he divided his workweek methodically in order to do everything he wanted. From Sunday to Tuesday he hit the road to sell his designs. From Thursday to Friday he was back on the bench, doing stone-setting jobs for hire, to pay his employees' salaries. "It was $1.50 a baguette in those days," says Henry. "I would lay out stones and set them for hours and hours. I was pretty fast. I could set a few hundred diamonds working fourteen hours a day, which kept my business afloat."

To break up the monotony of stone setting, Dunay took walks up Fifth and Park Avenues to look at work he admired in the windows. "My nose marks are

OPPOSITE AND ABOVE Cocktail rings, bold starburst brooches, and a cute animal pin are among Henry's early designs.

probably still on the windows at David Webb and Van Cleef," says Henry. Such field trips were informal lessons in design.

The jeweler formally educated himself in other ways. He studied gems in night courses at the Gemological Institute of America (GIA). To overcome the shyness he felt on the road meeting new people and to improve his sales skills, Henry attended a seminar one night a week at Dale Carnegie & Associates, the firm famous for its founder's bestselling publication, *How to Win Friends and Influence People.* And to keep his peace of mind, he started yoga. One day after an intense meeting at Winston, he stumbled onto a studio where a teacher and three students were performing the discipline. Intrigued, he joined them and began a lifelong practice of the art of meditation and yoga. "I have always felt yoga gave me a lot of flexibility and posture, but more importantly the meditation gives me a place to channel my energies and peace of mind," says Henry.

IN 1967, HENRY GOT HIS FIRST REAL BREAK as a designer. He entered and won a De Beers Diamonds International Award. N. W. Ayer, the advertising and publicity agency for De Beers, ran the competition. The firm had organized the awards in the mid-1950s to stimulate creativity in diamond designs. Unknown and established designers were encouraged to participate through all kinds of incentives. Winners looked forward to exposure in fashion shows, television, advertising campaigns, and personal appearances.

Henry's design for the competition was bolder and more artistic than anything he had ever done before. "I thought about it for a while," remembers Henry. The day it was due, Henry sat down with Peggy, who rendered his big gold ring with a surface deeply carved like the bark of a tree, glistening with diamonds and sapphires. When the self-assured design won, Henry proceeded to manufacture the piece for the publicity tour and promotional photos.

After he received some nationwide recognition from the De Beers Award, he sold the prizewinner to a client and that client in turn passed his name along through word of mouth to others. One in particular came to Henry with an exceptional request. "This man and his gorgeous fiancée came in to order an

engagement ring," remembers Henry. "That wasn't unusual—it was what came next." The gentleman, a true romantic in the medieval sense who had become more comfortable with Henry, commissioned an 18K gold chastity belt complete with lock and key. Intrigued by the unique commission Henry said "yes" immediately. "The lady would come in for fittings wearing black tights," remembers Henry. "She thought the piece was sexy."

After Henry made the couple's wedding bands, the client returned again for another personal order: a wine goblet made of gold. "I made him a seamless cup with three branches winding around the outside," says Henry. "One of the branches was pavéd with diamonds." Henry suggested putting some sort of liner on the interior of the cup so one could drink out of it. The client declined the offer. He said, "When I drink out of it I want to taste the gold."

MORE IMPORTANT THAN THE COMMISSIONS that presented Henry with technical challenges and a bit of fun, the Diamonds International Award gave Henry the confidence to move on from making jewels piece by piece to creating a complete collection. His first step was to ask the same question he had asked himself as a teenager on the Bowery: "How will I make my jewels stand out?" Downtown, he had found the answer by focusing on technique and becoming a standout craftsman. Uptown, however, the answer would be much more complicated. He needed to come up with a signature look. For inspiration, he studied the jewelry of his favorite contemporary designer, David Webb.

A superstar in American jewelry history, Webb pioneered bold gold daytime jewelry in the 1960s, an area that had been totally disregarded by important European jewelry designers. His gold jewels had a hammered surface that was bigger, brighter, and bolder than anything anyone else was creating. To pump up the volume, Webb used gigantic but affordable rock crystal with a few diamond accents. His casual cool caused a sensation. President John Kennedy and the First Lady Jackie Kennedy—who was a fan and client—commissioned him to design the Freedom Medal and to make objects with American gemstones for gifts of state. *Vogue* editor-in-chief Diana Vreeland, the Duchess of Windsor, and

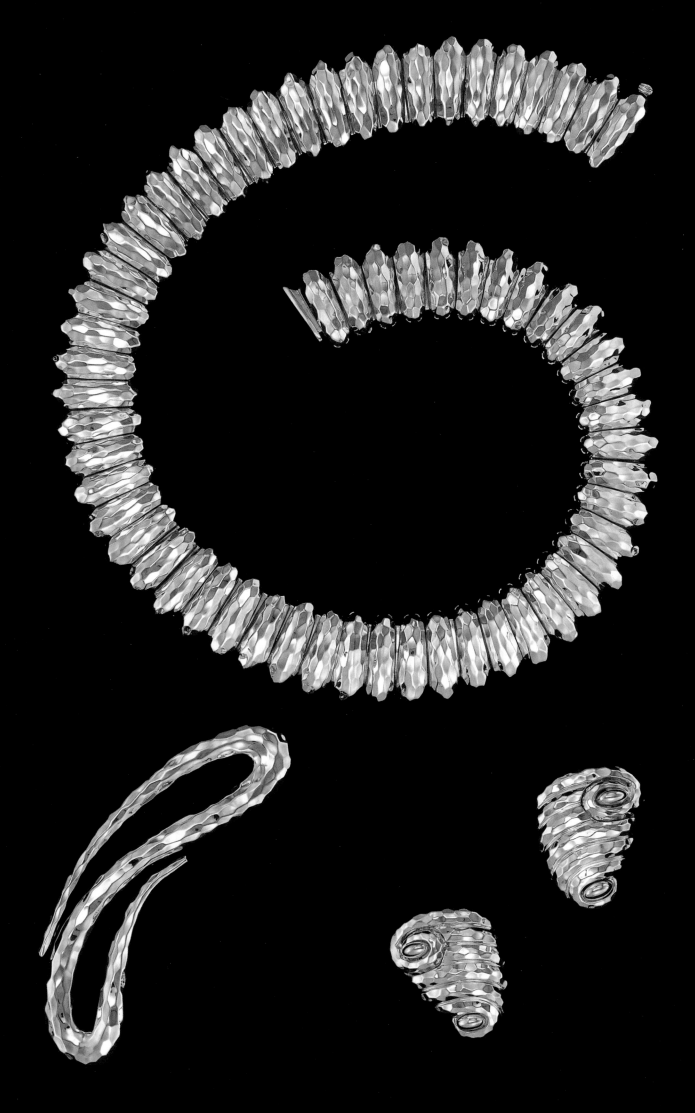

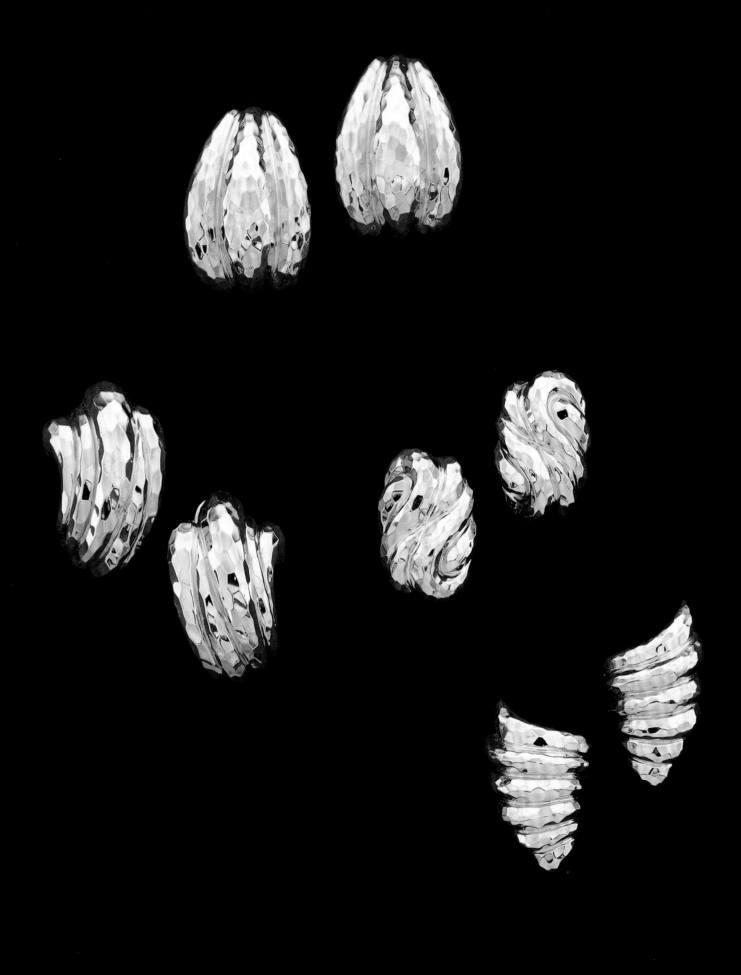

Elizabeth Taylor were among the women who crossed the threshold of Webb's Fifty-seventh Street Manhattan boutique, making him one of the biggest celebrity jewelers of the decade. "The stuff is not just ordinary diamond-and-rubies junk," Elizabeth Taylor said of Webb's work in a 1968 *Cosmopolitan* interview. "This is now—it's very chic."

Henry liked Webb's uninhibited proportions and his banged-up gold surfaces. The aspiring designer focused on these two concepts, then began creating his own imaginative, bold gold necklaces, earrings, bracelets, rings, and brooches. "Even though I had worked most of my career setting gems, I found working with gold easy," says Henry. "It was like swimming to me, I immediately felt comfortable with it." Another big plus with the precious metal was its price. It was very affordable and Henry could experiment with it for his designs.

To make his mark in gold, Henry went out to jewelry supply stores to find the right tool. "I started working with a frazer, a half-moon-shaped cutting wheel attached to a power tool," remembers Henry. "The spinning of the frazer allowed me to cut a strong pattern into the gold; things began to happen and the pattern became facets." The designer removed material to make concave areas and left the points intact. This process had a couple of benefits. The heat of the cutting sealed the porous surface of the gold. "In old European gold bracelets you can see thousands of tiny little holes under a microscope," explains Henry. "The heat generated by the frazer seals the porosity and makes the gold shinier." The technique made the faceting sturdy and virtually permanent. "People tried to copy it but they couldn't, because they would use a lapping machine to mock the facets," says Henry. "The look wasn't as sharp and the serrated detail wore down."

If the manufacturing process was original, so was the alloy. "I thought most of the 14K and 18K gold jewelry on the market was not flattering to a woman's complexion," says Henry. "My alloy is stamped 18K but it was actually 18½K with more silver and less copper. It made the color of the metal richer and warmer."

Henry aptly dubbed the collection Faceted. "The name came naturally," says Henry. "The pieces were chiseled into facets like a gemstone." After the breakthrough collection debuted, New York's fine-jewelry industry took notice of the

ROUND

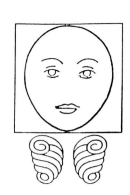

HEART

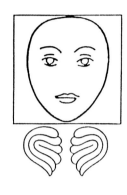

OVAL

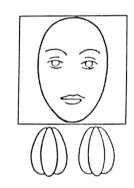

SQUARE

OPPOSITE A selection of Faceted earrings designed to fit different face shapes.

RIGHT Henry used diagrams with face shapes and complementary Faceted earrings to show women which style best suited them.

designer. Henry's idol, David Webb, gave him a call. "He congratulated me on Faceted and we talked about getting together in the future," says Henry. But it was not to be. David Webb died of cancer in 1975 at fifty years old.

When Henry started taking the fabulous Faceted collection to jewelry stores around the country, it was a tough sell. In the late 1960s very few department stores and independent jewelry retailers gave billing to American jewelry designers. The story was always the same with both fashion and jewelry: people were convinced that the best work came from France and Italy; American design was merely an echo. If a jeweler sold to stores, his work was presented as part of general inventory with no designer name attached. This was a dilemma for Henry, who did not want to sell Faceted anonymously. "I had no one to guide me about what to do and where to go," remembers Henry. "I hit the road and knocked on doors and tried everything; one place that did pick up the collection was the Denver branch of the Selco chain of jewelry stores, but it was difficult to find others."

To make matters worse, much worse for someone in the luxury trade, by the end of the 1960s, the economy's long period of post–World War II prosperity had come to a close. Things were particularly bad in New York where stock market losses, economic stagnation, and government overspending took their toll. The city almost had to declare bankruptcy. President Gerald Ford refused to bail out Gotham. The decision was emblazoned in a *Daily News* headline: FORD TO CITY: DROP DEAD. Oil was a big issue. In 1973 the Middle East Emirates of the Organization of Petroleum-Exporting Countries (OPEC) cut production and raised the prices of crude, bringing on inflation and an energy crisis. Ever resourceful, Henry turned his prospects to where the money was . . . Texas.

"I spent more and more time in Texas," remembers Henry. "That is where the sales were being made." Millions of dollars had been pumped into the economy through the oil industry, which had increased the number of rigs by over fifty percent between 1973 and 1974 to steady the markets. With the cowboy economy producing sudden riches for many, jewelry stores in the Lone Star State had clients lining up to buy.

The first place to carry Faceted in Texas was Eiseman Jewels, in Dallas's Northpark Center. Developer Raymond D. Nasher

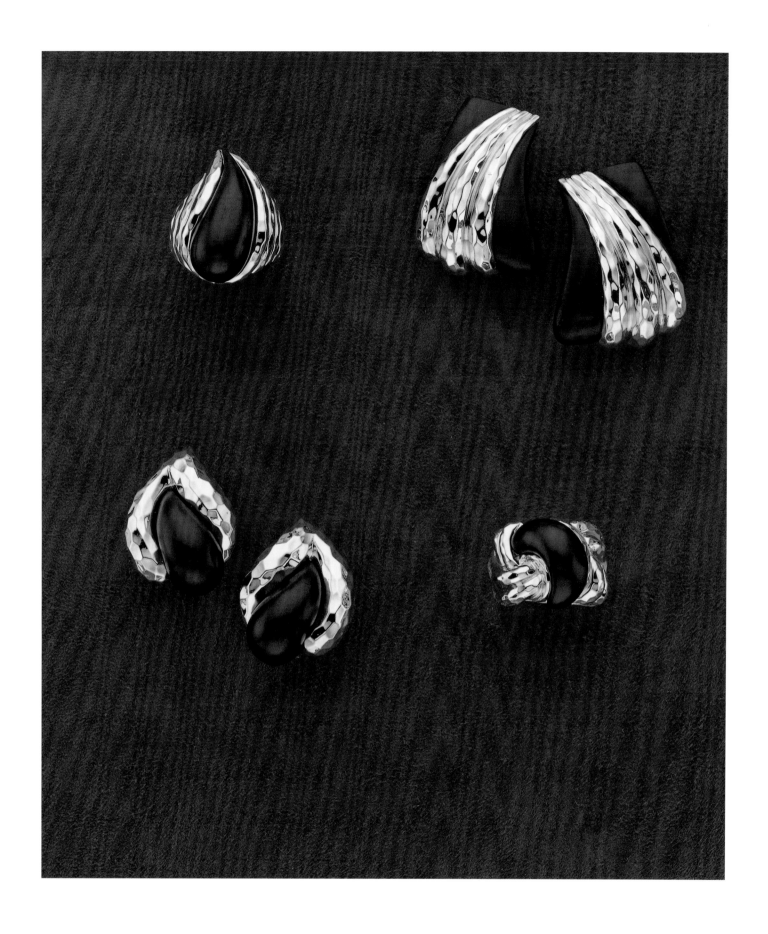

OPPOSITE AND ABOVE Henry
added ebony wood to Faceted
earrings, rings, and a bracelet
to create a new look.

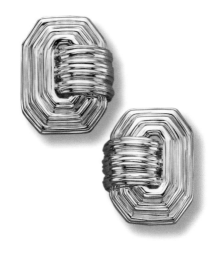

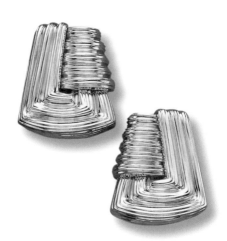

took pains to ensure that his complex, built in 1965, offered a stylish shopping experience. It was one of the few climate-controlled malls in the country; people could shop in air-conditioned comfort away from the oppressive Texas heat. Natural light flooded the architecturally impressive halls where Nasher exhibited his own museum-quality twentieth century art collection with works by Andy Warhol, Henry Moore, and Roy Lichtenstein. The swank atmosphere set the mood for some mega spending. "People at Eiseman loved my gold jewelry," says Henry. "I used to sell complete sets to one client there of a necklace, earrings, bracelet, and a ring."

Henry continued to travel around Texas like a pioneer in search of the right outposts for the collection. "I would go to a place like San Antonio, open up the *Yellow Pages*, find the biggest ad for a jewelry store, and go there. I would tell them I was a winner of the Diamonds International Award and show the line," he says. "Sometimes it worked, sometimes the biggest ad did not mean the greatest jeweler."

Henry's retail goal was to sell Faceted to Neiman Marcus. "My jewelry was big and it suited the Texas customer," says Henry. The designer optimistically believed, "If I created jewelry that was good enough, eventually Neiman's would accept it."

Although the department store only had a few locations in the southern states during the late sixties and early seventies, it enjoyed an international reputation for luxury second to none. Stanley Marcus, son of one of the founders, Herbert Marcus, conceived of countless ways to promote high-end merchandise. One of his most successful was an annual Neiman Marcus Award for Distinguished Service in the Field of Fashion. Christian Dior, Coco Chanel, Jacques Fath, and Elsa Schiaparelli were among the famous French fashion designers who accepted the honor at the store's headquarters in Dallas, Texas. Grace Kelly visited Neiman Marcus on several occasions, once to receive a Fashion Consumer Award, another time with Prince Rainer for one of the store's Fortnight celebrations, a two-week period with nightly events around a single theme. Kelly loved her experiences and the store so much she chose the bridesmaid dresses for her 1955 royal wedding from Neiman Marcus.

ABOVE Two pairs of gold earrings display strong outlines.

OPPOSITE Carved blue chalcedony and gold elements make a necklace.

Stanley Marcus added fine jewelry to the Neiman Marcus inventory in 1943. To publicize the new department, Marcus took the firm's jewelry collection to New York City where he could get national publicity for a preview party at the Pierre Hotel. Mary Martin, a Texas native and Broadway star, was the guest of honor. Soon after, ranchers and oilmen alike began adding countless carats to their holdings.

When Henry approached Neiman's with the Faceted collection, the head of the department, Dudley Ramsden, was as well known in the jewelry industry as Stanley Marcus was in the fashion retail business. His ability to make the magic sales happen was the stuff of legend. On one occasion, days before Christmas, Dudley chartered a plane to quickly reach a customer on a ranch three hundred miles south of Dallas and reshow him a diamond necklace he had passed on in favor of a competitor's. It was a compulsive, expensive gamble but Dudley was totally confidant the Neiman's jewel had superior quality and value. The sight of the two necklaces side by side on top of his pickup truck made the client realize the difference. He purchased the Neiman's piece and became a loyal customer for life.

Dudley was a brilliant salesman; as a buyer he was formidable. He believed in the old-fashioned ways—clients went to a jewelry store to buy from a salesman they trusted, not for designer jewelry. Ramsden rejected Henry's Faceted collection.

The designer worked around the obstacle. One of his clients, the publicist for Merv Griffin, said to him, "You do so much for me. What can I do for you?" Henry asked if he knew anyone at Neiman's. The client called Stanley Marcus and set up an appointment for the designer. Stanley, who was always open to new ideas for his store, took Henry to lunch and arranged a meeting for him with Dudley. The buyer didn't show up for the appointment in Dallas. Annoyed, Stanley made sure the buyer saw the designer in New York. "Dudley appeared one morning at around nine, unannounced," remembers Henry. "He obviously didn't like being told what to do and proved it by buying just one brooch."

Realizing he was not making any progress with Dudley, Henry again worked around the obstacle and showed his jewelry to Peter Lamia, the buyer for the Neiman's store in downtown Fort Worth. The strategy worked—ironically because of Dudley's traditional principles. Dudley Ramsden believed each store should

OPPOSITE A gold choker centers on a Baroque South Sea pearl and diamond pendant. A South Sea pearl glows in a gold ring.

RIGHT Diamond and Sabi gold nuggets form an organic bracelet.

operate like an independent jeweler. The salespeople were expected to take care of their clientele in specific ways. When a client walked into the department, a salesperson should greet him or her. If the phone rang, he or she should pick it up. Each salesperson kept a diary detailing a client's birthday, anniversary, favorite colors, anything that would help him or her keep in touch and make sales. The salesperson also kept an inventory of what clients owned, so the gaps in their collection could be filled—if a lady had gold earrings, the salesperson should let her know when a matching necklace arrived in the inventory. The system worked, and is used by the Neiman Marcus salespeople to this day.

The Ramsden tenet that allowed Henry in the door was the one that gave managers the power to stock whatever was right for their clientele. Peter Lamia, the manager at the Forth Worth Neiman's, liked Henry's jewelry, and so did Jack Boettiger from the Neiman's in downtown Dallas. The two men invited Henry to be part of a Neiman Marcus trunk show at the Greenhouse, an elegant and luxurious five-star spa for women located in a gorgeous mansion halfway between Dallas and Fort Worth in Arlington, Texas. "We had about fifteen minutes to set up before the one-hour presentation that lasted from six to seven at night," remembers Henry.

The Greenhouse effect was momentous. The ladies who attended bought and bought and bought. When the buyers reported the robust sales to Dudley, Henry was ushered into Neiman Marcus. At that point Henry Dunay was one of two fine-jewelry designer names in the department store. The other was a French woman named Jean Mahie who made artistic pieces.

Dallas became a base of operations for the designer. From there he took day trips to the branches. He worked closely with the salespeople at each location to check out what sold and to restock. "I was always refining the collection and bringing in new pieces," says Henry. "I added Baroque pearls, ebony and diamond accents to Faceted to keep the collection fresh."

To expand his presence at the stores, Henry created a sweet little mini-collection called Pearls of Love. It began with a single pearl pendant that was conceived as a beautiful basic. The designer mounted South Sea pearls with a few diamond accents. What Henry did with the setting caused a ripple of enthusiasm. "I made the setting out of openwork hearts. The hearts were a nice detail for women and

ABOVE A mini-collection called Pearls of Love consisted of various pearl, diamond, and gold earrings, as well as delicate pendants.

OPPOSITE Henry's popular Gold Heart gallery originated on the back of the Pearls of Love collection.

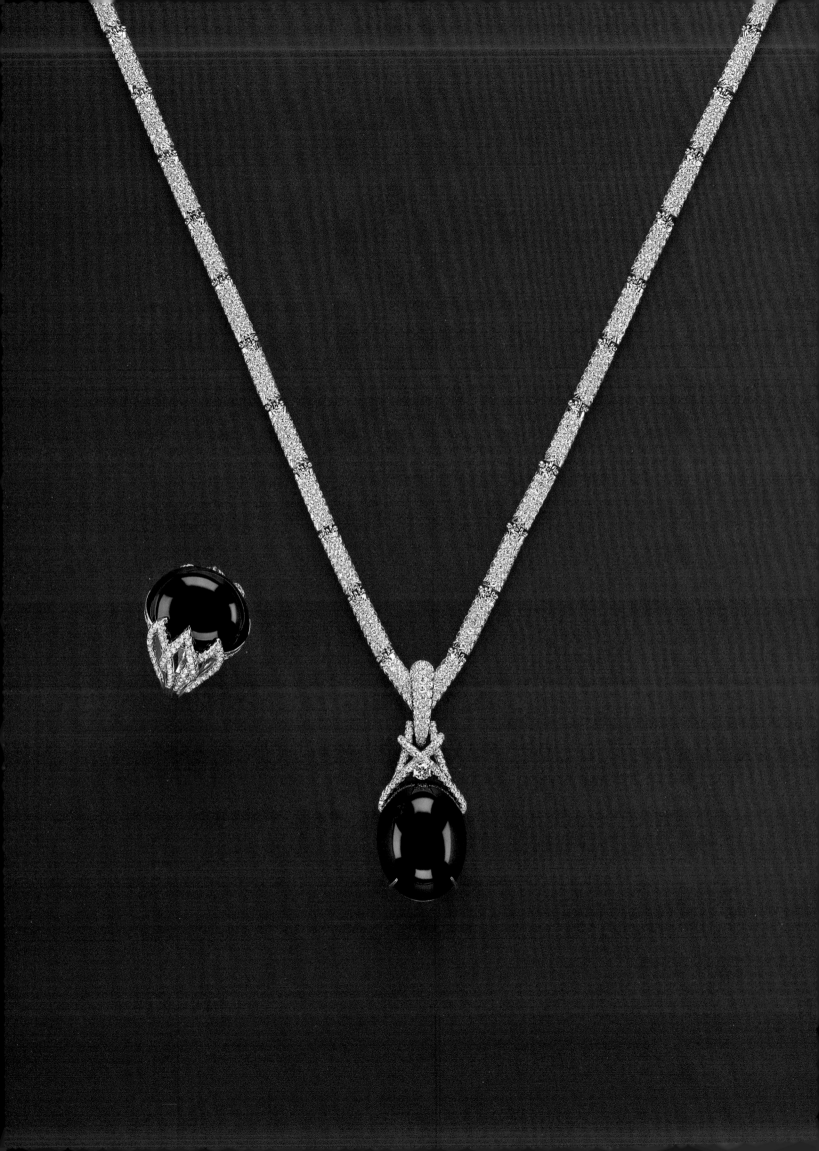

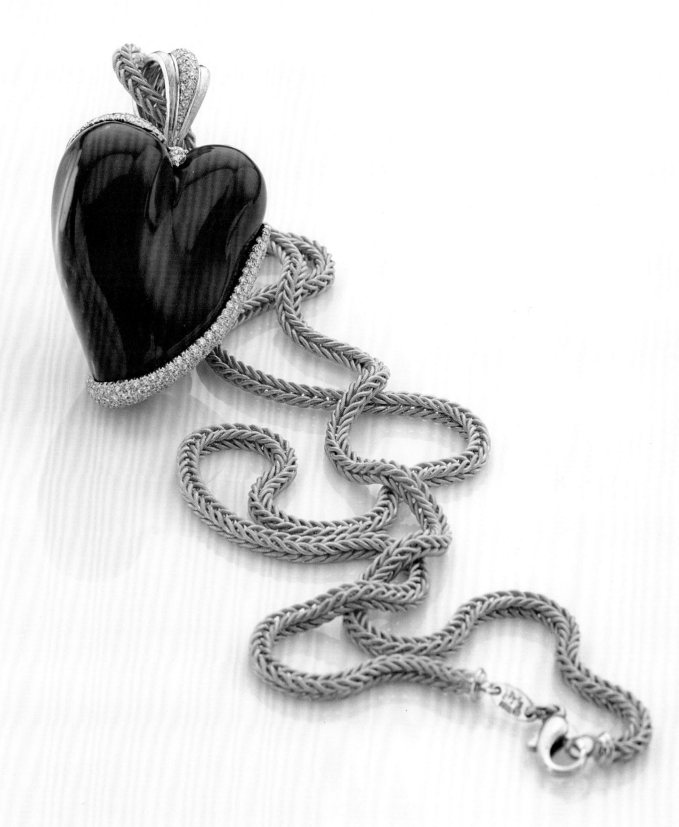

OPPOSITE Black tourmaline
cabochons create a graphic
color scheme on a diamond
and gold necklace and ring.

ABOVE A coral heart
pendant pulsates at the
end of a woven gold chain.

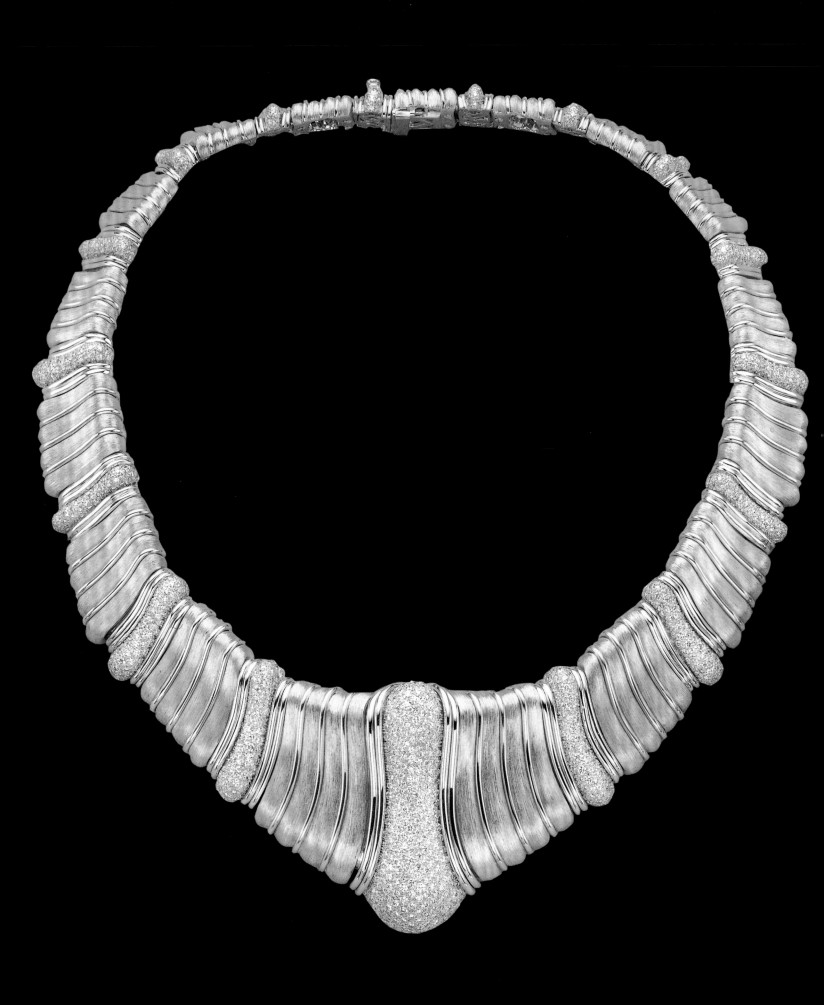

the men giving the earrings as a gift. They also gave the salesman something to point out in my work, why it was different." Soon customers requested hearts on all Dunay jewels. And that is how the signature valentine setting was born. "It was something that evolved from the customers," says Henry. "I felt it was the perfect message about the way I feel about my work."

These customers at Neiman's and the Greenhouse—where Henry appeared regularly at trunk shows—were his model clients, the type of women he called his "suntanned ladies." "She doesn't have to literally have a suntan," explains Henry. "What I mean by 'suntanned lady' is someone who works at being beautiful. Everything is well thought out, from her makeup right down to her underwear and of course her jewelry. When she walks into a room, there is an aura about her. She is wrapped in sophistication, elegance, and beauty."

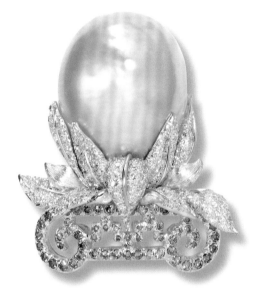

Henry's interaction with these fashionable women taught him volumes about shapes, styles, and proportions. "Certain clients pull things out of your head," says Henry. The designer knew the importance of listening to his clients from experience. It started at Hudson's department store in Detroit with Mrs. Bobby Fischer. "The buyer at the store, Russell Owens, saw the potential of introducing me to her," remembers Henry. The designer flew to Detroit and visited Mrs. Fischer on several occasions at her home. "She taught me a lot about style," explains Henry. "She was very specific. She would look at an earring and say, 'I would like a little drop added to the bottom'—a lot of small suggestions that made me see the big picture. The relationship with her was invaluable. It was the best thing that could have happened to me."

At Neiman Marcus, Henry continued to work like a couturier to fit a jewel to a woman's figure and face. "My inspiration is to make pieces such as earrings and rings look like part of the body," explains Dunay. "Jewelry should go with the facial structure, ear shape, size, and complexion. An earring should be an extension of the wearer. I don't design things to look flashy in the showcase, I design for women."

Henry went scientific with his earrings, the hottest area in the Faceted collection, creating diagrams for face shapes—oval, round, heart, and square—paired with line drawings of the appropriate earring. Women ate up the "how to" tips—

and the jewelry to go with them. Some of the earrings in the collection fit women's faces so well they are still in production today.

Henry's concern about earrings didn't end with the look; he extended his analysis to comfort, creating a little something for his clients no one would ever see: a piece of clear silicon to slide over the back of the earring and provide a cushion of comfort between the lobe and the metal. "The Gripper" was the name Henry gave these little lifesavers. "It is the simplest thing," says Henry. "Women are always complaining that an earring begins to pinch their ear after a certain period of time so I came up with the Gripper, patented it, gave it to my customers and I sold it to other manufacturers, too."

Henry's rapport with clients and super sales led Neiman's to promote the collection and break away from Dudley Ramsden's old-fashioned ideas. "A big department store can't have the same type of relationship with a client as an owner of a small jewelry store," explains Henry. "At a local store the owner works intimately with a client and find things for her. Slowly Neiman's began to see how promoting my name and jewelry and the personal appearances filled that need." Steve Magner, the Vice President of Precious Jewels and Divisional Merchandise Manager from 1984 to 2005, said, "Henry Dunay and Neiman's grew up together."

HENRY HAD TO RETHINK HIS COLLECTION when gold prices soared from a low of $216.55 per ounce in 1979 to a mind-boggling high of $850 per ounce the following year. Luckily, Henry had a reserve of gold to tide him over the initial shock but the price rise made him ponder adjustments to the collection. What would he do to reduce the amount of gold if it became necessary? One way Henry adapted without compromising his high standards was to add more colored stones and pearls to his jewels. Many cost less than bullion.

To learn all there was to know about colored stones—to go beyond his classroom experience at the Gemological Institute of America—Henry traveled abroad. As hands-on as ever, he accepted an invitation from his gem dealer Hans-Jürgen Henn to visit Idar-Oberstein, Germany, which was known as "The Gemstone Capital." Universally ranked number one for cutting and sourcing colored stones, the lapidaries of the scenic town nestled in the hills of the

ABOVE Gold earrings shine with diamonds.

OPPOSITE A gold curb link necklace is intersected by South Sea pearls and pavé set diamonds.

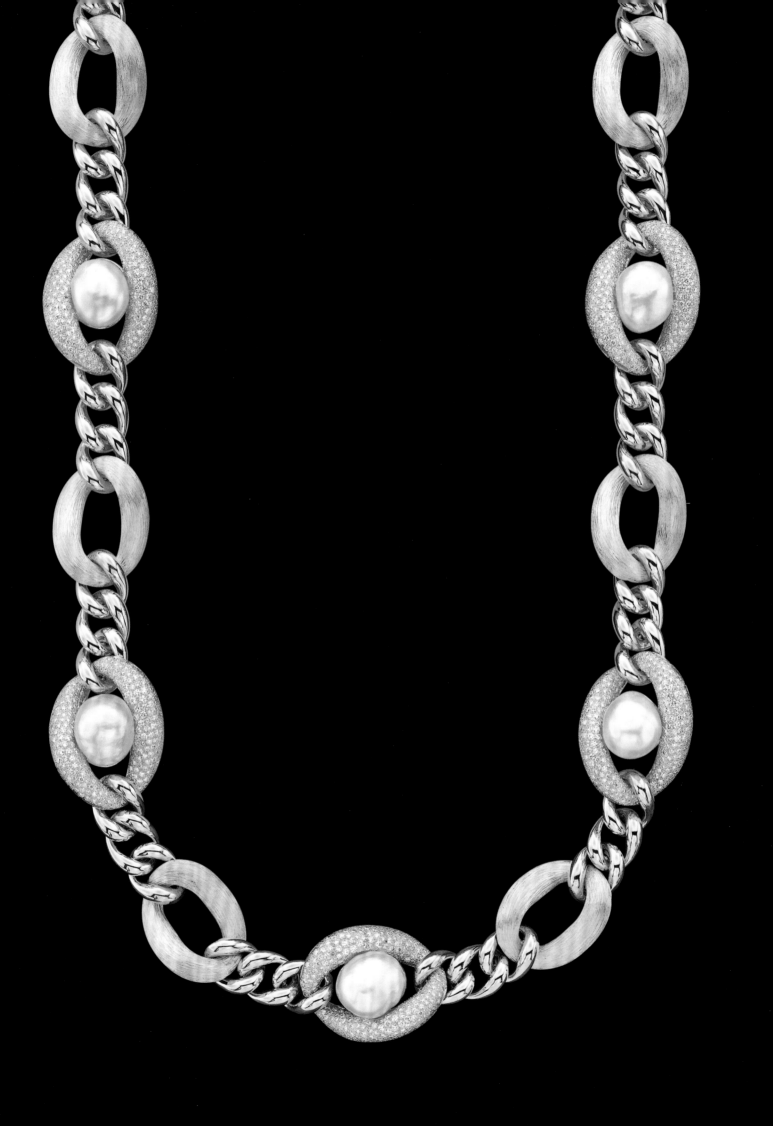

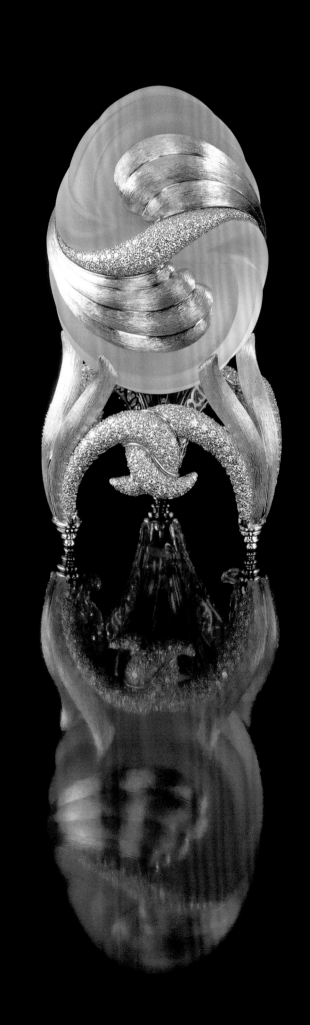

Rhineland Valley enjoyed an unparalled tradition of excellence. Their expertise extended back hundreds of years to when jasper, agate, and quartz were mined in the vicinity. "I had no idea what I was going to find there, but I knew I had to go," remembers Henry.

A fourth-generation gem dealer and stonecutter, Jürgen guided Henry through the intricacies of the vast field: the many types of stones and the process of taking a piece of rough and cutting it into a great gem. Jürgen's enthusiasm was contagious. Henry returned to Idar several times in the early eighties to buy gems.

On one trip, at a high-spirited dinner party with a few stonecutters and gem dealers, they brainstormed about ways to show off the talents and resources of the region to a wider audience. The conversation reawakened Henry's aspiration to make objects—the most artistic category in any fine jeweler's repertoire. That is when Henry came up with the idea of making a dozen quartz eggs.

The seemingly simple plan hatched over dinner took months of hard work to execute. Henry drew a pattern for every single egg on paper, toiling to make each one modern and unique. "I didn't want to do ornate Fabergé eggs," says Henry. "I fashioned lines characteristic of the twentieth century; swirling free like the movement of the wind, flowing in their simplicity, radiating with sensuality." Elegant swirls had appeared in a few Faceted pieces, but they came of age with the eggs. And their full, flowing forms have appeared in his work ever since.

These designs for the eggs were painstakingly carved into wax models. Next, Jürgen and Henry decided on the material to nicely highlight the carvings: white quartz. The quartz had to be clear, and that was difficult to find. The tip of a geode was the part of the quartz without flaws and inclusion. Even then finding a totally clean one was a challenge. To get the quality, the size of the eggs had to be small. "We went from duck-size to chicken-size eggs," says Henry.

Once the quartz was sourced, Henry and the lapidary Irvine Manfield Weild sat down at the vintage mechanical watch lathes and traced the designs on the pieces of quartz. The actual carving was done under Weild's supervision. Many eggs had to be carved in order to obtain a clean dozen. Flaws showed up on the pieces of quartz after they had been cut. "I'd say of the first fifty eggs carved about twenty were usable," says Henry.

OPPOSITE Allegro con Spirito:
Diamond, gold, and quartz egg
with stand.

Henry took the eggs to his workshop in New York City and added gem accents to the quartz. He made a unique 18K gold stand for each. "I wanted the stands to be beautiful, but their main purpose was function," says Henry. "I made them to anchor and protect the value and workmanship of the eggs." Henry's work at the bench was documented in a seven-minute video that shows him carefully crafting the precious details.

History, geography, mythology, and poetry gave Henry ideas for the names of the eggs. "I never give a piece a name until the end, and sometimes not until a piece has been around for a while," explains Henry. "Sometimes people see a piece and suggest things. But I can't give it a name until I feel it is right. That can happen immediately after it is completed or much later, when I hear the remarks people make about it. Or it can come to me when I am looking at a piece in a case at a store upside down."

Three of the eggs received romantic names. Curving lines folded together gave Henry the feeling of two lovers. A quatrefoil of radiating lines reminded him of a snowflake. A stroke of gold decorated with 6 carats of pavé-set diamonds evoked the night wind Henry envisioned cutting through an untouched desert. One egg had a Greek name: Ondine, the goddess of the sea, popped into Henry's mind when he mused on the eddying lines flowing down the side of the egg. Another had a Hindu name: *Shakti*, meaning a dynamic flow of creativity, captured for Henry in the crossover pattern of strong gold lines with a streak of 7.40 carats of diamonds. One inspired a Chinese name. An egg with terraced carvings reminded Henry of Gansu, a mountainous Chinese province. Five eggs represented Japanese concepts to Henry. *Kado*, the linear harmony in Japanese flower arranging was the essence of an egg with a continuous swirl. *Setsu-Gesu-Ka*, the ever-changing nature of snow, the moon, and the flowers, defined an egg with horizontal and vertical lines and a drift of 2.15 carats of diamonds. *Shibumi*, a term for elegance and nobility, described an egg with concentric circles and a center of 3.90 carats of diamonds. *Zoka*, a word for nature and creation—coined by a sixteenth-century Japanese poet—described a compound, complex egg with stately lines. *Tian Ran*, the Japanese term for naturalness, went to the simplest egg with gentle, understated lines. For the richest egg, Henry thought of an

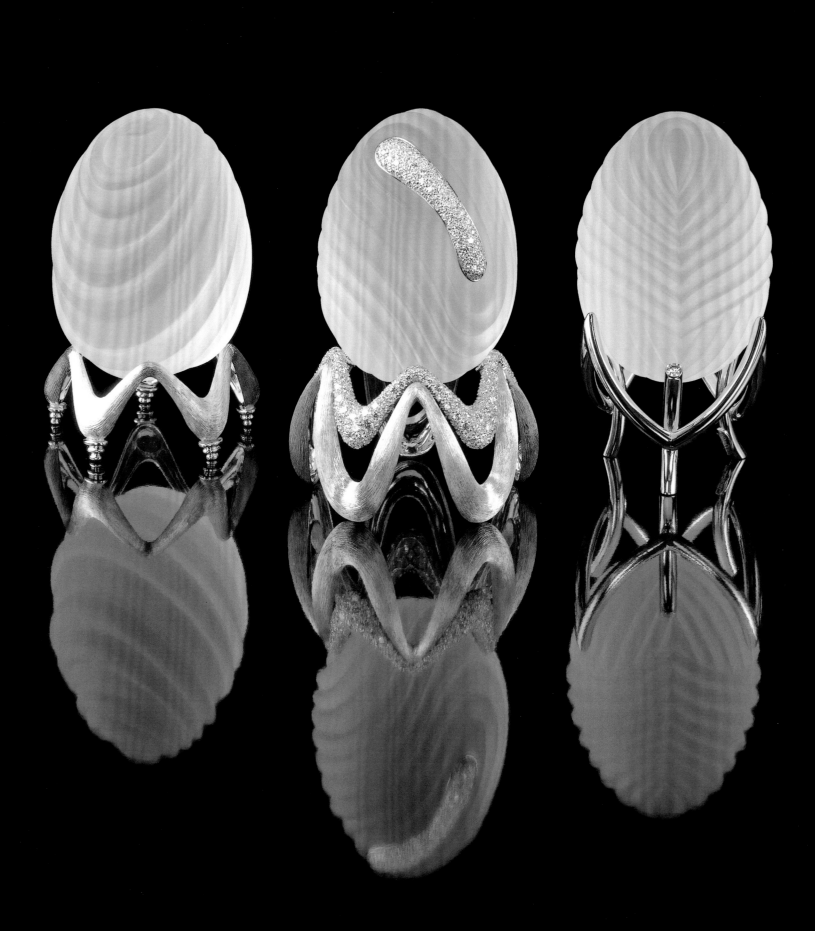

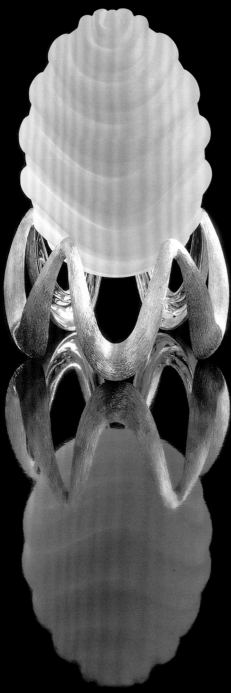
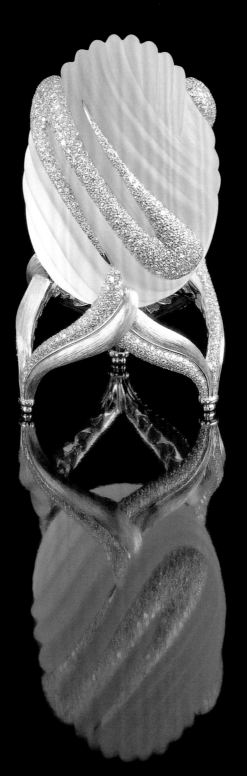
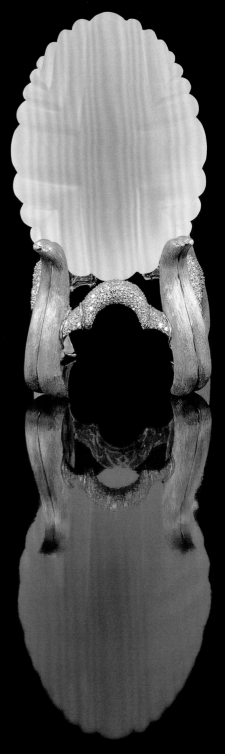

LEFT TO RIGHT Shidare-Zukuri: diamond, gold, and quartz egg with stand. Adagio: diamond, gold, and quartz egg with stand. Kengai: gold and quartz egg with stand. Sokan: gold and quartz egg with stand. Love Affair: diamond, gold, and quartz egg with stand. Fukinagashi: gold and quartz egg with stand.

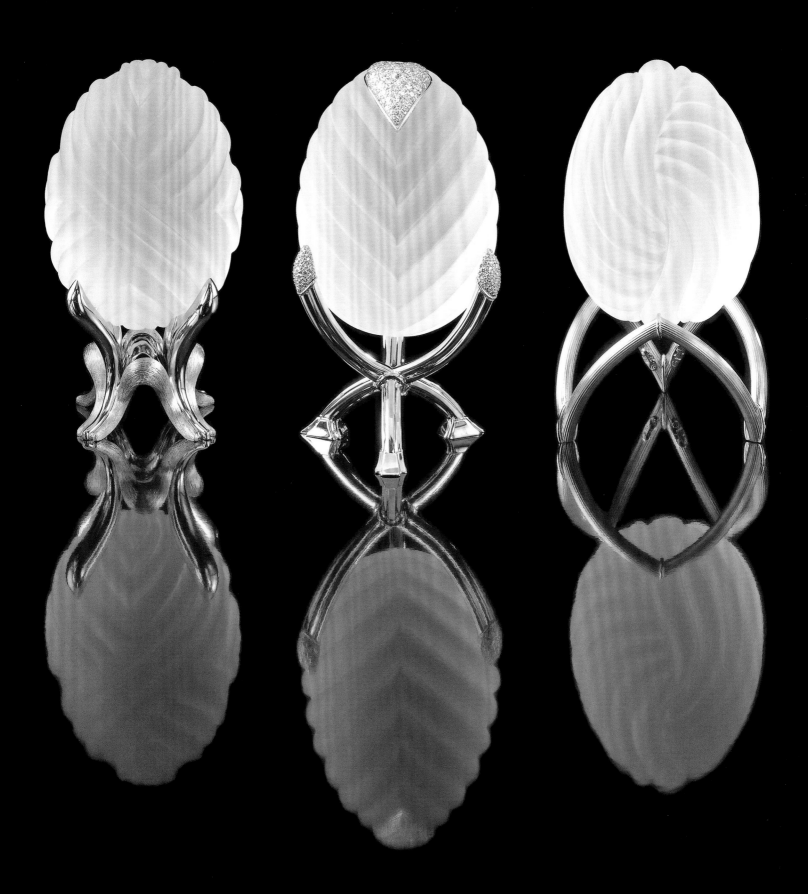

ancient ruler of the Ottoman Empire. The Sultan egg wore a hat of 2.90 carats of diamonds topped with a .85-carat cabochon emerald and stands on a regal based pavé-set with 2.60 carats of diamonds.

During the 1982 watch and jewelry trade show in Basel, Switzerland, the jeweled collection of eggs went on display at the Kunstmuseum. The exhibition was nothing short of a coup for the designer. Europeans dominated and ran the premier show, which had attracted buyers from all over the world since it began in 1917. For two years, Henry had been struggling to make his presence known at the show's American Pavilion. Yet few people visited the display located far from the main action. They did, however, find their way to the beautiful Kunstmuseum. At the exhibition opening, guests enjoyed viewing Henry's objects d'art and browsing the Van Goghs, Picassos, and Chagalls in the oldest museum in Switzerland. A stupendous success, the evening was a welcome break from the hustle and bustle of the show.

At a post-reception dinner for fifty at the Hotel Euler, Henry stepped up to the stove to celebrate the opening with a special Hollandaise sauce for asparagus— the vegetable which was always in season and very popular with fair goers. "I added Chandon champagne and honey mustard to the hotel's Hollandaise sauce recipe for zip," remembers Henry. Everyone loved it, including the chef, who added it to the menu as Sauce Dunay. The evening generated the type of excitement Henry wanted. "I came back from Basel with friendships, new friends who loved what I did," says Henry.

On the home front, the collection of eggs toured seven Neiman Marcus locations around the United States. "They showed the video of me working before I arrived at the personal appearances," says Henry. One woman watched the video several times before a salesperson said, "You should come and meet Henry at his personal appearance. The egg lover drove hours from Indianapolis to Neiman Marcus in Oak Brook, Illinois, to talk to Henry about the eggs and buy them. "People understood the passion we put into them," says Henry.

The complete collection of eggs sold out again and again at Neiman Marcus. It was a stunning example of the department store's prestige in the early 1980s.

OPPOSITE Scheherazade:
diamond, sapphire, emerald,
gold, and quartz egg with stand.
Early Spring: diamond, gold,
and quartz egg with stand.

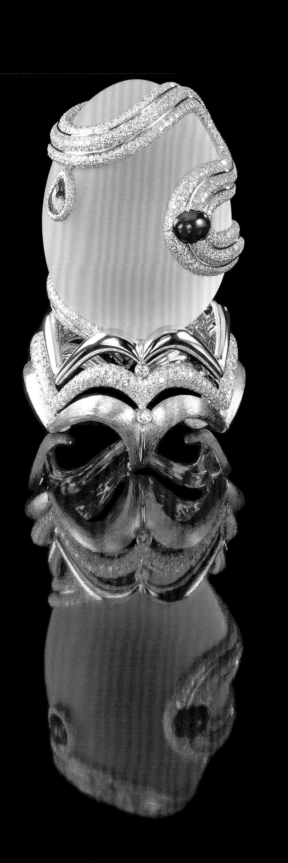
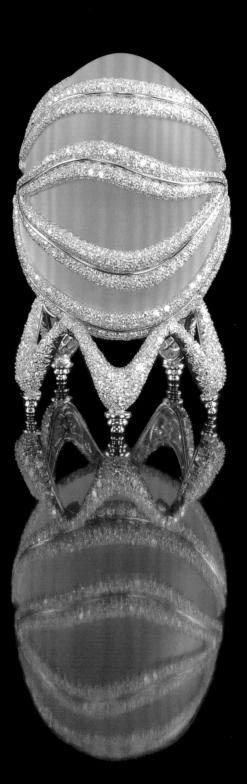

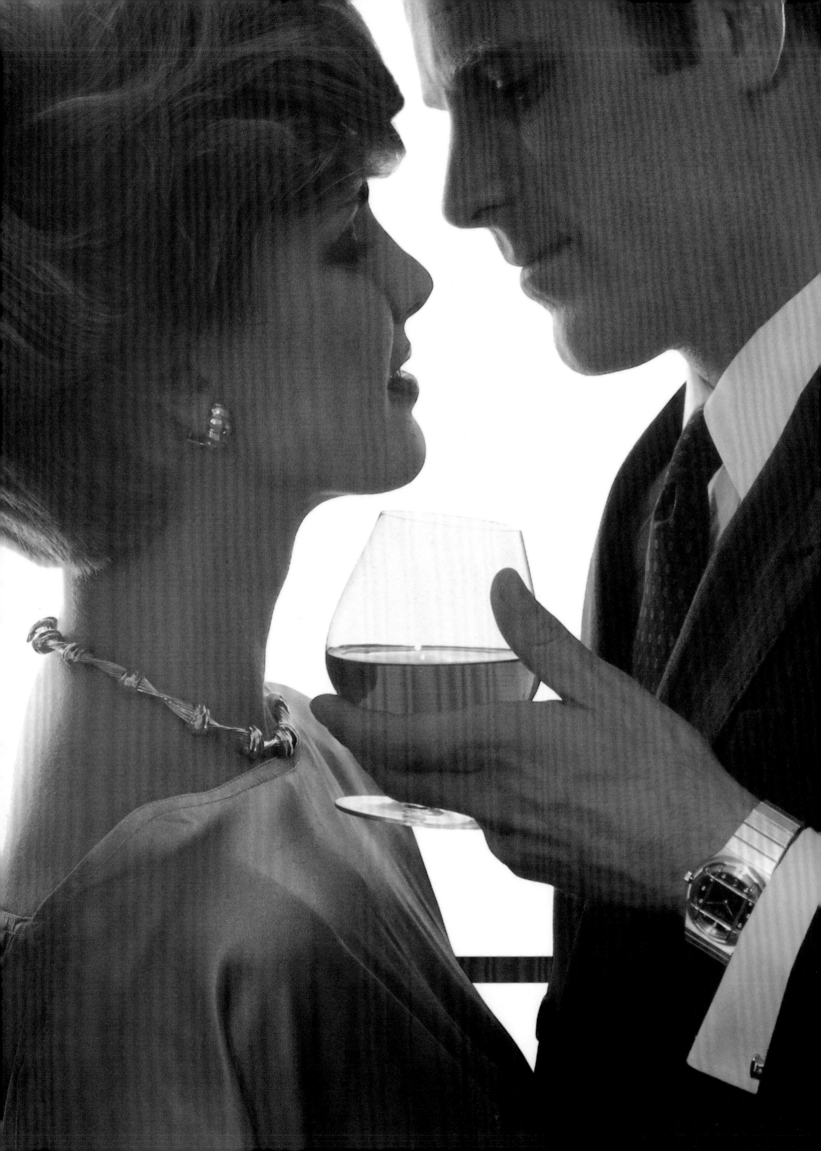

Women and men had become accustomed to picking up their favorite gold designer jewelry as part of the one-stop shopping experience at department stores—particularly Neiman Marcus. A new challenge for Henry in the 1980s was the competition. The jewelry designer experiment he pioneered in the seventies was such a success, department stores had become filled with designer names. During the long run of the bull market in the 1980s, the appetite for designer jewelry would grow to an all-time high. The strong images built by jewelry designers created a demand for products beyond jewelry, like belts, watches, and fragrances. Henry would do it all and become more aggressive about his image to make sure he stood out among the growing crowd.

The Diamonds International Awards had always been an excellent source of publicity. In 1982, Henry entered and won for the third time with the brilliant Liberation necklace. The honor catapulted him into the prestigious Diamonds International Academy and placed him within the ranks of great designers like Seaman Schepps, Pierre Sterlé, and Julius Cohen. The publicity was fantastic for the awards. The necklace appeared on *The Merv Griffin Show* and in a sexy De Beers national ad campaign with the tag line "Diamonds that shatter all the rules."

To generate regular publicity and promotions Henry decided to hire Linda Goldstein, president of Goldstein Communications, a firm formed in 1981 to merchandise, brand, and publicize designer jewelry collections. She had originated the concept of designer jewelry boutiques at Bloomingdale's department store in New York and Federated department stores around the country. Linda introduced Henry to accessories editors from fashion and trade magazines who placed his pieces on their pages. Cross-promotional events were one of her greatest talents. Henry's jewelry appeared in several national advertising campaigns for other products. A glamorous couple, he holding a sexy snifter and she wearing a Faceted necklace and earrings, appeared in an ad for the top-of-line French cognac Rémy Martin. The gimmick for a *Time* magazine campaign revolved around turning the "I" in *Time* into a various products. One of Henry's necklaces made the cut. The ads ran on billboards and in national magazines.

Henry launched his own advertising campaign around 1981. He worked with Bill Brown of the Brown + Partners advertising agency, based in Dallas, on the

visuals. "I believe a jewelry ad should be focused on jewelry and very little else; models and props can be a distraction," says Henry. "I came up with the idea of a simple silhouette drawing."

Clean and clear, the advertisements featured a black background with a white line drawing of a woman's head and neck and one key piece of real jewelry. The ad man introduced Henry to John Parrish, a still-life photographer based in Dallas, to shoot the jewelry they dropped into the silhouettes. The campaign ran in *Town & Country*, the publication for luxury living in the eighties. "People responded to the ads," remembers Henry. "I think it was the starkness on the page that got their attention."

To provide his sixty or so stores with a wider range of options to show clients, Henry produced loose-leaf catalogues. "No store could carry every piece in my collection," says Henry. "The catalogues provided a tool for the salesmen." They were simple still-life shots by John Parrish of the Faceted collection on Henry's signature black backgrounds. Things began to change after Henry had a eureka moment on an escalator at a Neiman's store. He glimpsed a model from a Bill Blass trunk show walking around wearing a white skirt, a blue blazer, a polka-dot top, and hat. "I said to myself, a woman buys that because she can see how it looks

ABOVE An advertisement promotes gold jewelry with a Dunay bracelet.

OPPOSITE A Dunay bracelet became the "I" in an advertisement for *Time* magazine.

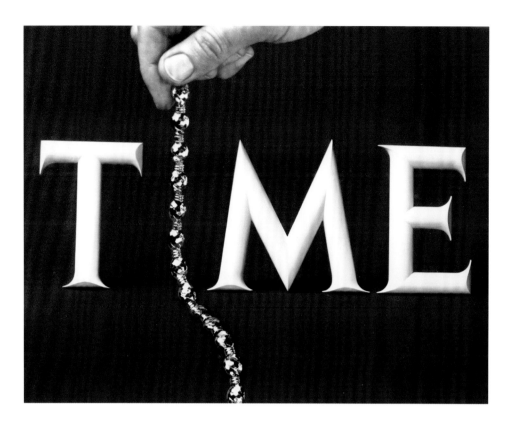

and how it should be worn on the model," says Henry. "I thought, why don't we do that with the jewelry catalogues."

Parrish photographed models wearing the clothes of the season and Henry's jewelry. The fashion images were interspersed among three or four pages of still-lifes that began to change, too. The number of jewels on a page was reduced. More complex settings and colorful backgrounds were added. "We started getting into the quality of the art," explains John. "At the beginning there were around nine pieces on a page. Eventually we were doing one piece."

Over the last thirty years John and Henry have collaborated for one week annually in Dallas on the catalogues. "There is not a layer between me and Henry as there is with so many clients," says Parrish. "This allows us to have a spirit of play." The pair has done everything from submerging jewelry in sand, rocks, and water to adding original art backgrounds. "We put Henry's bonsai tree brooches against some gorgeous Japanese-style drawings done by one of his salesmen, Don Santander," remembers John.

In order to prepare for the intense week of shooting, John and Henry brainstorm and John sends a couple of test shots. "Usually, we don't talk that much,"

says John. "Henry might ask for a few different things, but we basically understand each other." On the set in Dallas, Henry styles each and every page. John lights the jewelry on the set and shoots it one or two different ways.

The photographer who has seen so much of Henry's jewelry over the years continues to be amazed by his artistry. "I remember in particular a cameo of a woman's face with gold hair and her upper body coming out of a citrine," says John. "It is that kind of imagination in his work that perpetually amazes me." (See image on page 140.)

THE PUBLICITY, PROMOTIONS, ADVERTISING, AND CATALOGUE Henry started doing in 1981 gave his clients consistent exposure to his new work. It ensured his top ranking in the designer category within the department store. Designers, however, were not the only ones facing competition. Department stores were competing among each other to keep their clients and attract new ones. Neiman Marcus took the offensive. They enlisted designers to make collections just for their stores. The store Henry had worked so hard to break into turned to him for an exclusive gold collection in 1982. The price of gold had stabilized at around $450 an ounce. There was an unexpected rainbow after the storm: the prestige of gold jewelry rose to a new high with the markets and stayed there. It became the metal of choice for the decade.

Henry's confident new gold jewels were based on the best-selling shapes in Faceted but with an entirely different surface treatment. "I was thinking about this new collection when I was in New Orleans having lunch at Brennan's with a friend," remembers Henry. "It was raining like hell when we left and we walked past a furniture store and I saw it all in a flash in the reflection of a window. I asked my friend to go back so we could look again, but it was gone."

Bright light and shadowy spirals grooved into gold contrasted with ebony, opals, and diamonds defined the new collection of earrings, brooches, superior statement-making cuffs, and link necklaces. "The jewelry was bold but soft with movement," explains Henry.

The name for the collection came to Henry one night when he arrived home to Jersey City. "The driveway sloped down in front of the house and the wind would blow around the dirt in a sort of beautiful whirl," he recalls. Henry looked at the scene with the eyes of a poet and coined the new collection Nightwind.

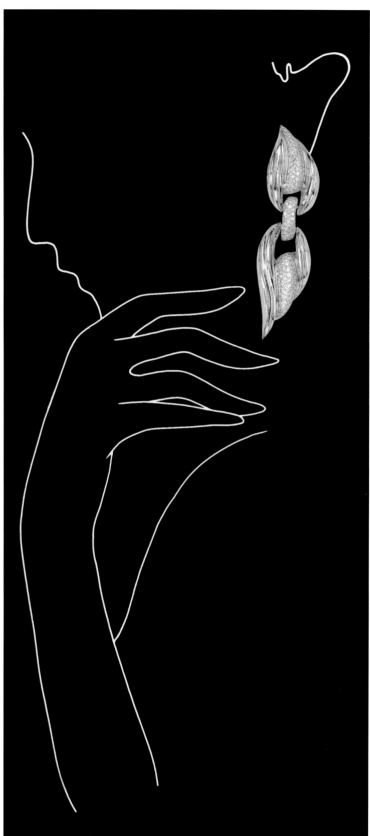

LEFT A large square Nightwind earring shone in a Dunay advertisement.

RIGHT A bold diamond and gold earring appeared in a Dunay advertisement.

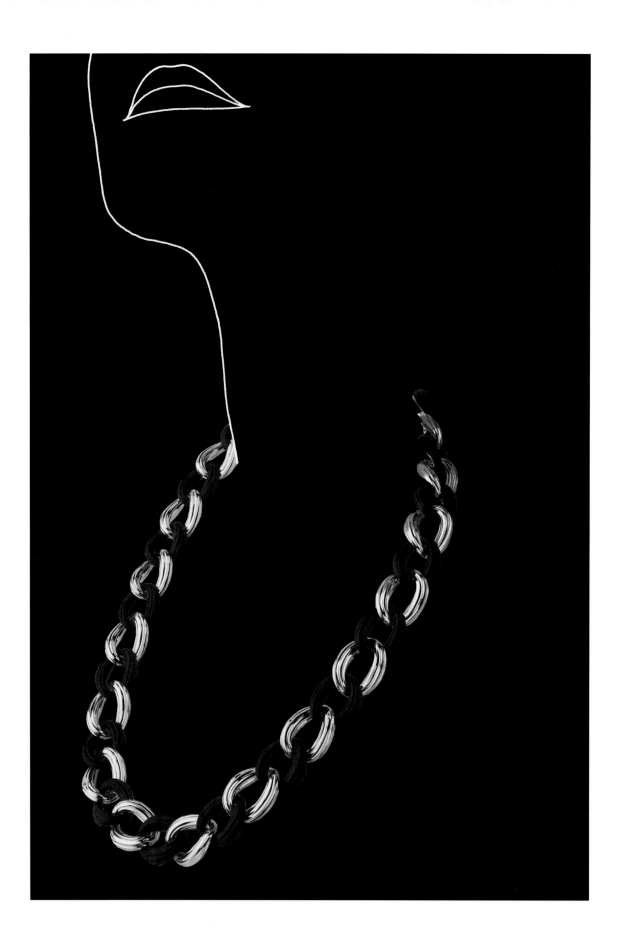

ABOVE A long ebony and gold
necklace made an appearance
in a Dunay advertisement.

OPPOSITE A striking opal and
diamond earring and necklace
added a splash of color to Dunay's
black-and-white advertisement.

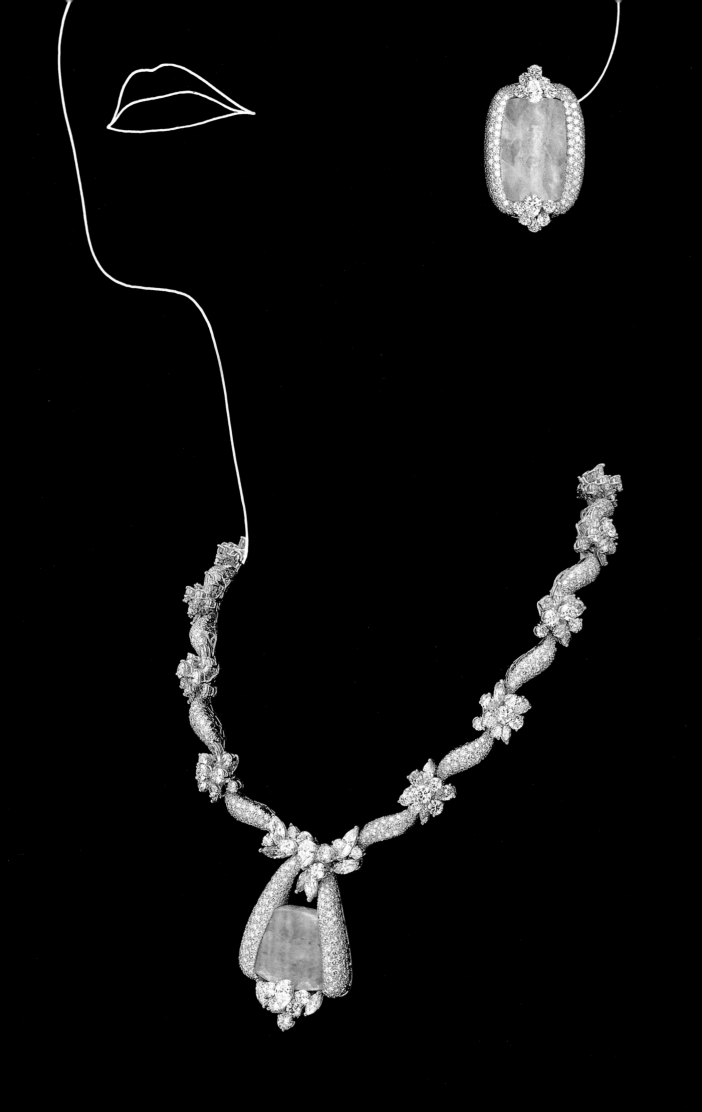

The sister collection to Faceted, Nightwind gave Henry's clients an opportunity to have something new, yet it blended right in with their older pieces. It was an extension of the jewelry wardrobing. "I don't like a set of jewelry to match exactly," says Henry. "There was variation in necklaces, earrings, and bracelets of Faceted to make a set for each woman slightly different. With Nightwind clients could mix and match and make the look their own look."

Jewelry was popular in American department stores during the 1980s. It was also big in Japan. "The Japanese buyers came around to my booth in Basel," says Henry. "I would say hello in Japanese, *Konichiwa*, and that broke the ice." Henry's first trip to the land of the rising, sun in 1982, was similar to his start in Texas with Neiman Marcus at the Greenhouse trunk shows. He joined a luxury kimono company for a weekend at a hotel with clients. Another parallel to Texas was the bubble economy. "I felt potential there," remembers Henry. The designer's work was not lost in translation. Seibu, one of the hottest department stores in the country during the 1980s, picked up the line. "It was a great union," says Henry. "Mr. Miaki, the buyer at Seibu, guided me in the ways of Japanese culture; he taught me alot, including the art of drinking sake."

ABOVE Henry and his dog, Lady, pose for a picture at Sutton Place Park, New York City, near his home.

OPPOSITE A necklace and earrings from the Nightwind collection Henry designed exclusively for Neiman Marcus.

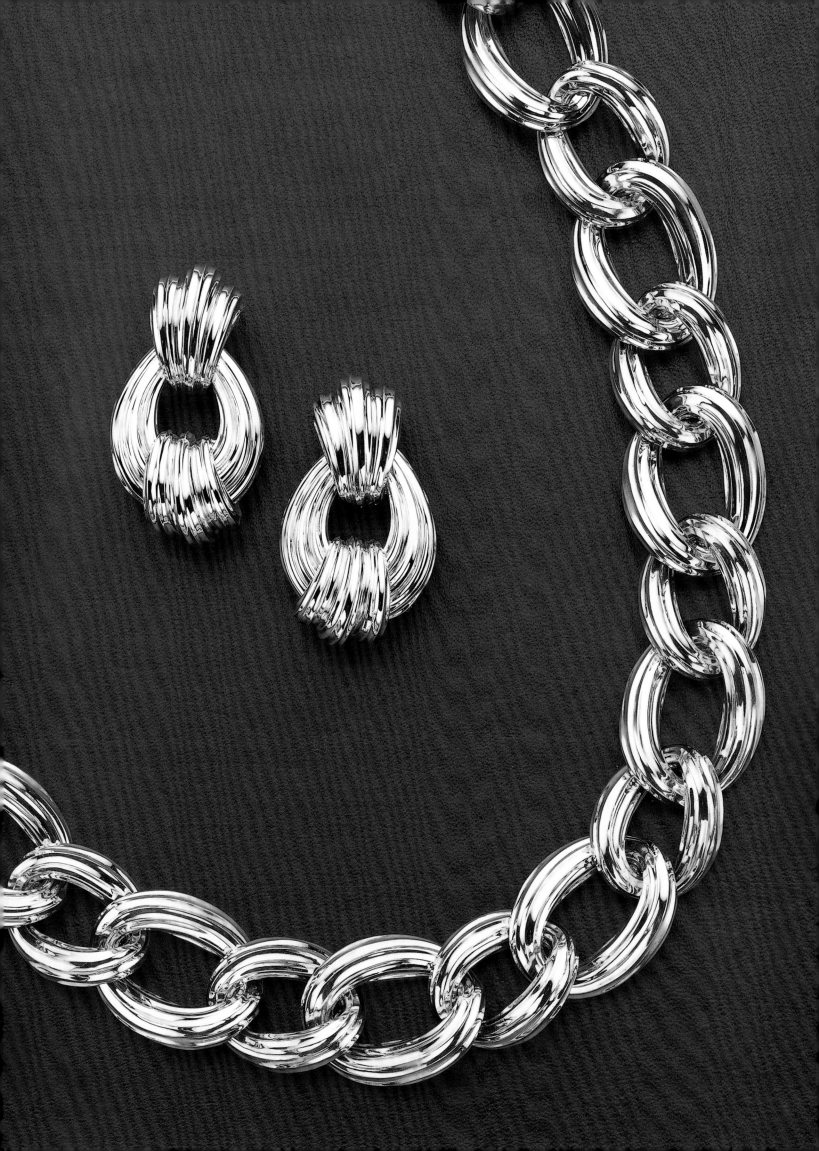

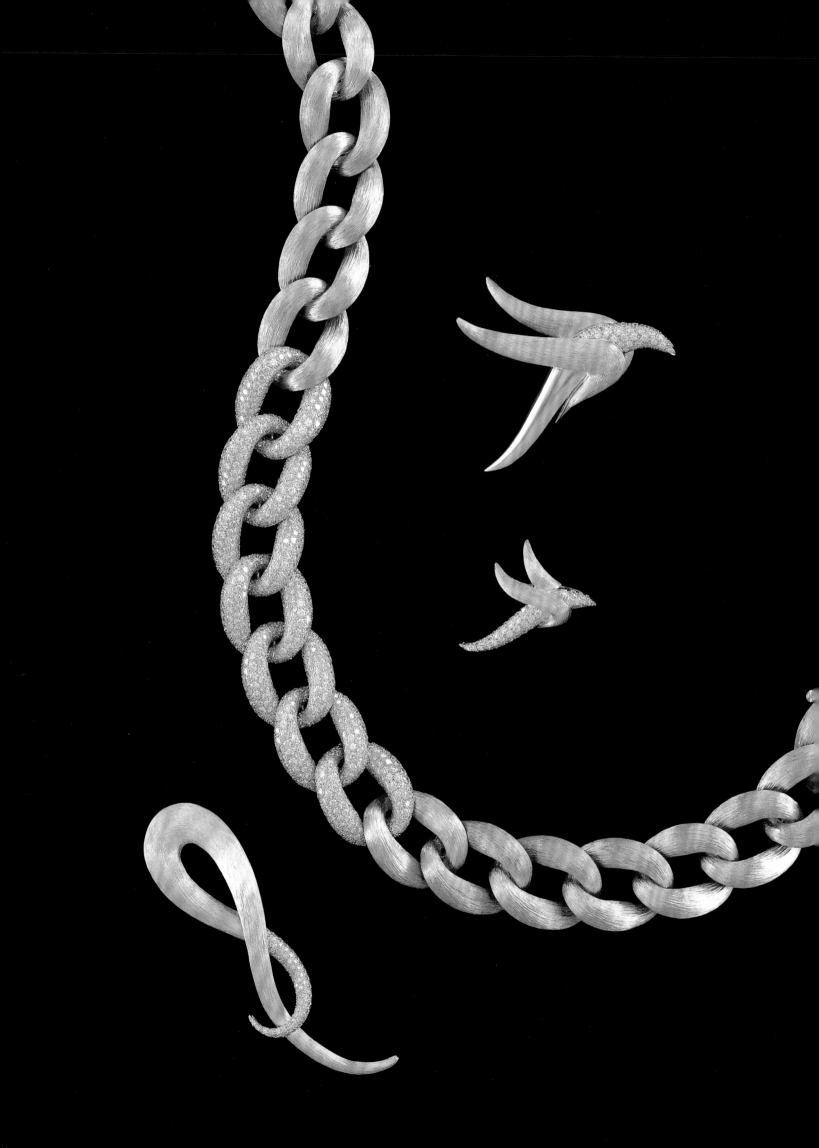

In the beginning Henry went twice a year to Tokyo, to attend events at the Takanawa Hotel, then he increased his visits to four to six expeditions a year and established an office. Henry found the eastern meditative culture captivating. "I enjoyed going outside Tokyo's frantic environment to the quiet temples in Kyoto and Kanazawa where people's homes have thatched roofs, everything is wood, and there are tatami mats, the traditional Japanese flooring of woven straw," says Henry. "The décor and lifestyle was simple, clean, and clear. There are amazing rock gardens and simple flower arrangements like a vase with one perfect flower."

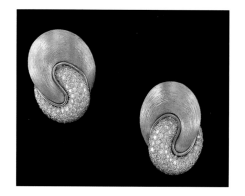

Aesthetic principles inherent in the language lingered in his mind. Henry was particularly intrigued by the word *sabi*. A scholarly interpretation of *sabi* reveals the deep aesthetic values of Japanese poetry and the tea ceremony, distilled in silence and gently passing moments, bringing a beautiful patina to everything. Basically, *sabi* can be translated as simple elegance. Henry chose the word as the name for his next collection.

Completely different from the audacious Faceted and graphic Nightwind, Sabi was subtle. "Japan had a refining effect on me," says Henry. His new gold jewelry featured slender lines, one next to another, carved so exquisitely they looked like golden strands of hair resting on the surface of the jewel. "An artist uses paint to create depth of feeling," explains Henry. "In metal a jeweler can do it by raising textures. The textures tell a story of what I feel."

In 1984, when Henry launched Sabi, he was a different man. He had separated from Carol and moved to Manhattan's East Side. The energy of the city excited him. "Everyday I took a different route walking to the office to explore the architecture and the store windows," says Henry. "The stylish way people dressed in the neighborhood was so exciting to see." Over time a romance blossomed between Henry and his publicist, Linda Goldstein. They enjoyed going to museums, galleries, and auction houses on the weekends. During the week, Henry threw himself into his work.

Henry had been meditating on Sabi for a long time. It was an evolution of the bark finish he had done on his 1967 Diamond Award–winning ring. He refined and refined the thick lines breaking the surface of the gold with a frazer. "I had boxes of frazers around the workshop," says Henry. "The center of the

OPPOSITE AND ABOVE A necklace, brooches, and earrings from the collection Henry named Sabi, after the Japanese term for simple elegance.

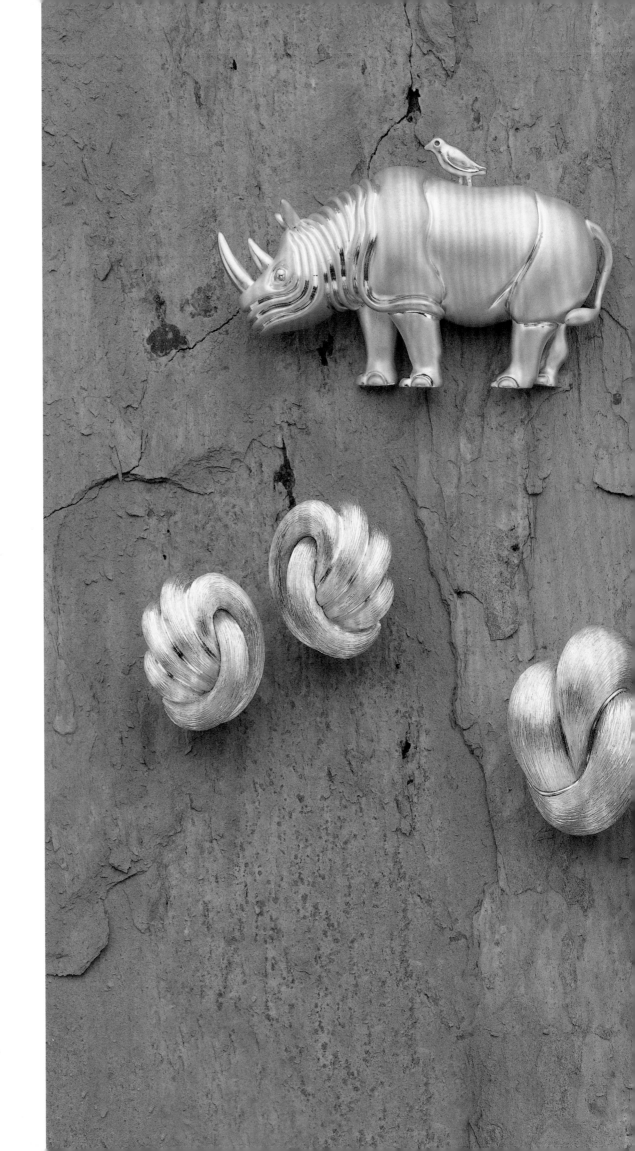

An array of gold jewelry
with platinum details
from the Sabi collection.

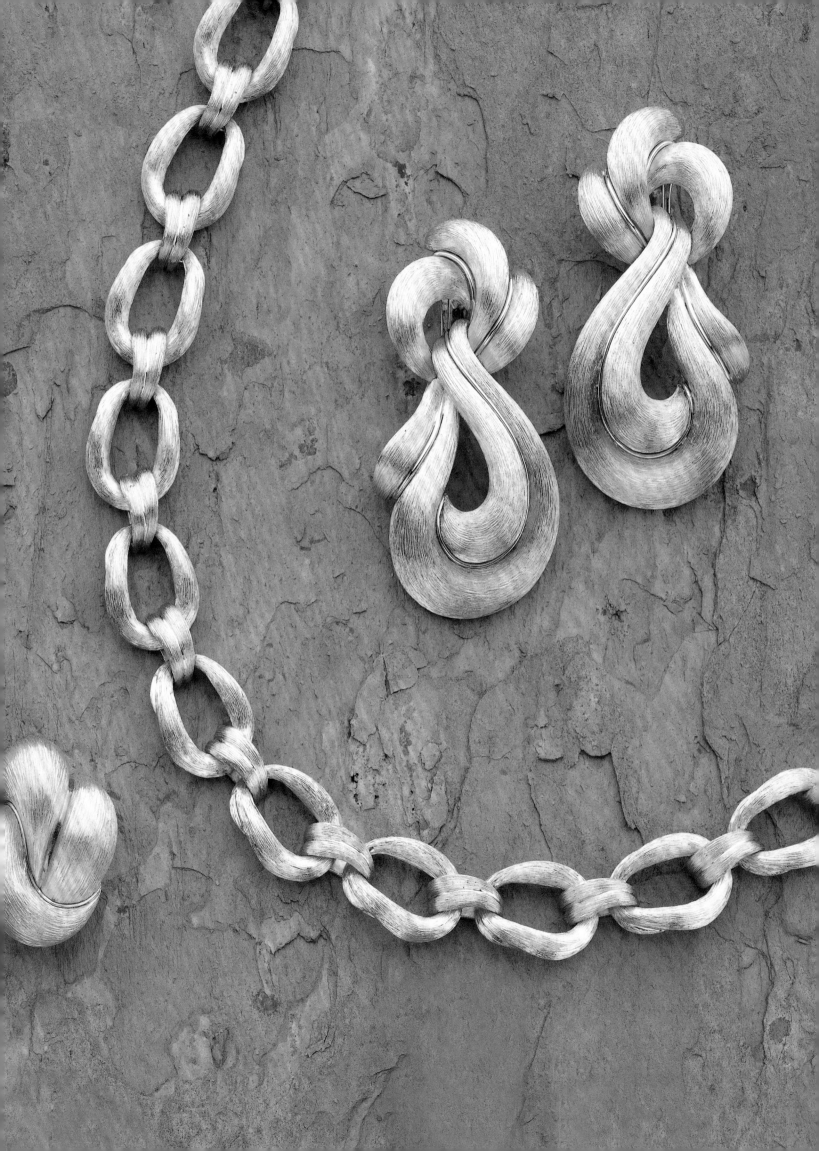

cutting wheel was worn down from making Faceted; I used the pristine outer edges to make Sabi." Once the piece was assembled and polished, he would go over the slender lines again to dull the surface to a sophisticated matte finish. "Every jewel I make has multiple steps in the process of production," says Henry. "And Sabi was definitely labor intensive."

Even though Henry was a master craftsman, he frequently nicked the tips of his fingers in the process of creating Sabi. One night, working late and alone, Henry did more than nick his fingers. He cut himself seriously and passed out. When the office alarm was not set at the designated hour, the security company placed a routine call. The ringing telephone revived Henry and he rushed to the nearest emergency room.

Henry did not have to put himself in this perilous situation. He had enough financial success and staff to give up his work on the bench, but he did not want to. Sabi completely reenergized Henry, at fifty years old, to spend as many hours on the bench as ever. "Sitting at the bench is not work, it is joy," says Henry. "It is where I figure out ideas for everything—including collections." The Sabi finish initially appeared on chain-link necklaces with Baroque pearls, abstract brooches with a graceful free-form line, and earrings in a range of sculptural, organic shapes.

Henry raised the bar for Sabi by adding platinum. The unbelievable hardness of the white metal makes it Mt. Everest for craftsmen. Henry destroyed the point of one tool for every platinum jewel he made, but the results were well worth it. The pieces with platinum and gold shone like stars in an already brilliant collection that attracted a whole new audience with some very high profile people to Henry's work. Among the many women who purchased the pieces were Princess Diana, Great Britain's Prime Minister Margaret Thatcher, cosmetics executive Georgette Mosbacher, and Hollywood icon and jewelry collector extraordinaire Elizabeth Taylor.

THE 1980S WAS A FLASHY FASHION ERA. Women made bold, colorful statements with their suits, bags, and shoes and they definitely wanted dimension and color in their jewelry. Henry gave it to them by adding huge colored stones to Sabi. The sophisticated surface complemented big gems perfectly.

OPPOSITE A model wears a Dunay watch with several of the designer's bracelets.

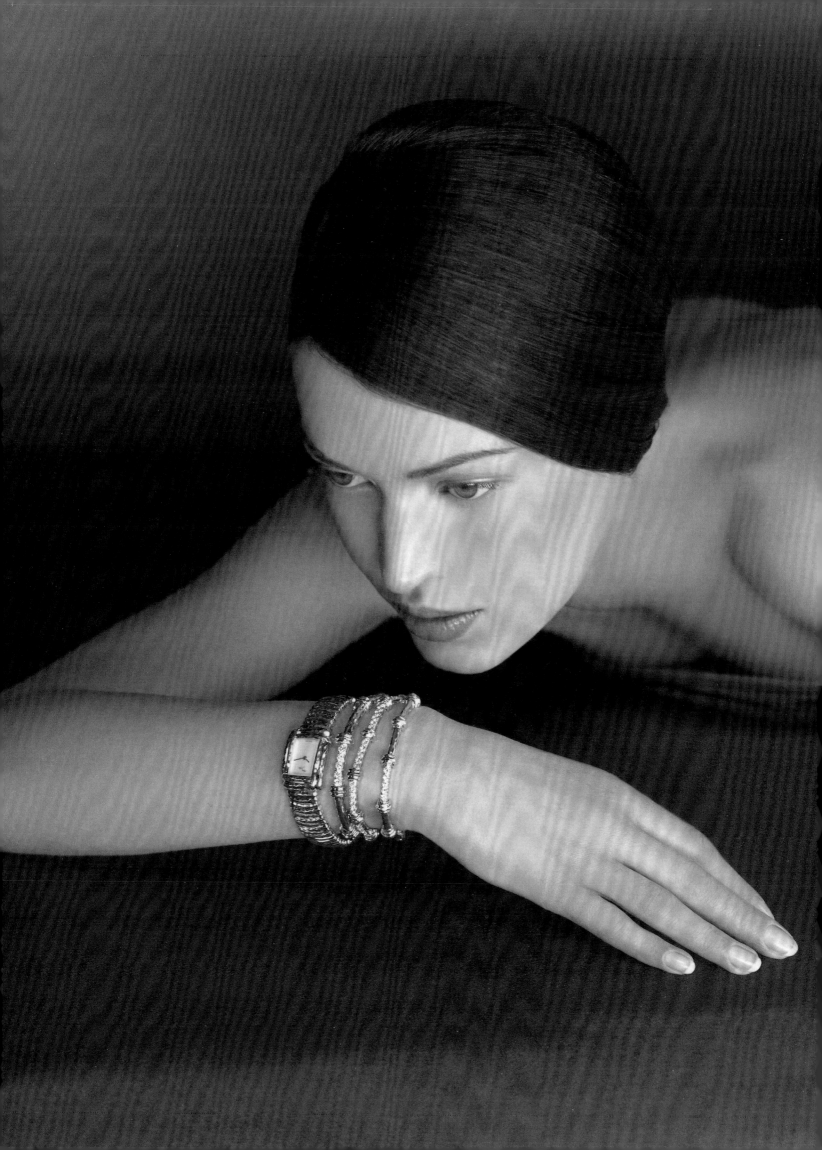

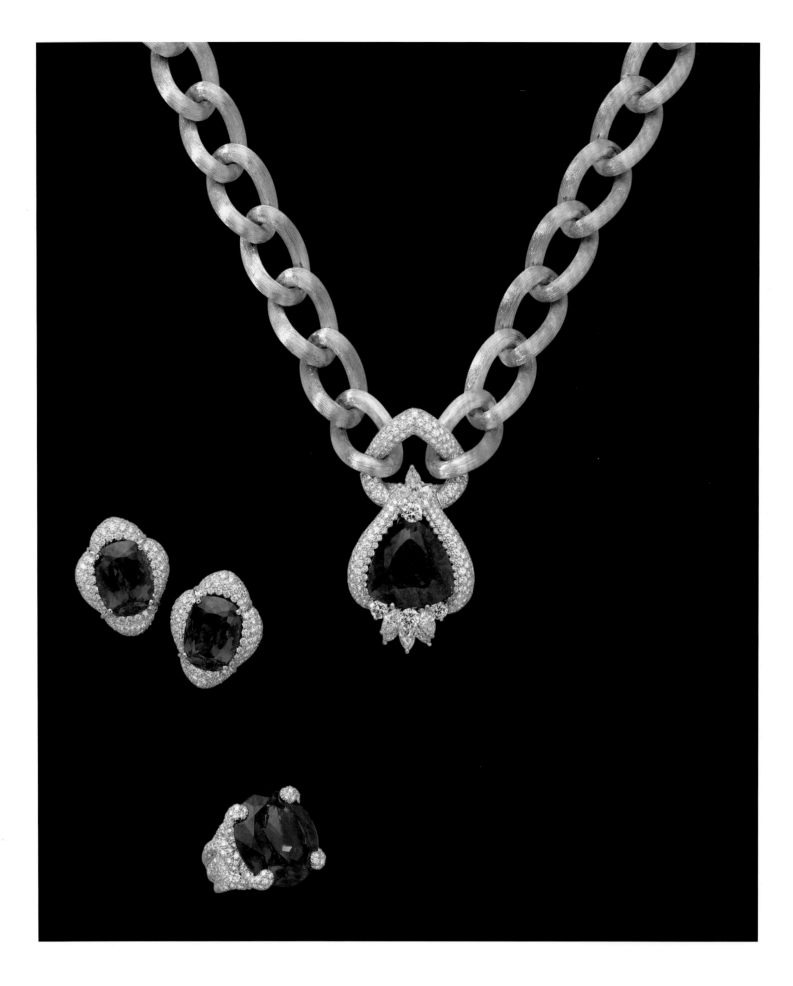

ABOVE Tanzanites shine in a diamond and gold necklace, earrings, and ring.

OPPOSITE Peridots light up a gold and diamond necklace and rings.

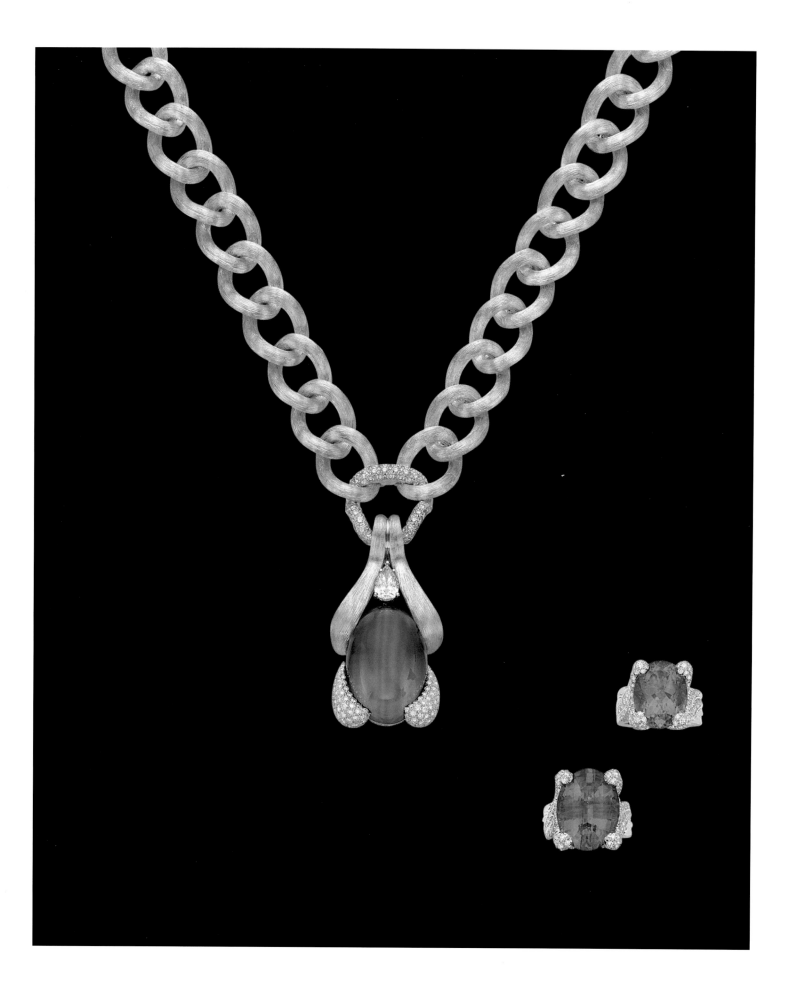

"I look for out-of-the-ordinary gems," says Henry. "I tell the stone dealers I see in New York, don't show me your basic stock. I want to see your best stones." In Germany, Henry bought lots of rough. The uncut material gave him the opportunity to create extra-large stones for one-of-a-kind pieces. One of the most amazing pieces of rough Henry bought was a tanzanite. "There was this huge tanzanite rough behind Jürgen's desk, and the light was hitting it beautifully," remembers Henry. "I loved the color of tanzanite; it is like sapphire."

The magical blue gemstone with a purplish hue comes from Tanzania, Africa; the region that gave it its name. When it was originally discovered in 1967 it was hailed as the "gemstone of the twentieth century." According to the International Colored Gemstone Association, "Experts literally held their breaths when they were shown the first deep blue crystals mined in the Merelani Hills near Arusha in the north of Tanzania."

Henry knew he could get numerous small stones from Jürgen's magnificent piece of tanzanite rough, enough to make many jewels. But he didn't want to do that. Henry wanted to cut big pieces of tanzanite and create some rare knockout jewels. Jürgen and Henry studied the stone. Henry drew some of his favorite shape, cabochons, on a pad, the curvaceous rounded cut following the sensuous lines of his jewelry.

Ultimately there were nine pieces cut from the tanzanite rough averaging about 35 carats each. There were a couple of novel cuts that approximated rounded cushion shapes and a couple of super cabochons. "The shape is called a high cabochon," explains Henry. "And I like them that way; why take from the rough if you have got it? A lower cab dissipates the color."

Eight of the gems went into magnificent rings, surrounded with pavé-set diamonds. The bonanza of the tanzanite was one amazing 50-carat trillion. Henry described it as "a relaxed trillion, like a pear with fat sides." He designed a magnificent chain-link necklace covered in diamonds around the stone.

"Peridot came right on the heels of the tanzanite," says Henry. "I spent a fortune on peridot from Pakistan." The deep-green gemstone had been discovered on

a 4,000-meter-high mountain near the border with Kashmir. Jürgen, an expert mountain climber, went to Pakistan and came back with unusually large and fine crystals, better than any peridots the world had ever seen. Henry and Jürgen called the new gems Kashmir peridot to connote the high quality. Kashmir means luxury in gems, because it is the place where the finest sapphires in the world were mined.

In Idar-Oberstein, Henry had many of his Kashmir peridots cut into cabochons, which brought out the golden green color better than any other shape. He set the gems in gorgeous rings and sumptuous necklaces covered in diamonds. "I am always thinking about how much light I can shine onto the gemstone," explains Henry. "I am expert in placing the diamonds in the right position around the stone to improve the color by as much as five percent."

Henry called the colored stones educational stones, because most people were not familiar with them. "I had to educate a client about what they were and explain the quality of the color," he recalls. "I would tell them where the gems came from." The luscious gems—the bold colors and extra large sizes—became a signature of the Dunay collection. They quickly turned Henry's suntanned ladies into rock hounds. "My suntanned ladies were into big rings," says Henry. "And I knew there were some out there who were courageous enough to wear the high cabochons."

Henry's talent and taste for extraordinary colored gemstones made him Jürgen's go-to man for teasing gem situations. Jürgen asked Henry if he had any thoughts about what to do with the huge chunk of African ruby left over after creating a clock for the Sultan of Brunei. "Jürgen and his group bored into this piece of rough, which must have been thousands of carats, with an ultra-sonic drill to pull out rods that were around ten or twelve inches long to make the columns for the clock," explains Henry. The dark, opaque red rock was left speckled with holes. Henry suggested transforming a chunk of rock into a beehive, filling the holes with gold and pavé-set diamonds, and adding a swarm of bees.

The unusual columnar shapes of the remaining stones intrigued the designer. One of the thick imperial-red columns weighing approximately 783 carats and

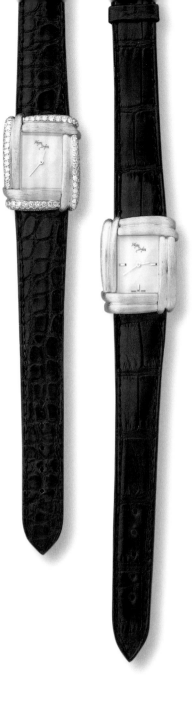

ABOVE AND OPPOSITE Henry
launched a line of gold Sabi and
Faceted watches in 1985.

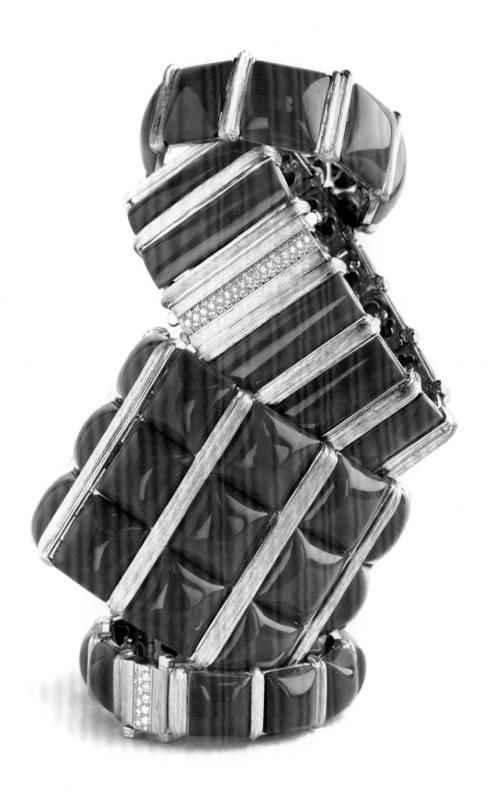

ABOVE Dark coral is set in a tuck and roll pattern in four gold and diamond bracelets.

OPPOSITE Vintage coral from Tibet moved Henry to design a prayer-bead-style necklace with a golden tassel and an emerald element.

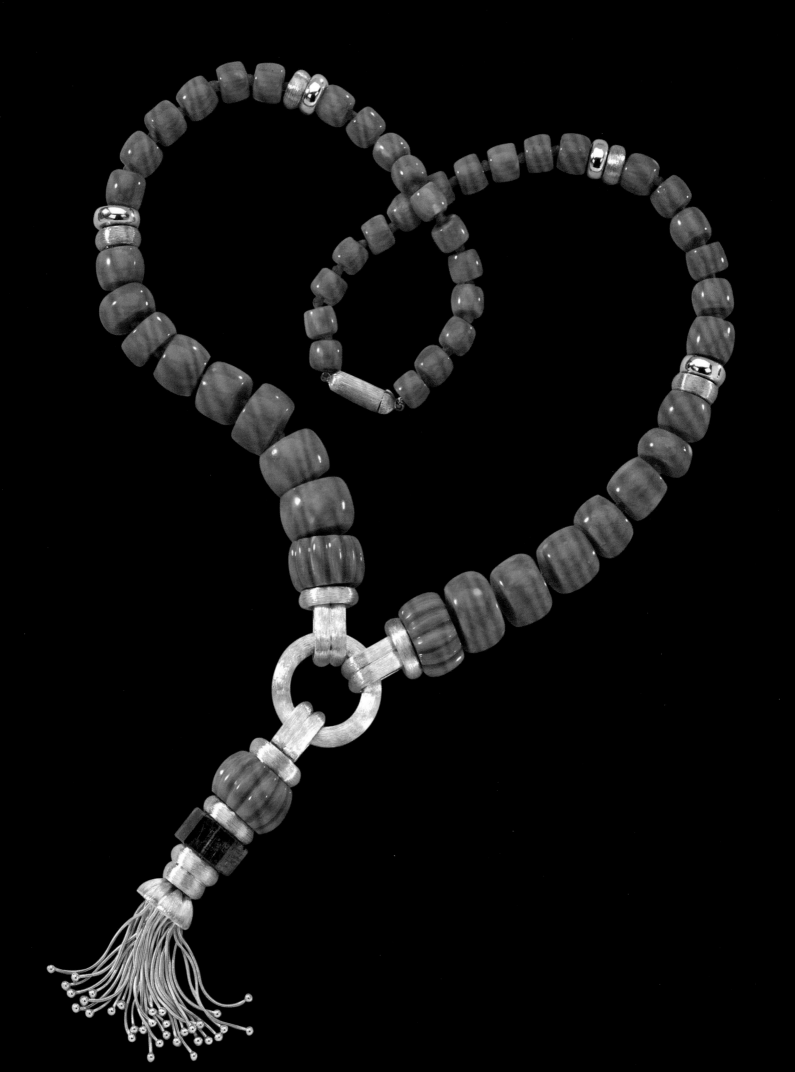

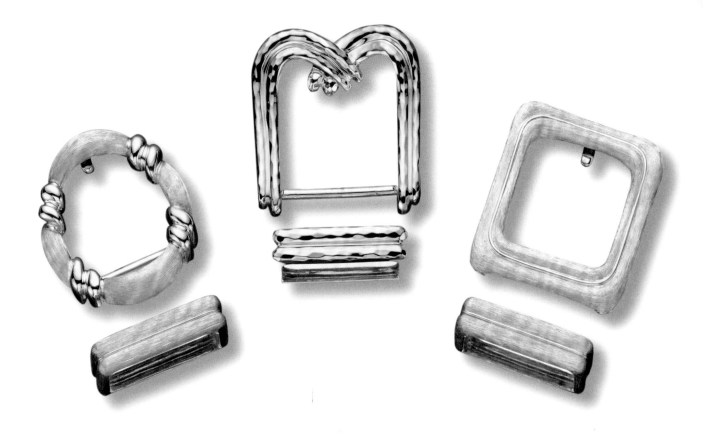

measuring around 5½ inches high reminded Henry of ancient Rome. He had a heroic scene carved around the drum. The narrative begins on the front with Hercules tackling his first labor, the lion of Nemea. On the back Hercules rests on the vanquished lion skin, the trophy of his labor, with his club beside him, and caresses his nude lover, Omphale, Queen of Lydia. Henry placed the precious victory column among ruins of broken gold columns and blocks that he textured with a diamond tip tool. He named the object Lost Empire. (See image on page 144.)

Henry decided to turn the smaller ruby columns into a necklace. He sliced them in half and individually crafted each piece with gold caps on both sides. When it was partially completed, Henry realized he would have to start over. The weight of the gems was going to be far too heavy for a woman to wear. He sent the gems back to Germany to be hollowed out and lightened up. The final piece featuring seventeen rubies weighing a total of 457 carats was an engineering feat that was well worth it. "I love rubies," says Henry. "The truth is I think they are my favorite stone. I say rubies are a girl's best friend."

ABOVE AND OPPOSITE Henry made Sabi and Faceted belt buckles during the 1980s.

HENRY HAD BECOME THE JEWELER WITH THE MIDAS TOUCH. He seized the moment to expand the house of Dunay into new luxury areas: watches and a fragrance. In his characteristically thorough way, Henry headed to the heart of Watch Valley, Chaux-de-Fonds, Switzerland—where the watch industry was born—and put his designs on the table for Dino Di Modolo. The watchmaking wunderkind and his team loved the concept of the timepieces with bold, gold brush strokes in the Sabi or Faceted finish, enclosing a rectangular face. Some had deluxe gold bracelets accented with diamonds. Others sported fine leather straps from the Jason leather company in Marennello, Italy. "The man who ran the company gave me a big bowl of pasta," says Henry. "Then he showed me the leathers from alligators in New Orleans; they had the softest inner belly." Henry chose all kinds of colors including black, three shades of brown, gray, red, lavender, and blue.

After the Swiss team did what it took to make the watches tick and the assembling was done, Henry did what it took to make sure the watches debuted at the Basel trade show in a big way by opening an office in Geneva in 1985. This strategic move established Henry Dunay as a Swiss company, a title that meant he could have his own booth with a good location at the fair.

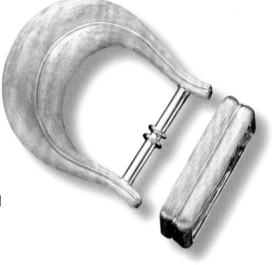

Mixing a perfume was next on the agenda. For this project the talent was all in the family. Henry collaborated on the alchemy of a Sabi scent with his younger brother, Richard "The Nose" Loniewski, a major player in the world of perfumers who was responsible for such blockbuster fragrances as Yves Saint Laurent's Opium and Giorgio of Beverly Hills' Red. "We tested many different blends over a period of years to find the one that was as elegant as my jewelry," says Henry. Two hundred and fifty natural oils made the final cut, which included jasmine, wild orchid, hyacinth, rose, ylang-ylang, and a few spices.

Once the chemistry was complete Henry designed all the packaging for the perfume and eau de parfum. Two styles of frosted glass bottles with patterns reminiscent of the flowing lines on his eggs were manufactured at a fine glass factory in Normandy, France. "I went there to proof the bottles," says Henry.

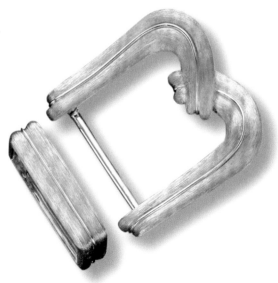

ABOVE Carved amber and
gold beads are combined in
a necklace.

OPPOSITE Gold elements
mingle among carved
nephrite beads in a necklace.

"It was important to me that they looked good on the dressing table and felt good in your hand." The Sabi body lotion and shower crème came in large stock plastic bottles. "The lotion goes in the bathroom so you can't do it in glass because it might break," explains Henry. "But I did create the gold cap with facets." The bottles came in black boxes with gold trim and lettering Henry also designed.

For a limited edition of fifty, Henry made Sabi the most expensive fragrance in the world. He went over the top of the columnar bottles with a gold and diamond-encrusted convertible cap. The lavish top could be screwed into another element forming an elongated egg-shaped pendant and worn on a thick, black silk cord necklace. Everything came in a black lacquer and gold-leaf presentation box Henry had made in a town outside of Tokyo. The limited edition collection sold at the record-breaking price of $30,000.

HENRY'S FLAIR WITH GOLD AND THE SOPHISTICATION OF SABI landed him a spectacular commission from Pinch, the oldest distillers of whiskey in the world. The company wanted him to re-create their famous dimpled bottle in gold and fill it with Scotch for a contest to promote the brand in the United States. Contestants were supposed to guess the total weight of the piece. "I accepted the commission because I felt it would be an engineering feat to recreate the distinctive triangular-shaped bottle," remembers Henry. "It would push my craftsmanship to the limit."

Dunay had the bottle and the label—copied down to the letter—carved in wax. He made sure the cap functioned. Then he put the dimples back with handmade plates. "Everything ran smoothly until it was fired and the base suddenly became convex," remembers Henry. Thinking quickly, Henry grabbed a hammer and tapped the bottom lightly. "It popped back into place," says Henry. "Everyone in the shop applauded."

The bottle was done three days before the competition. All that remained to do was the gold wire on the outside. "It took us the entire three days to figure out how to twist the wire so it would be right," remembers Henry. "We completed it mere hours before the press conference." Pinch garnered an enormous amount of publicity from the bottle. It went into the *Guinness Book of World Records* as the largest gold bottle in the world.

OPPOSITE The gold and diamond cap on the limited edition Sabi fragrance could be transformed into a pendant and worn on a black silk cord.

ABOVE Pinch whiskey commissioned Henry to re-create its distinctive three-corner bottle in gold.

HENRY FOLLOWED UP SABI with a collection in homage to Eastern art. It would mark the beginning of an entirely new chapter of his work, a real departure from gold and gem-set pieces to jewelry with imagery. "The idea started in Taiwan at the National Museum," remembers Henry. "It is filled with Chinese art. There was one floor with ivory and jade, another with porcelain dating from before Christ. On the top floor there were all these scrolls with landscape scenes, beautiful waterfalls, bridges and a house with mist coming down over everything. I admired them so much."

The name for the collection came from the Cinnabar Springs of the Huangshan mountain in China. Known as "the loveliest mountain in the world," it was inscribed a World Heritage site in 1990 by UNESCO for its natural wonders, like the cloud seas forming near the peak and the deposits of the deep red mineral cinnabar found by the Cinnabar Springs. All of these romantic notions ran through Henry's head as he designed. To make the name his own, he changed the *i* in cinnabar to a *y*.

Japanese lacquer boxes dating from the sixteenth to the nineteenth centuries with their mélange of dark and tawny landscapes lit up by flecks of gold and silver stimulated Henry's imagination for the manufacturing of Cynnabar. "The Japanese artists sprinkled gold and silver particles into the sap of a lacquer tree to create a slight texture," explains Henry. "I looked at that and thought about layering different colors of metal. Everything in jewelry is basically flat. My work always has had curves in the metal and cabochon-shaped gems—yet Cynnabar was the most sculptural thing I have ever done."

The crafting of every Cynnabar jewel involved numerous steps: carving a green wax model, casting it in gold, cutting it into pieces in order to polish every nook and cranny. Reassembling the gold gave Henry the opportunity to add sculptural geographic details. "Jewelry designers always have to think about the weight of a piece," says Henry. "Cynnabar was heavy with metal yet it was balanced. I worked hard on that in the process of manufacturing it."

ABOVE AND OPPOSITE Three Cynnabar brooches paint a picture of mountains and streams in gold, platinum, and diamonds.

The Cynnabar collection included cuffs of the four seasons—spring, summer, winter, and fall. They had undulating gold planes, waves of platinum, and splashes of pavé-set diamonds symbolizing the elements: earth, water, wind, and the sun. Each caught the moment of change in a season. Autumn, for example, shows the wind with lines of platinum, blowing leaves in different colors of gold and platinum. The textured surface of the cuff depicts the fading of a grassy field. Platinum clouds hover over the scene.

Henry interpreted geographical wonders of the world in Cynnabar. The many different colors of the Painted Desert in Arizona that stretches southeast from the Grand Canyon to the Petrified Forest became a precious panorama in one of the most spectacular Cynnabar bracelets. Like a *plein air* painter who works with the sunlight on a landscape, Henry had a time of day in mind for his desert scene—sunrise. "The bright ball of the sun at dawn shining down on the earth intensifies the color of the sand which I made with yellow and white diamonds," explains Henry. "The edges of the cuff gleam, showing the mountains in the early morning light. And wisps of cirrus clouds are outlined in bright platinum lines to reflect the progression of the dawn."

A Cynnabar cuff of a lake with lilies won a Grand Prize at the 1992 Diamonds Today competition. J. Walter Thompson, the advertising firm representing De Beers, sponsored and ran the American competition (formerly called Diamonds USA). Winners received publicity and promotion like the winners of the Diamonds International Awards. In 1992, a number of photographers were commissioned to choose one of the winning pieces and shoot it. Fashion and art photographer Albert Watson shot the Painted Desert cuff in a box with other objects, making it look like a lost treasure. All of the photographs of the winners were assembled in an exhibition called the Art of Diamonds, that toured museums and galleries across the country.

"Through my Cynnabar designs," Henry explains, "I was saying so many things. I wanted to relate meaningful messages about the destiny of humankind.

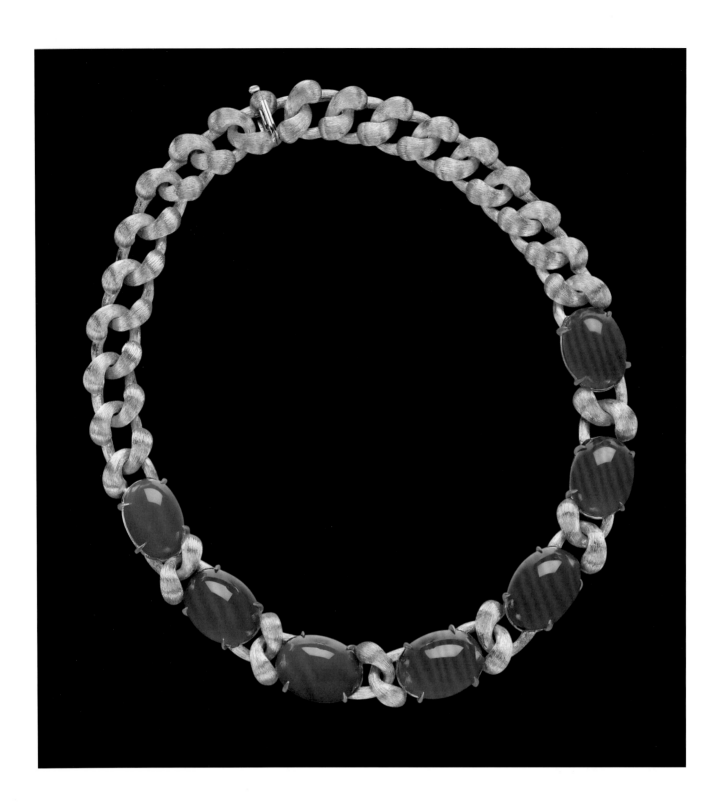

ABOVE Blue chalcedony alternates
with gold links in a Sabi choker.

OPPOSITE Orange moonstones
add vibrant color to diamond,
South Sea pearl, and gold jewelry.

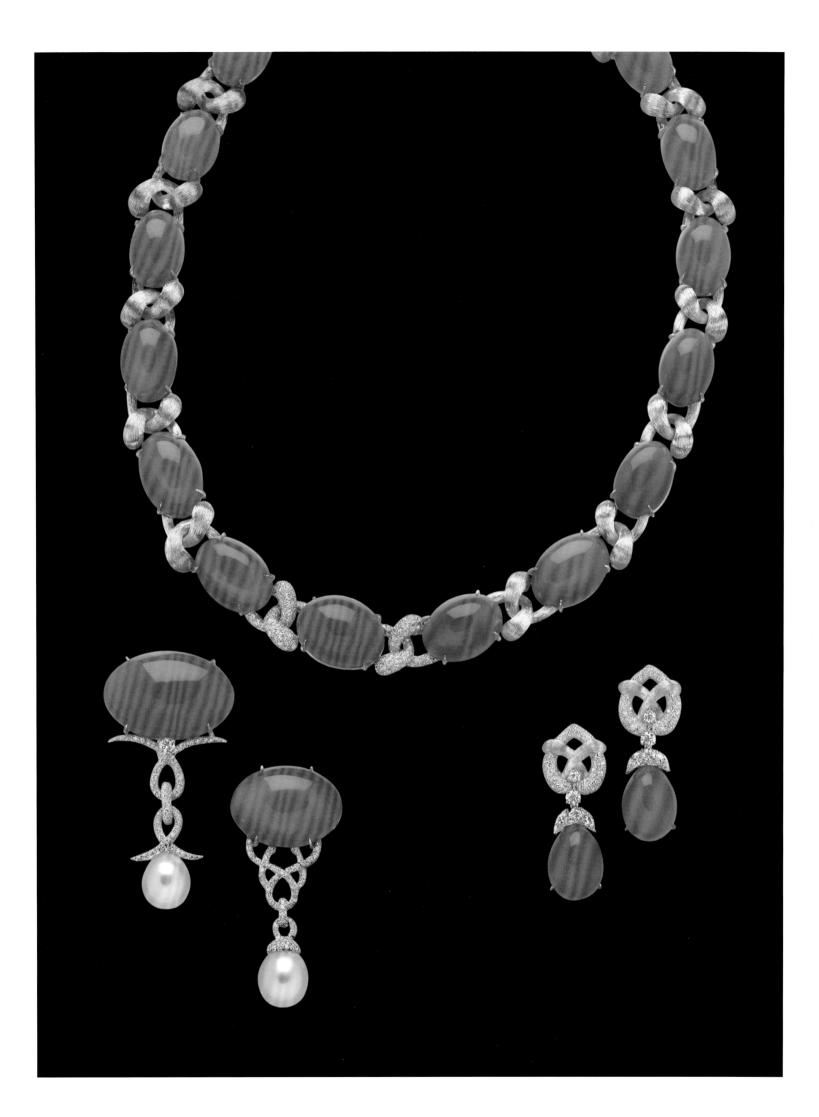

We must do all we can to create and sustain an environment where we can harmoniously coexist with our sphere." The designer hoped to motivate the next generation. Henry was a cofounding member of the American Jewelry Design Council, a non-profit organization established in 1989 and dedicated to promoting the art of jewelry through exhibitions, lectures, and other activities. "I believe in young designers and the next generation; I wanted them to look at Cynnabar and say, I can do my own fantasies and uniquely different designs," says Henry. "So much of what I was seeing from young people was simplistic or a retread of old things."

The Cynnabar collection appeared on the world stage at the 1992 presidential inauguration. Hillary Rodham Clinton wore a Cynnabar ring set with the 4.23-carat, flawless Kahn canary diamond. A polished piece of rough with strong color and a bright surface, the Kahn had been discovered in 1977 by a logger named George Stepp of Carthage, Arkansas, at the Crater of Diamonds located in a state park in Murfreesboro, the world's only publicly owned diamond site. A major tourist attraction, several nice gems had been found at the Crater— a 36½ acre gem-bearing volcanic pipe called a *cration*—but few as fine as the Stepp stone. The logger sold the rare American diamond to local Little Rock jeweler Stanley Kahn, who gave the gem its name.

For the inaugural design, Joan Parker, director of the Diamond Information Center, put Stanley in touch with Henry. "He was a three-time winner of the Diamonds International Award, which was a rare achievement for anyone and particularly an American" says Joan. "Whenever something important came up and someone was looking for a couture designer, I always thought of Henry. I knew he would do a beautiful job for the inaugural ring."

Henry met with the future first lady once to discuss the stone and the design of the ring. "Mrs. Clinton felt the stone was good luck for her," says Henry. "She had worn it to several events on a simple chain pendant as the First Lady of Arkansas, but for the inaugural she wanted something special. I told her about Cynnabar. And she talked about the plains, lakes, and rivers of the state." Henry

whipped up the setting for the Kahn canary in a record-breaking four days for the inauguration. The ring was a metaphor for the Natural State. Platinum represented the clouds. Green gold conjured up the trees. And pavé-set diamonds alluded to the Arkansas lakes and streams.

"Cynnabar opened an artistic door for me," says Henry. The designer went on to do what was essentially a companion volume to the Cynnabar landscapes: a collection of one-of-a-kind cityscape brooches. Gems in the rough ignited Henry's imagination—the pieces which lapidaries and gem dealers in Idar-Oberstein kept for themselves and displayed around their offices. "I convinced a few people to sell me these specimens," says Henry. "I thought they were so distinctive." The city brooches were Henry's way to use these gems in jewelry.

The top cities of the world—New York, London, Paris, and Rome—were not on Henry's itinerary. "The places I depicted in the brooches—Tibet, Zurich, and Budapest—had a sense of romance and mystery for me," muses Henry. "I remember them from films in my childhood like *Divorce Italian Style*, *The Third Man*, and the Charlie Chan movies." The adventures of Flash Gordon, the villain Ming the Merciless, and especially Prince Vultan's Sky City, as well as one beautiful shiny tourmaline specimen came together in Henry's first brooch, City in the Sky.

"I thought it was beautiful, the shape and color," says Henry. "Just the way it was, the way Mother Nature made it. The cutters took off the matrix and gave it a polish and that's how I used it." He studied the shiny piece of rough with skyscraperesque formations and thought of Vultan's mythical metropolis. Somewhere over the horizon he envisioned Flash Gordon flying his spaceship. Henry clustered golden buildings around the tourmaline and topped it with a tower reminiscent of the Empire State building. A baguette diamond shone in a window to represent the sun hitting a pane of glass.

The golden city brooch with the 64.68-carat emerald-green tourmaline got a second name as soon as it was complete. Many people called it Emerald City, after the destination of Dorothy and her pals in the

ABOVE AND OPPOSITE Three Cynnabar cuffs capture nature's topography in textured gold and platinum.

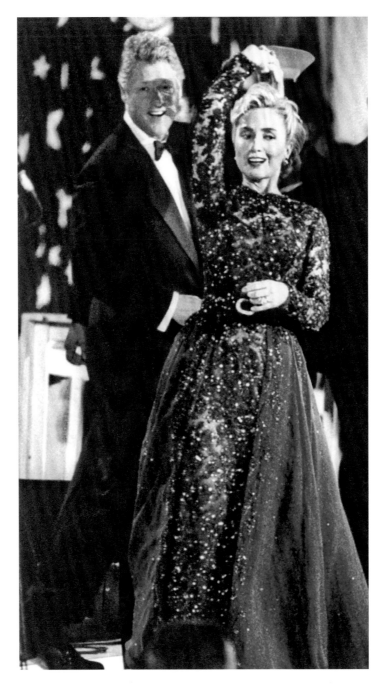

The Wizard of Oz. The name matched the look of the brooch—and more. Intense green tourmalines are sometimes called Brazilian Emeralds.

"For the Budapest brooch, I started with a picture of the city from a page I tore out of a magazine," explains Henry. "I liked the name Buda-*pest*." Henry chose an aquamarine crystal weighing 101.87 carats with a slight imperfection to represent the flow of the Danube River. Again, the background of the gem echoed in Henry's designs. The name *aquamarine* comes from the Latin words for water, *aqua*, and sea, *mare*. Historical buildings and a church with cut-out windows form an elegant skyline on the far side of the riverbank. A scenic bridge with arches and towers stretches in front of the Danube. Diamond snow made of 248 diamonds weighing 3.42 carats curled gently around the edges of the horizontal brooch. (See image on page 14.)

In order to give the one-of-a-kind city brooches dimension, Henry worked like a sculptor in the manufacturing process. He carved the scene in green wax, cast it in gold, then cut it into pieces. This last step, a labor-intensive addition to the standard casting process, which usually goes straight from wax model to gold jewel, enabled the designer to scrutinize the topography of his cities and the placement of the buildings and to position the gem specimens. "You look at a piece in wax and get a sense of dimension that is not exact," explains Henry. "It is different in metal. That is why I take the extra step—cut it apart and refine it and put it back together."

Henry transformed the picture book realm of Peter the Great—St. Petersburg, Russia—into a brooch that was all atmosphere and architecture. A gold and diamond onion-domed church soars at the top of the scene and a gold and diamond segment of the city's famous canal system is at the bottom. Everything is awash in the soft light of the 55.75 carat solid hexagonal golden beryl at the center. Henry used unusual mackel diamond baguettes—almost completely flat stones—to create staccato flashes of light in a few windows. The glow in the brooch symbolized the time in spring and summer, the long otherworldly white nights when the sun almost never sets on Russia's northern capital.

The ancient adobe villages between Sante Fe and Taos, New Mexico, were represented in a brooch with intricate golden detail right down to the little ladders

OPPOSITE, TOP President Bill Clinton dances with First Lady Hillary Rodham Clinton at the 1992 Inaugural Ball. The Cynnabar ring is on her right hand.

OPPOSITE, BOTTOM The Cynnabar ring worn by Hillary Rodham Clinton centers on the 4.23-carat Kahn canary diamond.

the Pueblo Indians climbed to get into their homes. Henry chose a rugged blue azurite, a gem native to the region, to represent a mesa like the ones dotting the flat New Mexican landscape. Gold and 267 diamonds, weighing 4.54 carats, wrap up the scene gently like the carefully folded fawn skin enveloping a papoose.

BROOCHES HAVE ALWAYS BEEN VEHICLES for jeweley designers to express themselves. Throughout history the canvas of a brooch has allowed them to create vignettes, a difficult task with earrings, bracelets, and necklaces. French royals had huge diamond flower brooches at the end of the nineteenth century. Little diamond brooches with charming themes flourished in the 1920s. During the sixties brooches were big again and bright with enamel. Henry's brooches, made in the 1990s, were unlike anything previously done. The strong sculptural quality of the pieces, the intriguing gem specimens, the combination of gold and platinum, and the fine detailing made them utterly unique.

The city scenes were so fresh and exciting, such beautiful and surprising objects, they enchanted Henry's clientele. "The Emerald City brooch was bought by a young Japanese businessman," says Henry. "I put it in an individual frame with an engraved gold background of the sun and clouds shining down on the city. My client hung it in his office in Tokyo. He said it reminded him of the beauty, romance, and power of flying into New York City."

A couple of Henry's clients asked him to take the city brooch concept a step further and make brooches of their favorite countries. For one, Henry took the essence of Scotland and transformed it into a brooch. "I went to Scotland, where I saw an armory on top of a mountain, an historical monument to fallen soldiers," says Henry. "That fascinated me." For the brooch, he transformed the armory into a romantic castle on top of a gold mountain that represented the Highlands. A 27.22-carat black opal at the center symbolized all the water surrounding the Scottish islands. At the bottom of the slopes, Henry engineered an old aqueduct in platinum and diamonds and placed it in front of a shiny piece of platinum and diamonds to create reflections like rushing water. Roads and a little village on the side of the opal completed the Scottish vista.

OPPOSITE, CLOCKWISE FROM UPPER LEFT An azurite mountain rises behind the gold and diamond houses in the Adobe brooch. The City in the Sky brooch is an urban landscape with one tourmaline, diamonds, and gold.

In the Scotland brooch, a black opal represents the water surrounding the gold and diamond island. A yellow beryl casts sunlight across the yellow gold and diamond building in the St. Petersburg brooch.

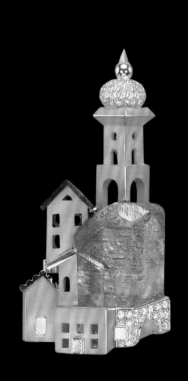

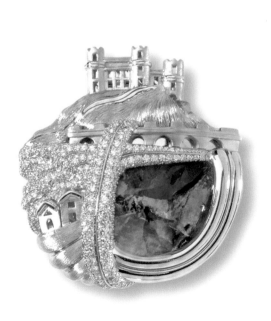

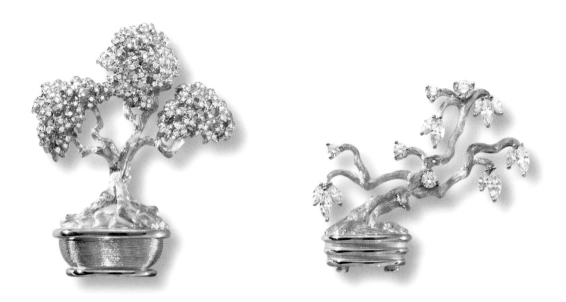

Other limited-edition brooch collections followed the success of the city brooches. An idea for tree brooches popped into Henry's head when he saw the Lone Cypress in Monterey, California. "The weather-beaten tree grows out of the rocks," explains Henry. "I re-created it in gold with large Baroque pearls representing the rocks." (See images on pages 148 and 149.)

Bonsai trees came next. In Japan, the bonsai symbolized the harmony between nature and man as artist and cultivator of the miniature tree. Henry liked what the trees represented and how they looked, with twisting roots and stylized branches full of character. Traditionally, the Japanese bonsai are the native species of pines, azaleas, and maples. Henry did his own forest with several different species. All of the ten or so trees in the series came in gold pots as is the way with the bonsai. One had an opal on the bottom to represent fall.

Henry's Women of the World brooches were a tribute to glamorous global style throughout the ages. The seven figures in the delegation represented France, England, China, Japan, Persia, Egypt, and the Aztecs. Through a few key elements Henry perfectly expressed the character of each country. He framed the pearl faces with the perfect hairdo or hat. Sabi and diamonds formed the

ABOVE Diamond and gold
bonsai tree brooches burst
into a bloom of gems.

silhouettes and garments. Colorful gems highlighted details of some of the costumes. A carved, cone-shaped citrine formed the Chinese lady's straw hat. A tall piece of Persian turquoise with diamond veils formed the traditional taj cap for the lady from the Middle East. (See images on pages 160 through 163.)

The city, tree, and Women of the World brooches were serious items. A menagerie of animals provided Dunay's clients with amusing additions to their collections. Few jewelry designers have attempted to make jokes in jewelry, because clients expect glamour and elegance in their precious pieces. In the last hundred years the majority of designers who mixed smiles with high styles were American. During Prohibition, when people were forced to have cocktail hour illegally in speakeasies, New York jeweler Raymond C. Yard made bunny waiter brooches carrying trays of drinks. These little protest statements were impeccably designed and manufactured with diamonds, rubies, emeralds, and sapphires. The master of this funny side of the jewelry genre, Hollywood favorite Paul Flato did everything from gold and enamel boxer short pins to gold feet brooches with ruby toenails.

Henry enlivened his gold animal brooches with subtle wit. He placed an egret on the backside of a rhinoceros brooch creating a sly juxtaposition of a lumbering beast and a little bird. Henry played off the idea of an old sailor with a sea dog gold brooch of a slouchy hound in a captain's hat and platinum eye patch at the helm of his ship. Elephants, frogs, parrots, and fish were a few of the other delightful creatures in the Dunay zoo.

In 1997, after a long romance, Henry married public relations executive Linda Goldstein. At the wedding he gave her twelve different bands in various combinations of gold, platinum, and diamonds, all engraved with hearts, to mix, match, and stack in whatever way she desired. "I loved the diversity," Linda told *Town & Country*. "At this stage in my life, I didn't really want the typical solitaire engagement ring."

The union was one of shared personal, professional, and civic interests. Linda and Henry enjoyed snorkeling on beach vacations. One time after a dive in Anguilla

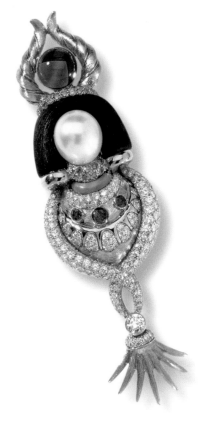

RIGHT The Egyptian Woman of the World Brooch has a South Sea pearl face, onyx hair, and a citrine cabochon at the center of her diamond and gold headdress. Turquoise and black opal accent her lavish diamond and gold gown. A stylized palm leaf, a popular Egyptian motif, forms the bottom of the dress.

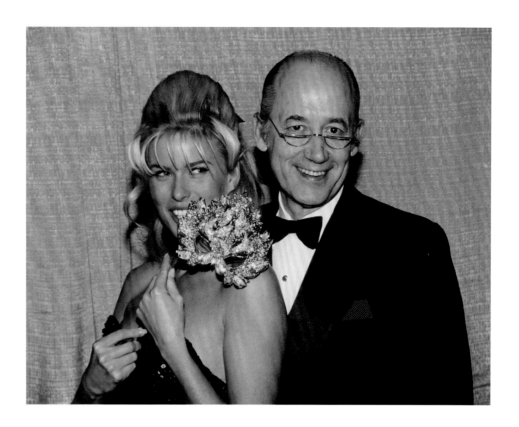

in 1988 Henry spontaneously came up with his signature look. "My hair is very thin and I used to comb it over," says Henry. "When I got out of the water I tied up the back in a small ponytail and said 'not bad.'" He has worn the hairstyle and black from head to toe ever since.

Over the years, Linda put Henry together with various charities for which he created a number of unique jewels. In 1993, for example, he made the exquisite Lachrymosa mask for amfAR (the American Foundation for AIDS Research). "I felt AIDS was such a tragedy," says Henry. "It is like a different version of the black plague and it was hitting New York hard. I used to walk along the East River very early in the morning. Once I saw a man carrying another man who was clearly in the final stages of the disease. He was taking him to a park bench, so they could watch the sunrise together. It was a tragic yet beautiful moment."

Lachrymosa captures the essence of what Henry saw. It sparkled with 936 diamonds totaling 135 carats; a golden tear flowed out of the left eye. The title for the mask comes from the Portuguese word for tears. It is also the name of the last movement of Mozart's final composition, a hauntingly beautiful requiem mass he

ABOVE Henry joins Vendula, who holds the Lachrymosa mask at the 1993 amfAR event at the Pierre hotel.

OPPOSITE Henry made the Lachrymosa mask to promote a 1993 amfAR fundraising event.

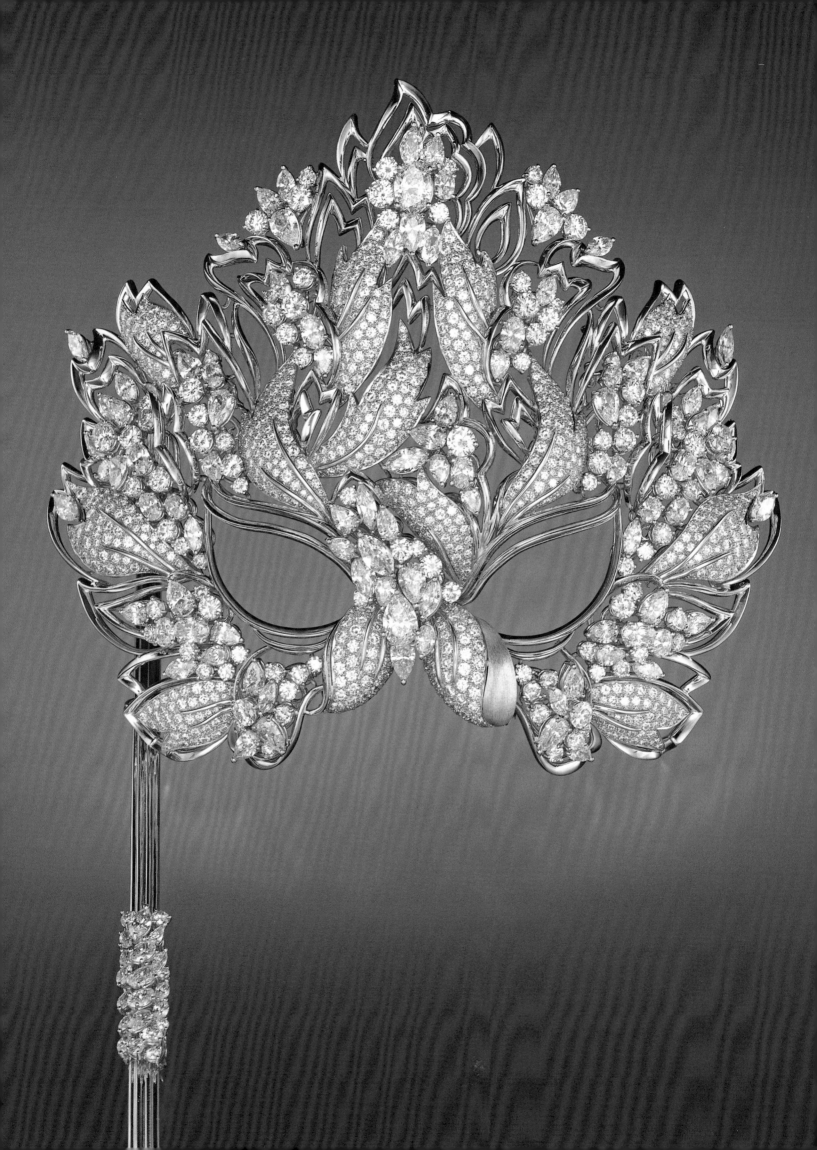

never finished before he died in 1791. The mask became the symbol of the amfAR event in New York at the Pierre Hotel hosted by Elizabeth Taylor.

Another charity jewel Henry poured his heart into was the World Foundation for Peace pin. The Foundation asked Henry to design a jewel symbolizing world peace for celebrities to wear at the 75th Annual Academy Awards in 2003, which took place shortly after the war broke out in Iraq. The jewel was intended to be a symbol of hope for a brighter future. "I was thinking about the dove Picasso had designed for the United Nations," says Henry. "I made the silver dove pin with flapping wings and long legs so it would show up on a dress or lapel." The elegant bird flew down the red carpet on many celebrities including, Daniel Day-Lewis, Susan Sarandon, director Pedro Almodóvar, and Oscar winners Adrien Brody and Chris Cooper.

AT THE DAWN OF THE MILLENNIUM, rings held the same importance as earrings had when Henry launched Faceted in the seventies. Women wanted statement rings in a couple of different styles for their jewelry boxes. The designer satisfied their desire with two new collections.

Henry has always been inspired by his surroundings, travel, art, culture, and nature. This time the genesis for the collection came organically from work he himself had done: Sabi, haute couture rings, and the city brooches. Pleased with the results, Henry eventually augmented the collections with earrings, bracelets, and necklaces.

For one collection, Henry distilled his passion for colored stones and cabochons to its very essence. "Everyone loves the Sabi finish," says Henry. "I thought I'll make an everyday Sabi ring—but big." The rings were shots of pure color featuring one large cabochon. Pink tourmaline, yellow beryl, peridot, chalcedony, topaz, and carnelian were among the candy colored gems in the collection. The rings were a ready-to-wear version of his couture high-cabochon designs. Henry playfully titled the collection like a children's book: Color Me Henry.

As the collection developed, Henry threw moonstones into the mix. The dreamy gems, unlike any others in nature, became the key stone of Color Me Henry. Gemologically speaking, they have a characteristic called adularescence,

OPPOSITE Nicole Kidman and Adrien Brody, who wears the World Foundation for Peace pin in his lapel, pose with their Oscars at the 2003 Academy Awards.

ABOVE The World Foundation for Peace pins designed by Henry were made in both silver and gold.

an inner glow that shimmers and changes shape when the gem is moved. Certain moonstones show a cat's eye—a white rutile down the center. "Some clients don't believe the color and cat's eye in the gems are natural," says Henry, "because they often appear supernatural."

The majority of moonstones found in vintage jewelry are blue gems from Sri Lanka. Henry made use of all the new colors of moonstones—kiwi green, chocolate brown, peach, metric blue, smoke, olive, and vanilla white—discovered in southern India. The gems were mounted in rings and earrings and a few dramatic necklaces.

Henry sifted through 600 carats of white moonstones to find perfectly matched gems for one necklace. He had each cut to the right size so the blinking cat's eyes in the stones would be aligned when they were set together. It took two years to finish the necklace of twenty round moonstones and an oval-shaped pendant drop, totaling 388 carats.

Henry extended his moonstone phase an extra cycle to brooches. I Just Can't Get Over the Moon was the name with double meaning he gave to the series of cosmic brooches with a turtle clutching a moonstone cabochon for dear life. The struggle of the adorable creature attempting to hoist himself up and over the moonstone is completely disarming.

The first ring in the glamorous second collection had an orange imperial topaz Henry removed from an antique brooch. "I recut the stone to an emerald cut to bring it to life," says Henry. "I wanted to lift it up in the air and that is how I con-ceived the setting." He built the sculptural ring with diamonds twisting around and then down the curvaceous shank, like the snowdrifts along the side of the Danube in the Budapest brooch. Plushly pavéd prongs curled over the topaz on the corners. "My diamond pavé is exceptional; it always has been," explains Henry. "I use various-sized diamonds to snuggle into every curve of a piece. The diamonds are packed tightly. It is very different from the straight-line pavé most people do."

The rectangular-shaped topaz and diamond ring gave Henry the impetus to do a collection defined by geometric stones as opposed to the rounded shapes he usually used. Their long lines added a sleekness to the rings. Colored stones—peridot, tanzanite, orange, pink- and rust-colored imperial topaz—added fireworks.

OPPOSITE Various semiprecious gems decorate Color Me Henry gold rings.

ABOVE There are 600 carats of vanilla moonstones in the diamond and platinum necklace.

OPPOSITE Gold and moonstone turtles strike a variety of poses in the I Just Can't Get Over the Moon brooches.

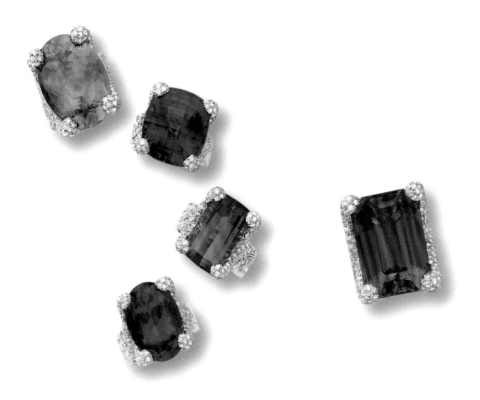

Henry called the rings Harmony because, he says, "I felt there was a beautiful harmonious balance to the design."

Extra long geometric gems—specimens similar in style to the stones Henry employed in city brooches—made up the one-of-a-kind companion pieces to the Harmony rings. An elongated 194.17-carat yellow beryl pendant was embraced in a super-duper pavé of 395 diamonds weighing 9.93 carats that swept around the corners in ribbons and over the top and bottom. Pear-and marquise-shaped diamonds glittered in the pavé.

Two matched rectangular-shaped aquamarines totaling 43.29 carats became one of the most dazzling designs in the series. Henry took the twosome and set them vertically in a pair of earrings with a frothy mix of round-, pear,- and marquise-shaped diamonds on the top and bottom. The jewels made an impressive appearance on the ears of Denzel Washington's wife, Pauletta, at the 2002 Academy Awards. Even before congratulating her on her husband's Best Actor win, Oprah Winfrey asked Paulette, "Honey, where did you get those earrings?"

ABOVE Large semiprecious stones are at the center of the gold and diamond Harmony rings.

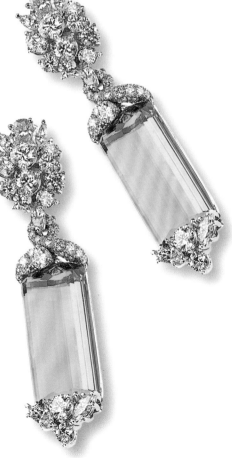

LEFT Denzel Washington
attended the 2002 Academy
Awards with his wife, Pauletta,
who wore Dunay earrings.

RIGHT The earrings worn by
Pauletta Washington had 43
carats of aquamarines and
diamonds set in platinum.

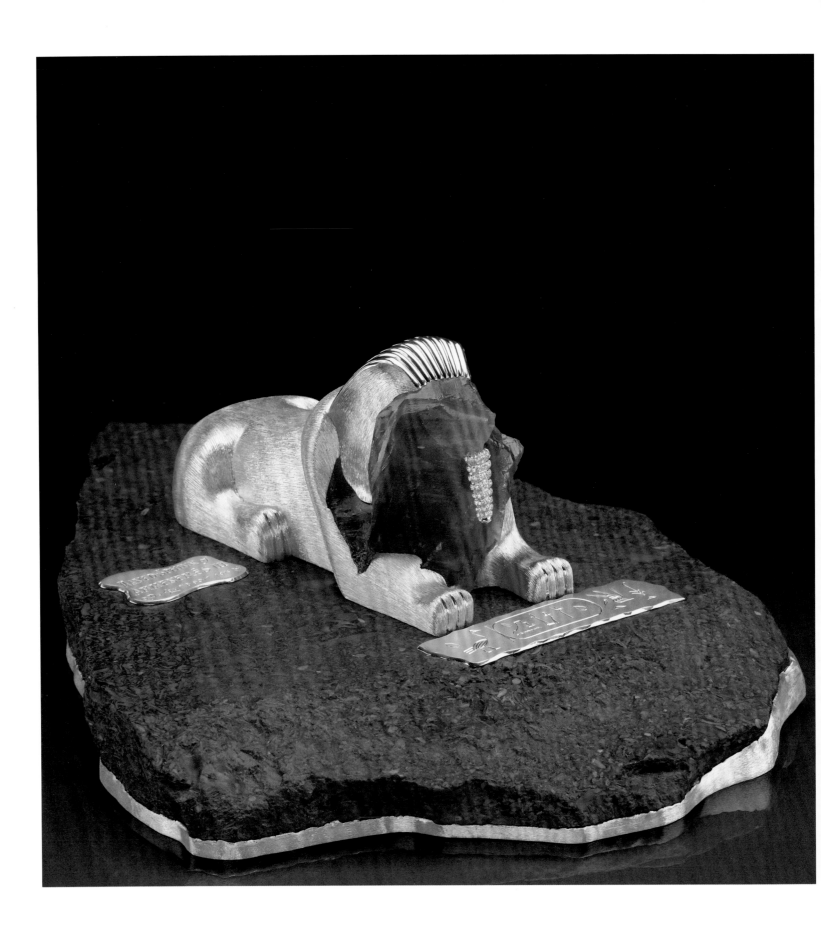

THROUGHOUT HIS CAREER Henry has continued to fulfill the dreams of his youth, the ideal of Fabergé he learned from Mr. Cacioli when he was a young apprentice working on the Bowery. Dunay singlehandedly built his business on the luxurious model of the great jewelry houses of all time: Fabergé, Cartier, and Van Cleef & Arpels. He made magnificent jewelry fit for royalty, watches, and even a fragrance. He has taken his designs all over the world—Switzerland, Japan, Hollywood, and the White House. His career has been a chronicle of hard work, imagination, ingenuity, passion, determination, and an absolute unerring instinct for being in the right place in the world at the right time. What has always separated Dunay from the rest is his ability to design the jewelry and to make it with his own two hands. No member of the Fabergé, Cartier, or Van Cleef & Arpels families ever had the skill to work on the jeweler's bench.

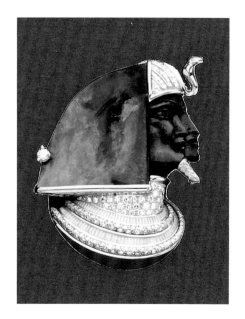

Henry had almost done it all. The missing element was an assemblage of spectacular jeweled objects, pieces in the mode of Fabergé's Easter eggs. The collection of a dozen quartz-jeweled eggs he had made in the early eighties was a prelude. Henry's new pieces prompted the press to call him "the next Fabergé."

The idea for the first object came to Henry when a client presented him with two enormous opal earrings. "They were so large, they almost seemed too big to wear," remembers Henry. "But I thought the stones were so beautiful they should be displayed." He transformed the earrings into a small object of a desert scene. It bloomed with white and colored diamond flowers. Geodes formed rocks on the ground.

"She wanted it for Christmas, which was difficult because that is the busiest time of year," remembers Henry. When he completed the piece Henry put it in a cardboard box with bubble wrap and flew down to Dallas. "I had worked on it so hard I wanted to take it myself," says Henry. "I apologized profusely that I didn't have a proper box for it." When he took it out and put it on the client's table, she cried. "I have never forgotten that."

Around 2000 the designer began making objects in earnest. "I felt strong enough financially to go for it," says Henry. He begins each object by looking at gemstones. "When I see a stone I know what I am going to do with it," says Henry. "I always think the stone talks to you." The dialogue between Henry and the material was inevitably about his two favorite subjects: art and nature.

OPPOSITE The 653-carat garnet gold Sphinx of Ammenemes rests on a granite base.

ABOVE The matrix of an amazing black opal forms the profiles of an Egyptian pharaoh and his wife. The colorful part of the stone becomes the headdress in the Reflections of an Egyptian Pharaoh gold and diamond brooch.

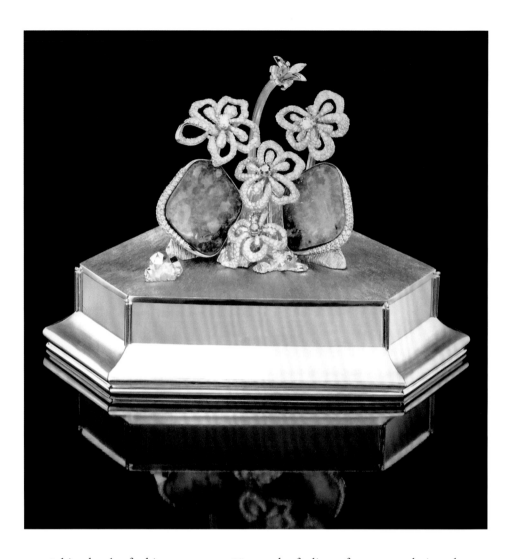

A big chunk of white agate gave Henry the feeling of a contemplative place in nature. "I loved the opening in the stone and the shimmering white-gray layers of the mineral," recalls Henry. To show off the chasm, he carved the agate into a clean rectangular block. The split in the rock was reflected in ninety-six diamonds weighing 3.25 carats and carvings on the gold base. Henry's title, Silent Crevice, caught the elegiac mood of the piece. (See image on page 218.)

A hefty piece of orange-colored phantom garnet—the name for a type of stone showing signs of growth on the interior—moved Henry to create a mysterious sphinx worn down over time to a smooth surface. "I saw the sphinx in the stone," says Henry. The 653-carat phantom garnet became the bust and torso of the half-man, half-beast. Gold filled out the rest of the creature that was modeled on the red granite sphinx of the Egyptian Pharaoh Ammenemes II complete with a false beard and royal *nemes* headdress—two symbols of power and longevity. He placed it on a

ABOVE The first major object Henry designed was an opal and diamond desert scene.

OPPOSITE In La Familia, a Native American mother and child are sculpted in a 366-carat green beryl. A second child is made of diamonds and gold.

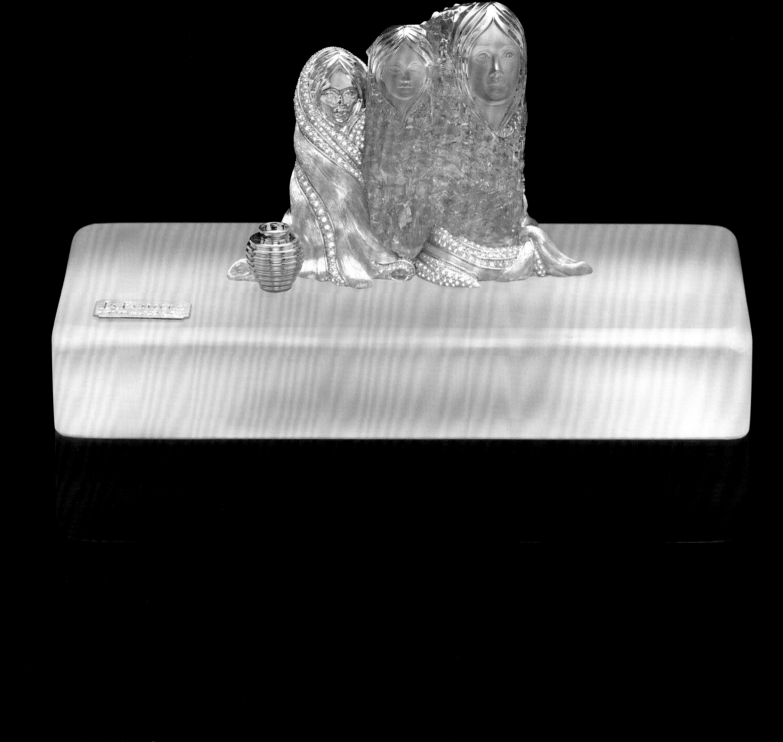

slab of red jasper edged in gold. A small gold plaque before the sphinx's paws is inscribed with the same hieroglyphics as the original at the museum in Cairo.

Henry transformed a gorgeous aquamarine rough that originally weighed around 940 carats into the thought-provoking Ides of March. "Jürgen and I were with the gem carver Michael Peuster," says Henry. "He had these thick books with paintings done by the artists Napoleon took with him on his conquest of Egypt." From these texts Shakespeare's tragedy *Julius Caesar* leaped into Henry's mind. Michael carved the protagonist Brutus and Caesar into the sky-blue colored gem. When he finished, the aquamarine weighed 827 carats. Henry made it the upright support of a broken gold column with 237 diamonds weighing a total of 6.15 carats. From top to bottom the object measured 6½ inches. Henry took the name for the object from the soothsayers' warning to Caesar before his friend Brutus and others in the Senate assassinated him on March 15, 44 B.C., "Beware the ides of March." (See image on page 145.)

From pale blue to the darker shades of sea blue, from the interestingly flawed to the near perfect, Henry appreciated all types of aquamarines. He brought out a very different side of the gem in four comedic objects with a happy family of fish-eating polar bears. "When aquamarine grows in the ground, the natural top looks like a crusty iceberg," says Henry. The designer took the mountainous top half of an aquamarine weighing 830 carats and surrounded it with 449 diamonds weigh-

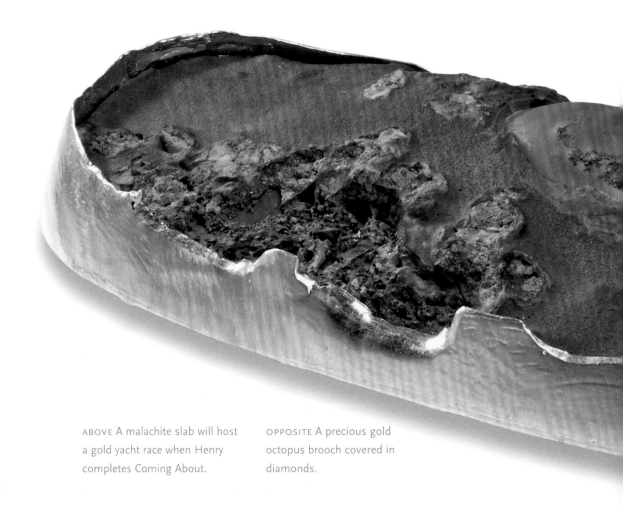

ABOVE A malachite slab will host a gold yacht race when Henry completes Coming About.

OPPOSITE A precious gold octopus brooch covered in diamonds.

ing 8.30 carats for the snow. The mother and cub polar bears playing on top and the father lumbering across the ice cap handed Henry the title, Trilogy of Bears, for the object that measures 6½ inches long, 4½ inches wide and 5 inches high. (See image on page 216.)

For the 2007 celebration of Neiman Marcus's hundreth anniversary Henry is making a miniature mountain range made out of five Burma ruby peaks. A small town will be built on a plateau. It is an apt tribute to the department store where Henry reached his first summit.

After more than fifty years in business, Henry has not slowed down in the slightest nor rested a moment on his laurels. He has begun a new phase of his personal life; he and Linda have decided to go their separate ways. In his professional career the pattern remains the same. Every weekday and Saturdays, he shows up to the office early, around six A.M. He keeps his mind agile working on the bench as he has done since he was a teenager, making masterworks for his devoted clientele.

Henry is logging more frequent flyer miles than ever before. In addition to his usual itinerary of a dozen American cities, Tokyo, Basel, and Switzerland, there are new groundbreaking trips to Monaco, the Ukraine, Moscow, and Dubai. Henry predicts the new cities will influence his jewelry in the future. "The clients in these places love rubies, emeralds, sapphires, and big diamonds, which is an area I have always wanted to explore more," says Henry.

When he travels and while he works, Henry thinks of the history of jewelry and all the objects made in the past and his own work. "God has put me on this earth to do something special. I know it is jewelry but I always ask myself, what in jewelry? Why do I have this knowledge and ability? Maybe there is that one piece, one day, I will make and say that is it; it is over. But I don't think so. It is the dream of jewelry that keeps me going."

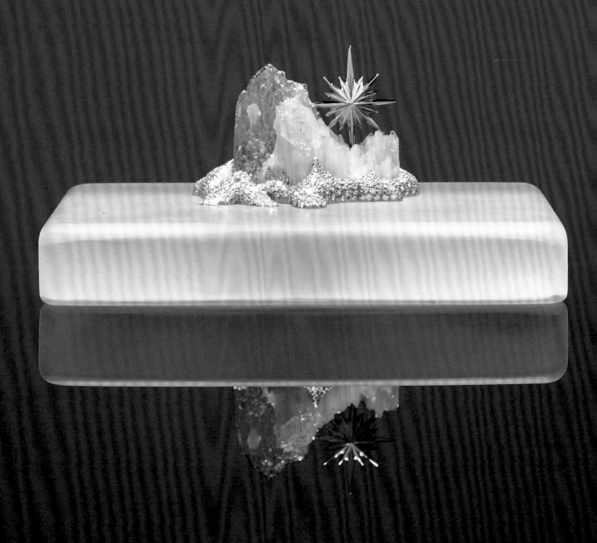

ABOVE A gold sun shines on an
aquamarine, diamond, and
platinum glacier in the South Pole.

OPPOSITE A platinum polar bear
enjoys the golden sunshine in the
aquamarine and diamond North Pole.

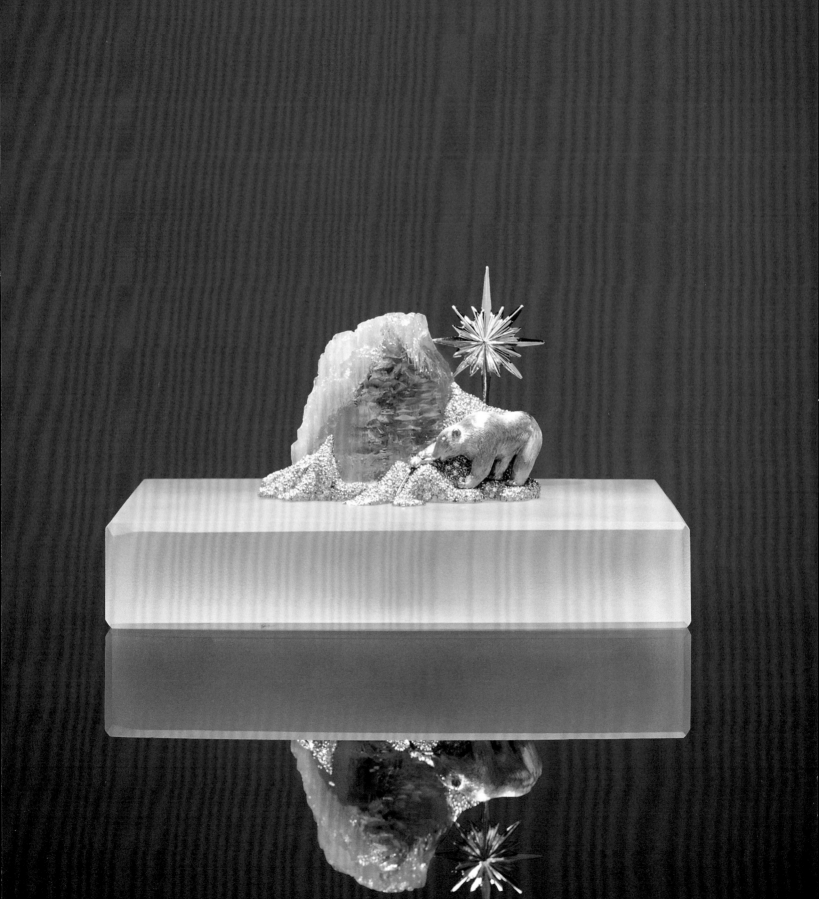

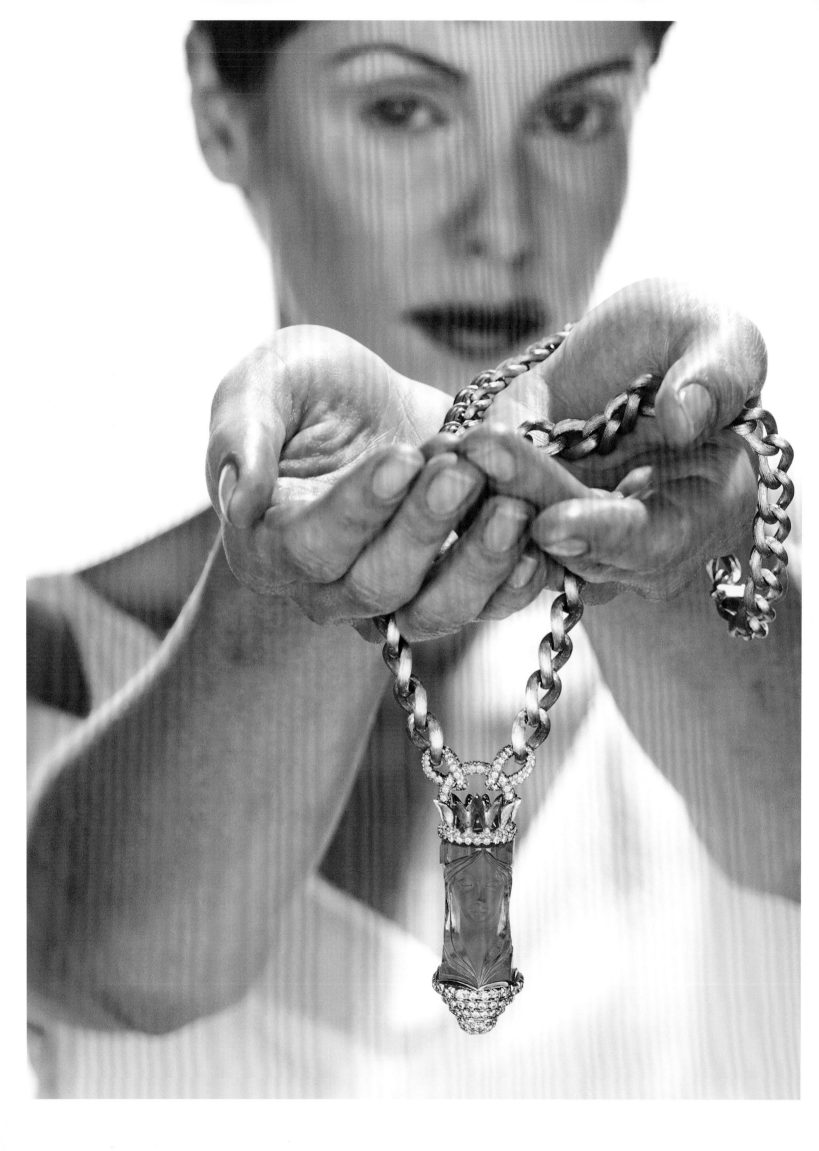

RIGHT A long blue aquamarine forms the largest building in the diamond and gold Zurich brooch.

OPPOSITE, CLOCKWISE FROM TOP LEFT A yellow beryl towers in the diamond, platinum, and gold Chateau brooch. A pink tourmaline rises above the gold and diamond in the Forgotten City brooch. A Boulder opal shimmers at the center of a diamond and platinum waterfall brooch. A ripe green peridot is the main peak in the gold, platinum, and diamond Blue Ridge Mountain Cynnabar brooch.

As the prior chapter has recounted, Henry Dunay is a talented craftsman and gifted designer. To be so requires the gift of the "mind's eye," to imagine, literally, the potential for a fabrication from an object in hand and one's sensibilities. Such talent is God given, enhanced by experience but not really possible where the essence does not already exist. This is Henry's good fortune. Henry is also bold, which, to be sure, is particularly required in New York City, both a social crucible and jewelry capital of America. Whether the city pushed Henry or vice versa, no matter, his works are daring in form, color, and size. However, when Henry was starting out he had a problem—diamonds are the traditional top gems for pulling out the stops in jewelry in New York. Henry realized that large diamonds with their moon prices tie up a lot of capital, which he just could not afford at the time. Other stones would be needed to provide the signature in his gemstone jewelry if he was going to make more than a piece here and there. Fortunately, Henry loves vivid, vivacious color—"no wimpy stones for me" he told me—so colored stones were to become his signature. This requires a little clarification; traditionally diamond, ruby, sapphire, and emerald are referred to as the precious stones, and all other gems generalized as colored stones. This is far better than the somewhat derogatory term *semiprecious stones*, which says little other than that precious stones are generally more popular and, thus, more pricey. If a colored stone may not be so pricey as fine luscious ones, then there is room for producing more impressive pieces, particularly when Henry was starting his own line of jewelry. Henry also has a keen eye for combinations of fineness and form, and as his education about the gem kingdom advanced, so did his selectivity. A designer thinks in images, so he can quickly see opportunities in both fashioned gems and natural crystals. In his freest moments, a picture will appear in his mind's eye upon seeing a particular crystal or pearl, and he will fabricate a jewel or scene from that image. Moreover, he has come to know both his special clients and what he wants to express, and collectors have come to know him, so fanciful creations find a ready home. Enough of the generalities. Henry had to get an education about gems and the market: his school was Idar-Oberstein and his mentor/partner is Hans-Jürgen Henn.

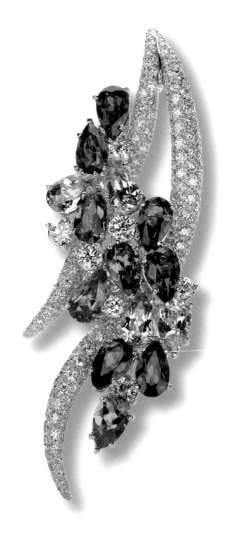

RIGHT A rainbow of gems cascades over a diamond brooch.

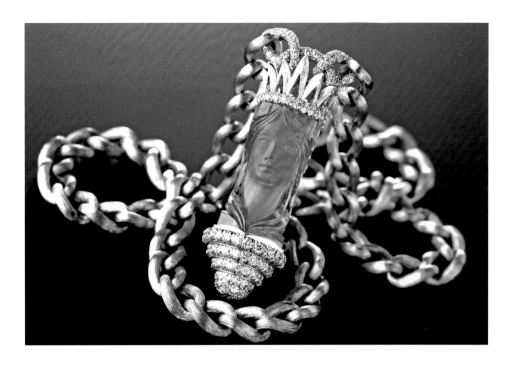

When I was first approached to contribute this chapter, I knew of Henry Dunay as a preeminent designer of jewelry, but not, as I am now aware, as such an important figure in the presentation of the gem kingdom in wearable and decorative art. Among the first things I learned about Henry was that he grew up in Jersey City, New Jersey, had come to New York to perfect his talents, and had learned to love large, beautiful colorful gems. Immediately the name George Frederick Kunz came to mind, and the game was begun. George F. Kunz is perhaps the greatest gem expert and promoter the United States has produced. A naturalist turned gem expert who worked for Tiffany & Co. from the age of nineteen until he died in 1932, fifty-five years later, he pioneered in the advancement and promulgation of colored gems, first American ones but ultimately all the world's treasure of the time. He wrote prolifically, traveled the world chasing his gem quarries, and created prize-winning gem collections for numerous museums, including the two foundational Tiffany-Morgan Collections at the American Museum of Natural History. He, too, started as a boy from Jersey City, so I had a sense this was going to be interesting.

PREVIOUS A model presents the Goddess of Northern Lights necklace.

ABOVE The ice blue sheen of a 108-carat aquamarine cameo beams at the center of the Goddess of Northern Lights diamond and platinum necklace.

Coloring Henry: An Education on Colored Stones

By George E. Harlow, Curator of Minerals and Gems, American Museum of Natural History

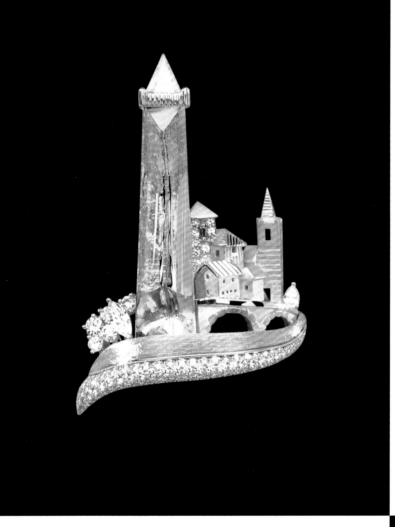
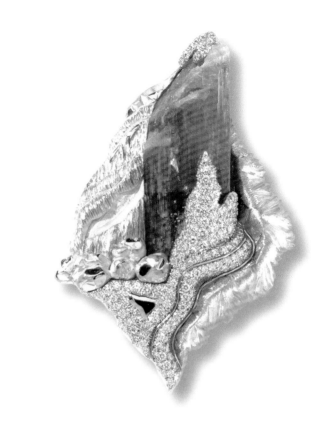
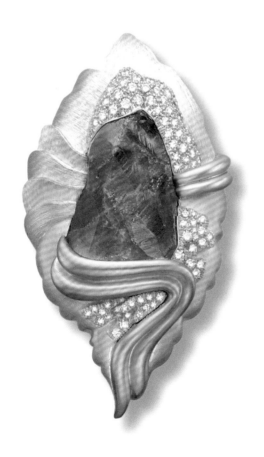
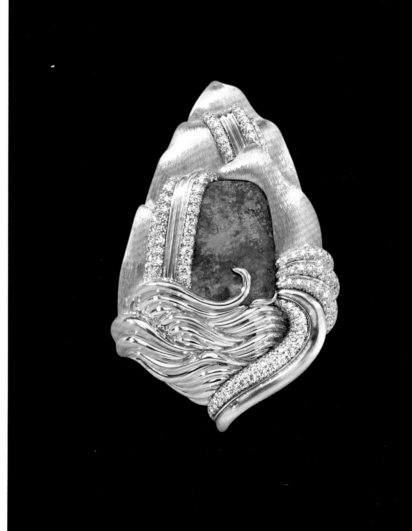

SOME GEM-RELATED DEFINITIONS

A *gem* is a mineral (or rock) that has been cut and/or polished to enhance its natural beauty. The quality of a gem is related to its color, brilliance, hardness, durability, clarity, size, and rarity; however, there is a changing balance among all of these variables for each kind of gem.

A *mineral* is a naturally occurring substance (usually inorganic) that is crystalline (has a regular internal order of its constituent atoms) and has a composition that can be defined by a chemical formula. Diamond is a mineral.

A *crystal* is a solid body having a regularly repeating arrangement of its atomic constituents. Natural planar faces on a crystal are the expression of the internal order. All minerals form as crystals but not all examples have faces or are large enough to be seen with the unaided eye. Most transparent gems are fashioned from crystals.

A *rock* is a consolidated assemblage of grains (particles) of one or more minerals. Lapis lazuli and jade are rocks.

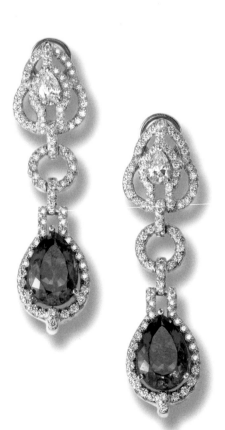

Idar-Oberstein owes its unique position as a gem capital, with peerless expertise in gemstone carving and faceting, to its surrounding geology. Situated some seventy-five kilometers southwest of Mainz in the valley of the Nahe River of westernmost Germany, Idar is overlooked by Steinkaulenberg just to the south. The mountain is formed of andesitic rocks related to regional Miocene volcanic activity about 100 million years ago. Driven by the volcanic heat, super-heated water circulated through fracture systems in the rocks, depositing reddish agate and jasper, as well as amethyst, which over time became exposed near the peak of Steinkaulenberg. Inhabitants of the valley found these colorful stones by the late Middle Ages and started fashioning gems and carvings from them in the winters when farming activities were at a standstill. Eventually, water mills turning large sandstone wheels were built to partially mechanize the fashioning of stones. Today, a mill is preserved on the edge of town as a historical monument and tourist stop. Idar and Oberstein, originally separate towns about a kilometer apart, became famous throughout Europe for agates, cameos, and carvings made from the local stone. This all became threatened in the eighteenth century when vast new deposits of agate were discovered in the New World, particularly in Brazil. Rather than lose their markets to cheaper and more varied American agate, leaders of the local lapidary businesses decided either to emigrate to South America or to import these new materials and focus on their craft of carving and polishing. Actually both happened. Eventually Idar and Oberstein were amalgamated into the single Idar-Oberstein, the "Edelsteinestadt," a city of gemstone carvers and faceters, importers and merchants who add the value of their workmanship and expertise in a broader gem industry.

Hans-Jürgen Henn's roots in the gem industry date to the start of the twentieth century when his grandfather Ernst Henn started a gemstone carving and cutting business in Vollmersbach just outside of Idar-Oberstein. Ernst's grandsons started the company Gebruder Henn in 1964, and in 1968 Hans-Jürgen commenced his trademark international travels with a gemstone-buying trip to Sri Lanka—a major gem producing country. So both Henry Dunay and Hans-Jürgen Henn were getting into their strides when they met in Henry's workshop in the early 1970s. Henry was having trouble finding the kinds of stones he was looking for

LEFT Ching Dynasty motifs embellish a pair of tanzanite and diamond earrings.

WHAT PROPERTIES DO GEMS NEED?

As gems are beautiful, some important characteristics relate to visual appeal, and, to the extent they are worn in jewelry, they must be durable. No gem is perfect in all respects, and sometimes sheer beauty trumps other weaknesses.

THE VISUAL PART

Color Quality is generally related to the depth or intensity (called saturation), which should be sufficient to be lively or vivid but not dark or muddy. Likewise, uniformity is important unless a material has interesting banding or figure, as in layering or a picture-like quality. Fluorescence, the characteristic of glowing under black light, or the daylight brightness of "day-glo" colors, is breathtaking in some rubies and diamonds. If color is absent—colorlessness, as revered in diamonds —it should really be absent.

Clarity For transparent stones, this means approaching water-clear—free from inclusions, fractures, or flaws. For translucent stones the requirements are less strict. Opaque gems should not show flaws on the polished surface.

Brilliance This quality relates to the luster—the capacity to reflect incident light and bend light as it enters the gem. Generally high brilliance is a positive quality and is related to the velocity of light in the gem as compared to that in a vacuum, the ratio being the Index of Refraction or RI. High RI (greater than 1.7) yields great brilliance and internal brightness in a faceted gem. As the density of the arrangement of atoms in a crystal can change with direction, so the RI can vary in the same way. Multiple RI in a crystal is called birefringence, which can produce interesting optical effects and is used in gem and mineral identification.

Dispersion The optical property of a transparent substance, such as a glass prism, that separates white light into the visible spectrum of colors. Dispersion is the variation in refractive index with the wavelength or color of light. Dispersion gives diamonds their fire, and is thus important for colorless stones.

THE SURVIVABILITY PART

Hardness A gem must be sufficiently hard to resist scratching. Quartz, which is common in dust and similar in hardness to common ceramics and other objects "bumped" into in the everyday environment, is the metric for gem hardness. Mineral hardness is conveniently measured with the Moh's scale, on which talc is 1, quartz is 7, and diamond, the hardest known substance, is 10. A gem with a hardness of 7 or higher is considered a hard stone.

Toughness Resistance to breakage or cracking is called toughness or durability, and is important for exposed stones worn in rings and bracelets. Diamond is very hard but not as tough as sapphire or jade.

Cleavage The chink in diamond's armor is a plane of weakness in its crystal structure that can lead to planar fractures. This characteristic is called cleavage and is an undesirable quality in a gemstone. Parting is a lesser version of cleavage, not usually as prominent, and typically related to planar defects or alterations in a crystal.

MARKETING AND STATUS ISSUES

Carats A carat is $\frac{1}{5}$ of a gram and the unit for measuring the mass (weight) of a gem. Because smaller fine pieces of a gemstone are less abundant than large ones, gem values generally increase geometrically with size (larger stones costing more per carat than smaller) up to the point where a gem is too big to be desirable or wearable.

Rareness Status and value have been conferred by rareness since the Neolithic period, so gem materials tend to be valued and revered for their rareness. However, a material that is so rare as to be unavailable, even to an exclusive market, is not likely to become a coveted gem as few will know or recognize it.

from the New York stone dealers—there was always some problem about this or that not being available or not being possible. Jürgen was, on the other hand, a man of possibilities, coming from Idar, traveling in search of Earth's gemstone bounty, and someone dealing in yeses rather than nos. Jürgen's pioneering efforts at seeking out gem rough at the source and bringing it back to Idar was matched by Henry's singular eye and flair for turning the best of these finds into signature jewelry. But more important, at the start, some thirty-five years ago, the two men developed an instant liking for each other. Without this spark they may have gone their separate ways, but the meeting grew into a business relationship that matured into a kind of marriage: a life-long partnership built on admiration, friendship, respect, and trust.

HENRY'S PARTY At the Basel fair each spring, Henry sponsors a dinner at the posh Hotel Euler for his colleagues in the gem and jewelry business. The timing just about coincides with Henry's birthday, so on the occasion of Henry's fiftieth birthday, just prior to dinner, Henry's son, knowing of no one more appropriate to make a toast to his father, asked his longtime friend and colleague Hans-Jürgen Henn. As one who would normally prepare for such a presentation, Jürgen was caught unprepared, but he had little problem speaking with some emotion from his heart: "I want to honor and celebrate the successful relationship Henry and I have had together by acknowledging the single most important factor in it— trust, complete and utter trust in one another." He recalled their intertwined histories: Finding new and exotic gems and Henry's delight with them and creation of fabulous jewels. But at the core of it all was their trust in the other's judgment and value in their work together. At the end of Jürgen's short speech, you could hear a pin drop in the dining room.

The pair's relationship has an annual ritual: Henry starts each year with a trip to Europe, and his first stop is with Jürgen in Idar. The wild, hectic holiday-shopping scene that constitutes the mainstay of the jewelry business finally ends in January, so Henry pulls out of New York and recharges his inspirational batteries and gemstone stocks by immediately making this pilgrimage. Jürgen will be ready for him, having organized his own stocks and that of many colleagues to

ABOVE The geometry of a hexagonal tsavorite meshes with the Ching Dynasty style designs at the center of the diamond and gold necklace.

OPPOSITE Rubies heighten the drama of this classic diamond jewelry.

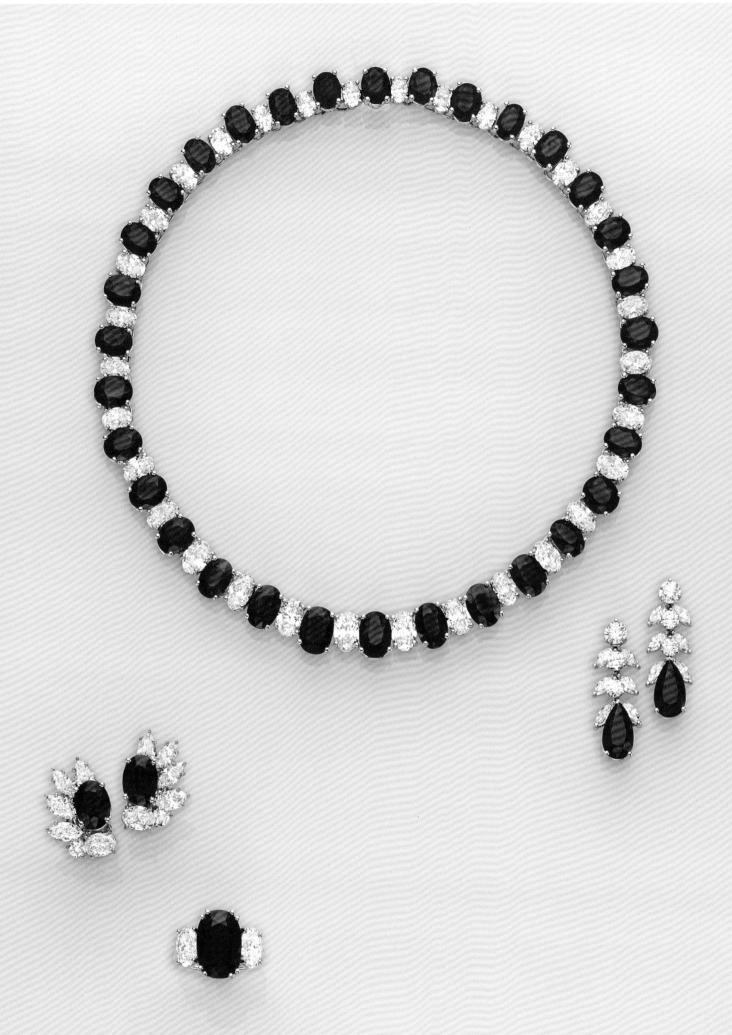

be ready to show Henry a vast array of gems and carvings. Henry literally inhales the scene, examining an extraordinary assemblage of gems in only a couple of days. However, he always has time to sit and talk with the cutters and dealers, letting them know and feel the shared values of a fellow artist and lover of gems. Nevertheless, the stones speak to Henry quickly—"Over here, look at me"—and he sees that special perfection—a superb tanzanite, a suggestive shape,—an intergrown beryl cluster, or a sanguine ruby cabochon—he knows he can apply to excellent effect. Jürgen says there is no one with a faster eye than Henry's at picking out what he wants, even while going through thousands of stones in a sitting. Even when Jürgen suggests Henry put a stone or parcel aside for a second viewing, on the prospect that in retrospect it will look better, only most rarely does Henry change his mind. Although there is much to see and learn in Idar, and Jürgen usually asks Henry to stay a little longer, the designer invariably only stays a couple of days, moving on to Torre del Greco near Naples, Italy, to seek out lurid colors of coral, and then to Milan where he can culminate his pilgrimage at La Scala, for emotional rejuvenation.

What is an example of the special relationship between Jürgen and Henry? A telling example is the story of the Kashmir peridot. Peridot is the gem variety of olivine, a common rock-forming silicate, which is a transparent crystalline gem with a characteristic grassy green color; it has been used since antiquity. An important aspect from Henry's perspective is that peridot does occur as large stones of over 100 carats, although such beauties had been rare until recently. Important sources have been the island of Zabargad in the Red Sea, which has not produced many stones for years (in part because it has been placed off-limits by the Egyptian military), and the Berndardmyo deposit near Mogok in northern Burma (Myanmar), made more distant by its pariah government. Large Burmese peridots have come out in small quantities for years, but Henry found them "sleepy" due to microscopic inclusions that give them a slightly turbid or hazy appearance. The United States produces small peridots from the San Carlos reservation in Arizona, but most of the stones are less than 10 carats. Hence, Henry had not been interested in peridots, that is, until the early 1990s. At about this time reports of a find in the Himalayas of Pakistan started to be heard among

ABOVE The gold Tibet brooch has a golden beryl retreat and diamond rooftops.

OPPOSITE Luxurious emeralds define a diamond and gold necklace, earrings, and ring.

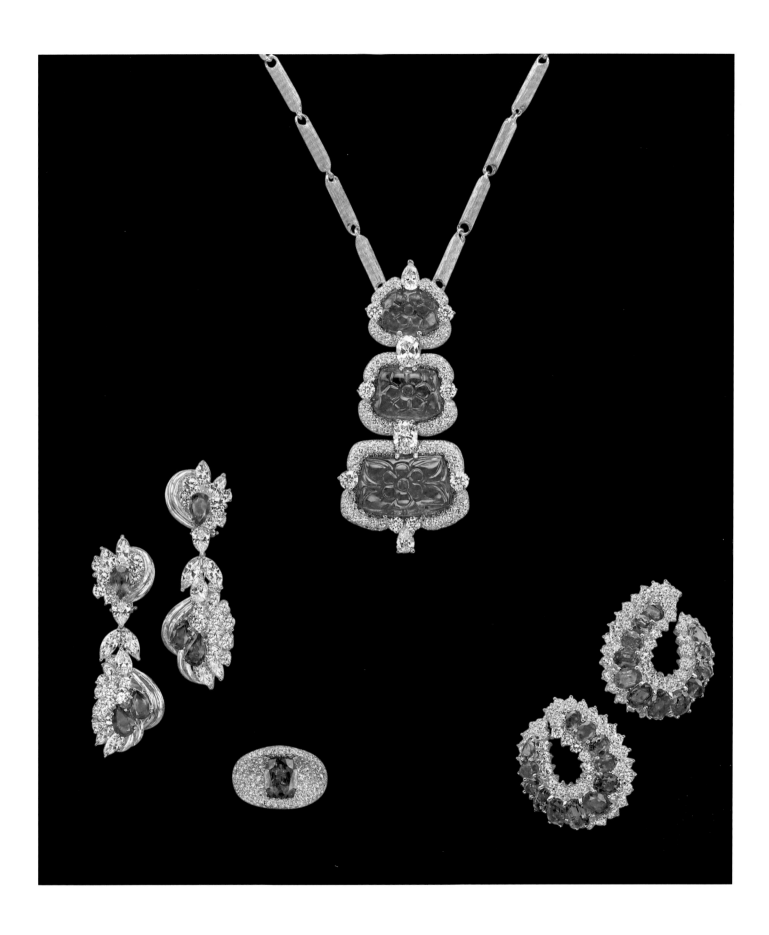

PERIDOT

Peridot is on the cusp of being soft and only moderately durable, so its real appeal is its color and availability. A birthstone for August, larger stones should have intense grassy green color.
Sources: Kashmir peridot from Pakistan; other large stones from Bernardmyo, Mogok Tract, Burma; Zabargad Island, Egypt; China; Amklavdalen, Norway; San Carlos reservation, Arizona, United States.

THE QUARTZ FAMILY

Amethyst The purple variety of quartz, and, as quartz is the definition of a hard stone, it is adequately hard as well as durable. The color in amethyst is usually concentrated in the growth layers forming three of the six faces on a quartz crystal "point," thus amethysts often manifest color zoning that detracts from the beauty of a faceted gem.
Sources: Rio Grande do Sul, Brazil; Zambia; Uruguay; Namibia; Ural Mountains, Russia.

Citrine The yellow variety of transparent quartz. Natural citrine is rare but heat treatment of some amethysts will render them into citrine (as nature does). As with amethyst, color zoning is a problem. The finest citrines are intensely yellow almost verging on orange—such stones are rare.
Sources: Minas Gerais, Brazil; Spain.

Rock Crystal The colorless form of transparent quartz. Once used as a poor substitute for diamond, rock crystal is normally fashioned into carvings, objets d'art, or spheres—crystal balls.
Sources: Many places—Hot Springs, Arkansas; Minas Gerais, Brazil; Ural Mountains, Russia; the Alps.

TANZANITE

The blue variety of gem zoisite; most untreated stones have color change in the three crystallographic orientations: blue, violet, salmon orange. Tanzanite is somewhat fragile so stones set in rings should have protective settings.
Source: Merelani Hills near Arusha, northern Tanzania.

PRECIOUS OPAL

Opal exemplifies how shear beauty can outweigh a gem's disadvantageous properties–the fragility and softness is outweighed by the fabulous play of colors (iridescence) produced by optical diffraction from arrays of tiny ball-like structures that characterize the precious variety.
Source: Around the artesian basin of Australia, Mexico, Slovakia.

PEARLS

Pearls are a special version of shell used by mollusks to coat irritating foreign objects entering their shelled domain. Pearls are revered for their characteristic luster and range of colors. Most pearls in the marketplace are cultured. Baroque pearls are irregularly shaped complete pearls. Keshi pearls are like Baroque pearls but smaller than 10 millimeters.
Sources: Japan, China, Tahiti, Australia, Myanmar, and many other places.

Peridot *Amethyst* *Citrine* *Rock Crystal* *Tanzanite* *Opal*

THE BERYL FAMILY

Emerald The intense green or blue-green variety of beryl. Color is due to chromium (a controversy exists over whether beryl with more vanadium than chromium can be called emerald, even though the color is very similar). A classic precious stone with great popularity. However, emeralds rarely occur without flaws whose appearance can be minimized by various enhancements, most of which are reversible.
Sources: Muzo, Cosquez, Chivor, and other areas in Colombia; Minas Gerais, Brazil; Sandawana, Zambia; Swat and Mingora, Pakistan; Panjsher Valley, Afghanistan; Alexander County, North Carolina, United States; Takovaya, Urals, Russia.

Aquamarine The greenish-blue or light-to-moderately blue variety. Color is due to ferrous iron. Its popularity has been overtaken by topaz made blue by laboratory treatments.
Sources: Minas Gerais, Brazil; Mozambique; Jos, Nigeria; Zambia; Madagascar; Afghanistan; and Pakistan.

Heliodor Also known as golden beryl. The yellow to golden yellow variety. Color is due to ferric iron.
Sources: Minas Gerais and Goias, Brazil; Woladarsk Wolyn, Ukraine.

CORAL

Corals are the skeletal remains of colonial marine polyps. The hard (calcite-based) species used as gem material are the red *Corallium rubrum* in the Mediterranean and nearby seas and similarly red *Corallium Japonicus* in and around the South China Sea. Soft (conchiolin-based) corals come in black, blue, and gold colors. Over-exploitation has led to bans on harvesting gem corals in the Mediterranean, but Asian varieties are still being extracted. Coral is often imitated with synthetic resins or substituted with fossil material.

MOONSTONE

The iridescence in moonstone is produced by submicroscopic interlayering of feldspar with different compositions and is the result of the unmixing of a single mineral into two upon cooling. The layers have a thickness on the order of the wavelength of light (hundreds of nanometers) causing light scattering. Body color typically results from a natural staining ingredient such as iron. Deposits are usually associated with volcanic rocks.
Sources: Sri Lanka, India, Burma (Myanmar), Mexico.

JADEITE JADE

Jadeite jade is the harder and more colorful type of the two jades (jadeite and nephrite). Generally used for carving and bangles in Asia, but the finest, translucent green and lavender colors are revered as cabochons.
Sources: Northern Burma (Myanmar), Motagua Valley, Guatemala; Itmurundy, Kazakhstan; Yenisey River, Khakassia, Russia; Itoigawa area, Japan; Ketchpel, Polar Urals, Russia.

Pearl

Emerald

Aquamarine

Heliodor

Coral

Moonstone

Jadeite Jade

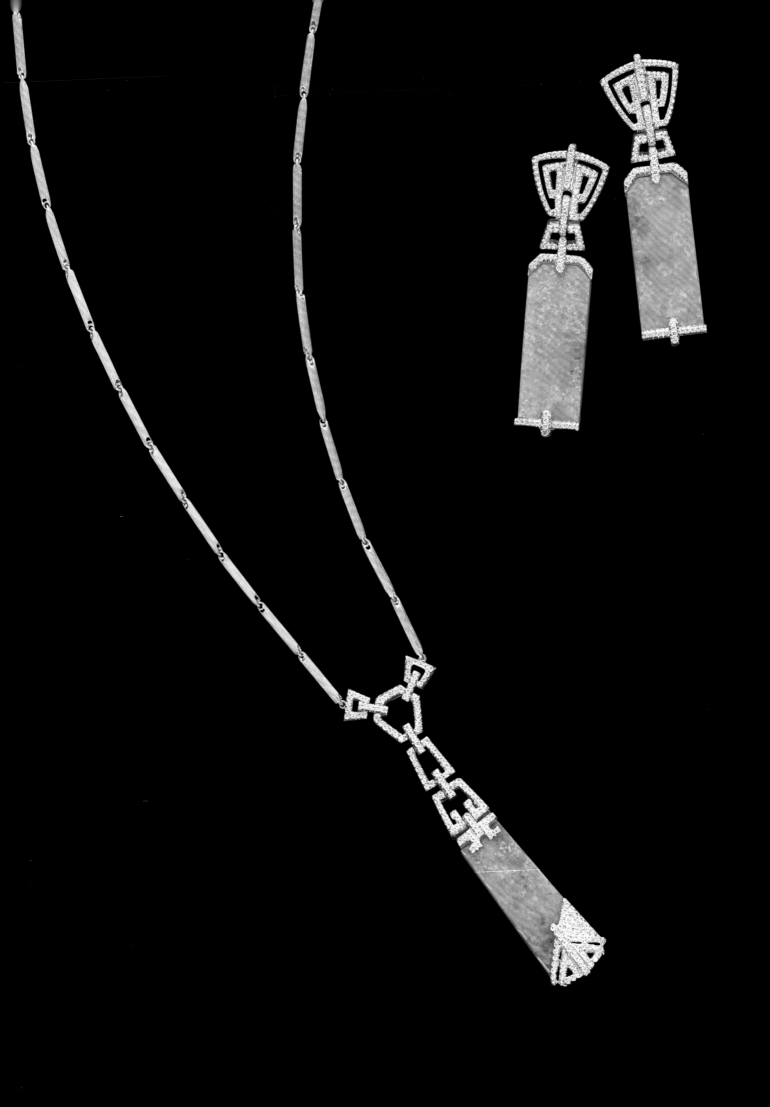

those with their ears to the ground. And certainly one whose ears were well attuned to such news was Jürgen. In a valuable coincidence, one of his avocations is mountaineering and, as you might guess, a gem deposit in the Himalayas means high up in the mountains, somewhere between 4,000 and 5,000 meters elevation. Combining his role as a gem expert and buyer who goes to the source with his mountaineering ability, Jürgen was the first westerner to be invited to and actually visit the mines of the Parla Sapat area, northeast of Naran in the Kaghan Valley, very close to the Kashmir border. Thus, he was one of the first people to see the material in its raw state, and he immediately thought of Henry—this was gem material for him. He started importing rough to Idar-Oberstein, cutting it in his workshops, and seeing how it looked, which turned out to be fantastic for peridot—large, clean, intensely green stones in sizes up to and exceeding 100 carats. Jürgen soon showed the material to his confidant, Henry, who fell for it completely. Together they coined the name Kashmir peridot, in reference to the region of its source. Henry made a quick change in his production to bring out a line featuring this gem and promoted the line successfully with Neiman Marcus. Kashmir peridot became a big success for them both. Such is the nature of the collaboration of these two "rock stars" and their implicit trust in one another.

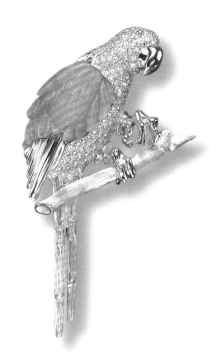

Finally, Dunay's expertise at integrating a gem into jewelry must be addressed. In addition to the matchmaking of color and shape in a jewel, for which Henry is renowned, wearable gems must be able to withstand the kinetic existence of part-time residence on a human—after all the essence of jewelry is adornment on "us" and that means becoming a more-or-less constantly moving object. Hardness, resistance to scratching, durability, and resistance to breakage, are important assets for all gems, but with all the beauty nature has bestowed into the mineral kingdom, not all minerals are supremely tough. Decisions about what is too fragile to become a gem are, indeed, somewhat arbitrary. Some minerals with astounding and curious beauty are in fact a bit more fragile than is most desirable for a gem, a fine example being precious opal. Opals are somewhat soft and subject to fracture upon physical or thermal shock. Should we, sadly, not wear opals because of their foibles? Maybe, but fine designers figure out how to

OPPOSITE A gold and diamond necklace and earrings feature large rectangular black opals.

ABOVE Fossilized opal forms the Macaw's feathers on a gold and diamond brooch.

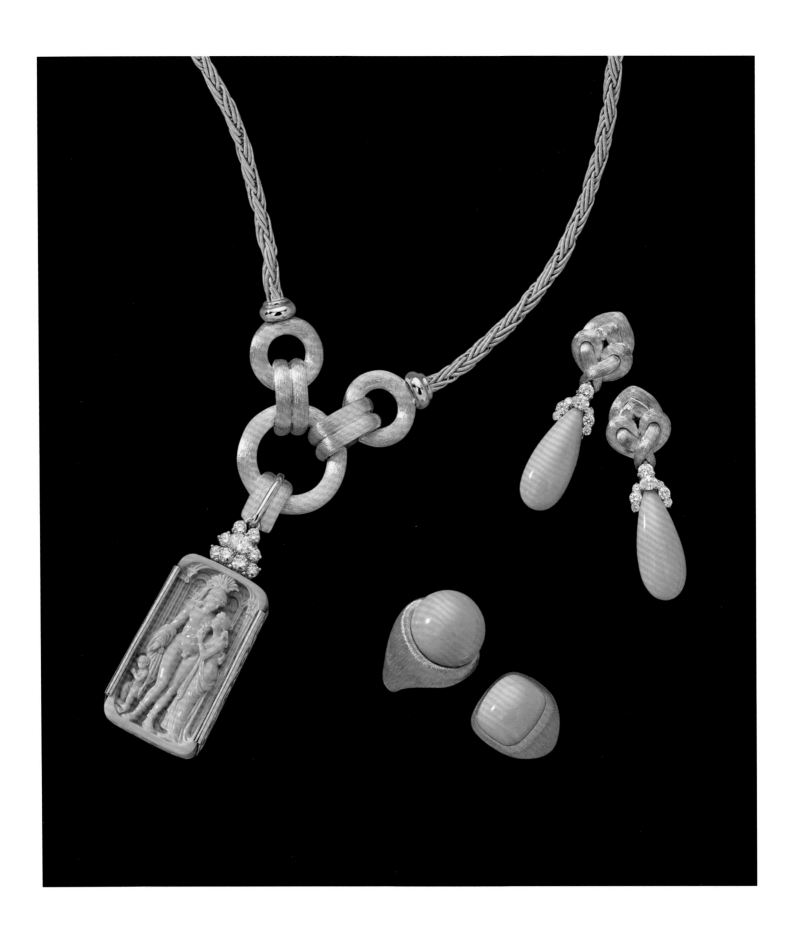

protect the stone without hiding it in a cage and a wise owner knows to protect the jewel from perilous circumstances. Henry employs various techniques in his settings, such as eyebrow-like raised metal around an opal or tanzanite to offer some defense from glancing blows. He does not like large raised prongs as they are clumsy looking and interfere with the form of a jewel—they are a distraction. Prongs are also used to clasp gems, being bent against or over the gem to hold it in place. Henry has developed an alternate method of clamping stones into his jewels, like a vise using a screw mechanism. The effect is similar to the modern tension mount for diamonds but cannot typically be applied to the softer colored stones. Part of the practical and engineering beauty of his mounts for larger stones is that the gem can be unclamped from the setting to be inspected or enjoyed; such unclamping is far less perilous to the stone than releasing a gem from prongs—I know of too many sad stories of a tourmaline or peridot damaged when removed to resize or fix a setting. In this way, Henry is an architect of jewelry, like a Frank Gehry working in miniature.

A TOUR OF HENRY'S GEM FLAVORS As already noted, Henry likes the intensity, clarity, and nuance of Kashmir peridot, which, combined with the availability of this gemstone from Pakistan, permits impressive signature creations. While mostly working with faceted gems, Henry has on occasion worked with peridot crystals, surrounded with yellow and white gold and diamond pavé.

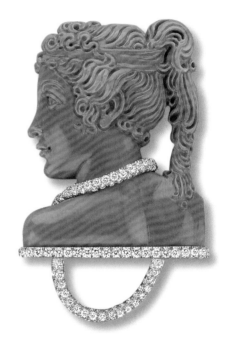

The first stone and object Henry introduced to me was a large, intensely blue, high-crowned tanzanite cabochon set in an impressive gold ring. Tanzanite has a beautiful blue to purplish blue color but must be handled with care because of its sensitivity to blows; it has perfect cleavage, and is not very hard. The ring has two high ridges in the cradle clasp that holds the tanzanite, providing it with considerable protection while not interfering with the imprimatur of the grand stone. Others might dodge large tanzanite, but for Henry the sheer lusciousness of the color, clarity, and size of these stones is irresistible. There is only one known source of tanzanite, the name given by Henry B. Platt of Tiffany & Co. in 1967 to the deep blue variety of zoisite from the Merelani Hills, near Arusha in northern of Tanzania, so there are limited supplies that vary from time to time.

OPPOSITE Light angel skin coral makes this necklace, earrings, and rings super feminine. The coral cameo depicts a hero leaving his family.

ABOVE The neoclassic Lady in Red coral cameo brooch looks svelte in a long diamond necklace.

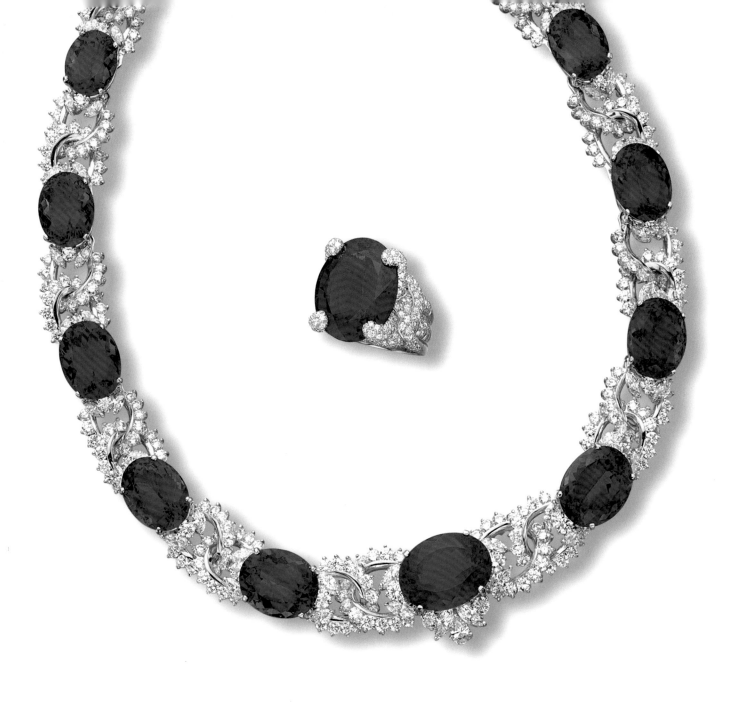

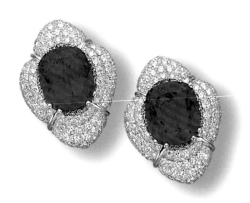

ABOVE A formal diamond and gold necklace, earrings, and ring showcase oval-shaped tanzanites.

OPPOSITE Tanzanites light up this diamond and Sabi gold necklace and ring.

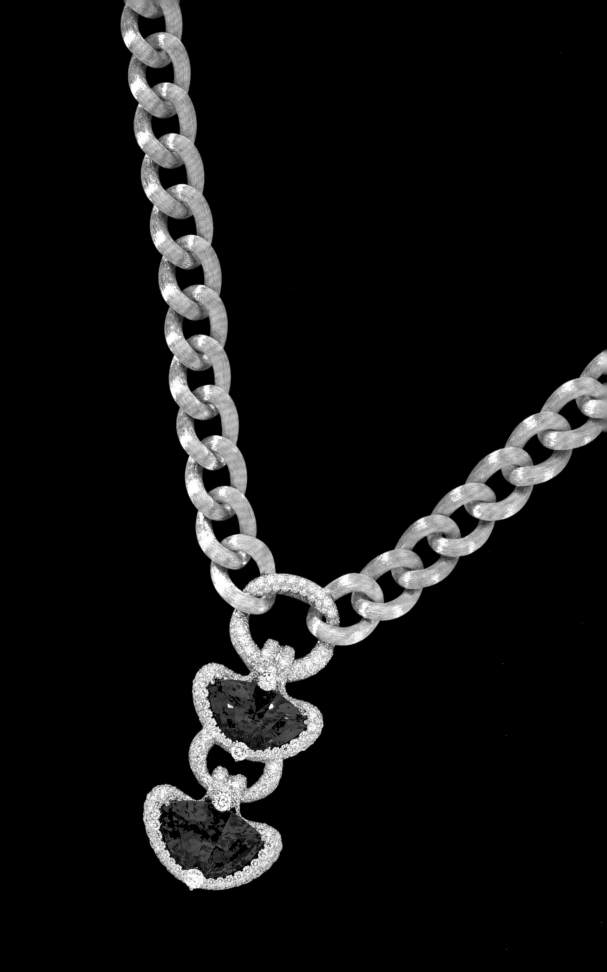

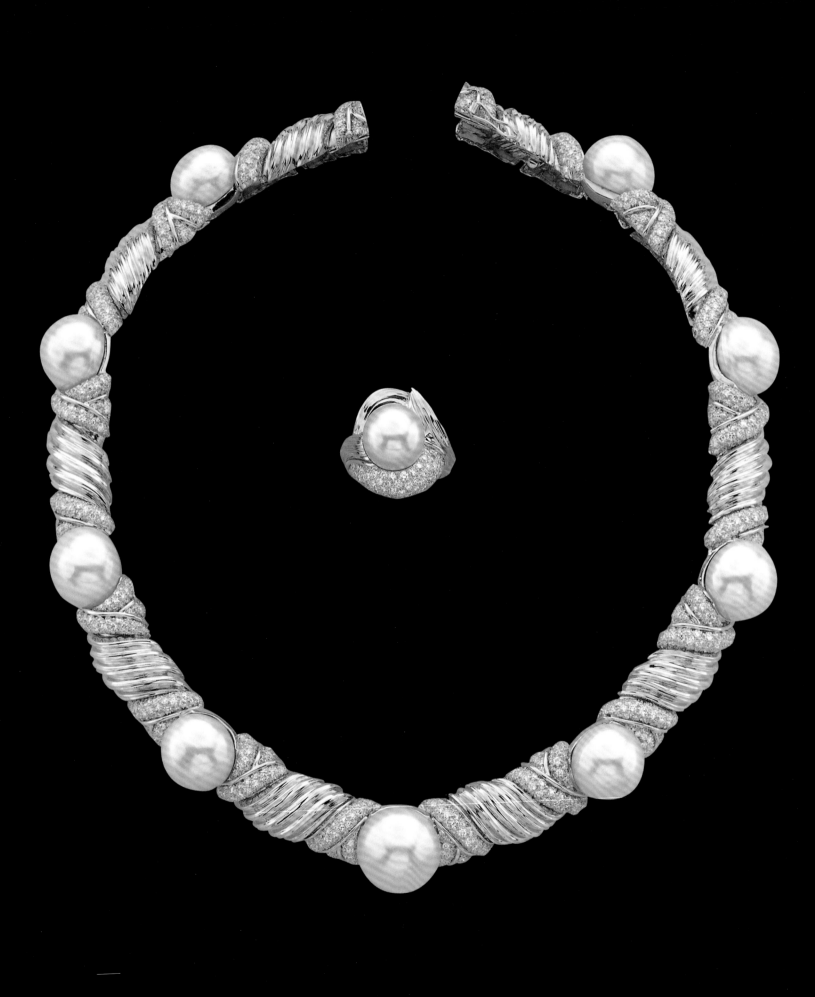

Tanzanite is another example of a stone that became available on Henry's watch, and as the stone spoke to him, his heart—rather than consumer demand—sparked his enthusiasm and ingenious use of the gemstone.

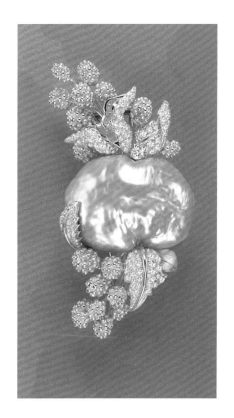

Pearl is among the few non-mineral gems but is one the most historic and desired. If diamond with its fire is the sun, then pearl with its soft glow is the moon. Pearl was the first gem used in a form we still utilize because essentially they are found in finished form, in the shape that the mollusks make them. Pearls are unique in that their luster is their characteristic signature, and, although relatively soft, they are quite tough—nature's equivalent of a high-tech composite structure made of many layers of nacre. They come in many sizes and many colors, but Henry prefers large ones and favors those with interesting color and character, particularly those with undulating, irregular shapes, known as Baroque pearls. Baroque pearls are an invitation to design imaginative settings, as was done by Italian jewelers in the Renaissance—typically the pearl reminds the designer of a character or scene in which the pearl is the central form. However, this does not mean he does not appreciate a fine, large, colorful sphere. While visiting Burma (Myanmar) to attend the auction in Rangoon (Yangon), Henry was shown a fabulous lavender native pearl about a half-inch in diameter—although it took some doing, he did not leave the country without it. In addition to Baroque and fabulous individual pearls, he has a taste for keshi pearls, which are a kind of adventitious cultured pearl with a solid seed nucleus, known for their impressive orient—the iridescence that accompanies the pearly luster—as well as Baroque-like shape. He also appreciates the large South Sea and "black" Tahitian pearls, as well as the large pearls being cultured in Australia; these tend to have intense color and fine orient.

Aquamarine is a gem variety of beryl and is the first I will present because of Henry's admiration for them. Aquamarine is the blue to blue-green variety that covers a great range within this grouping. Beryl is a hard, durable mineral that makes for a fine gem, but beryls rely on color for their desirability, as they are not as lustrous as some other minerals. Henry prefers the most saturated and bluest aquas, and the terms for these that come to mind are "Martha Rocha" and "Santa Maria." The former name refers to a single massive crystal from Marambaia,

OPPOSITE Big South Sea pearls punctuate a gold and diamond necklace.

ABOVE A South Sea pearl turns into a rock among blackberry bushes in the Mythical Alexandria Blue Pearl brooch.

Minas Gerais, Brazil, that was named after the 1954 Brazilian beauty queen. Santa Maria de Itabira was a mine in Minas Gerais that produced fine, intense blue aquas, so Santa Maria was used as the moniker of such fabulous aquamarines. Unfortunately, the mine is finished but the name persists and has jumped continents, particularly to Africa where "Santa Maria Africana" refers to fine, intense-blue aqua with a hint of gray from Mozambique. Large clean crystals from Africa came to Henry's attention around 2000, and he readily employed these in various pieces of jewelry, such as pendants and earrings. In about 1991 some exciting long prismatic crystals from the Jos Plateau of Nigeria appeared again in the marketplace, after an absence of some years. These were intriguing because they had both good blue color and etch lines running along the prism faces. Henry set one of these aquamarine crystals as a river with a multi-arched bridge in the foreground and spires and rooftops in the background. The etch lines on the crystal faces, suggested waves to Henry, and helped inspire the motif for the Budapest brooch. He used other aqua crystals, with their hexagonal profile, either as the body for carved figures or for dangling pendants.

A less appreciated beryl that has connected with Henry Dunay is golden-yellow beryl, usually called heliodor. Yellow gems come in and out of fashion because they do not possess a primary color: red, green, or blue. However, intense yellow is nonetheless impressive, so it is no wonder that Henry has made some interesting creations from fine yellow beryls from Woladarsk Wolyn, Ukraine. With Oriental whimsy, Henry created a vase for a tower featuring an onion-shaped dome from one Ukrainian crystal. Another composite crystal with stepped terminations is a fanciful tower itself with a curved diamond-covered roof. In both cases the strong yellow of the crystals holds up to the intensity of the gold setting and pavé of diamonds—no wimpy crystals for Henry.

The most highly prized variety of beryl is emerald, the archetypal emerald green gem. Whereas the unrivaled source for emeralds is Colombia, primarily places such as Muzo, Cosquez, and Gotchala, Henry says these emeralds have a tinge of yellow that detracts. Rather, he prefers ones from the newer sources, from Zambia and, particularly, the Sandawana mine in Zimbabwe. Now some say

TOP The blue aquamarine and green tourmaline in the Shallow to Deep brooch represent the change in color of the water in the Caribbean, from the shore to open sea. The clusters of round diamonds capture the foam of a breaking wave.

BOTTOM A long yellow beryl creates a columnar effect in a diamond and gold brooch.

Sandawana emeralds have the yellowish cast and Colombia ones a bluish one, so here is where I really learned that Henry has his own eye for color. I suspect it may be that the African emeralds are bit cleaner than typical Colombian stones, which characteristically have internal fractures and voids. Thus, it may be that the entire effect of color and clarity in large stones is what sways his decision. After all, any fine emerald is a kicker for eye-catching color. Henry also likes the emeralds coming from Pakistan (an ancient source that has had increased production in recent years), so I asked Henry if he had seen the new emeralds from Afghanistan. He had not, so perhaps there are new possibilities in the offing.

The original gem and carving materials of Idar-Oberstein were *agates* and *jaspers*, so with Jürgen as his muse it is not surprising that Henry favors the two varieties of cryptocrystalline quartz. The banding in agates and figure in chalcedony and jasper begs to be carved into cameos or sculptures, and Idar remains a capital for such creations. Henry loves cameos and was able to convince Erwin Pauly, a master carver and engraver in Veitsrodt (near Idar-Oberstein) famous for his profile cameos in agate, to fashion some slightly thinner so Henry could more readily incorporate them into jewelry. A new carver, Michael Peuster, who opened his carving atelier in 1991, has caught Henry's eye with his work, and Henry sees a future synergy for jewels with him, too. The agates that find their way into Henry's art invariably come from Brazil; Jürgen says there is such a regular supply from there that searching for other sources, although there are many, just does not make sense.

Moonstone is a subtle gem that glows with iridescence, particularly stunning in soft light and, in some stones, with a flash of the cat's eye effect. The finest moonstone historically came from the Isle of Serendib, Sri Lanka, and gave off a blue shimmer that was often displayed in necklaces and brooches of large stones for formal occasions. Unfortunately, the source of this material is exhausted and no major source has been found to replace it. However, large pastel-colored stones from India caught Henry's eye and have been used to impressive effect in large jewels. Moonstone is a case where an eye-catching visual display has trumped the need for intense color in Henry's jewel box.

OPPOSITE A 32-carat tsavorite crowns a diamond and gold ring (top). A 31-carat cabochon emerald makes an impressive centerpiece in a diamond and gold cocktail ring (bottom).

ABOVE An important yellow sapphire and diamond pendant with emerald and diamond streamers hangs casually from a gold chain necklace.

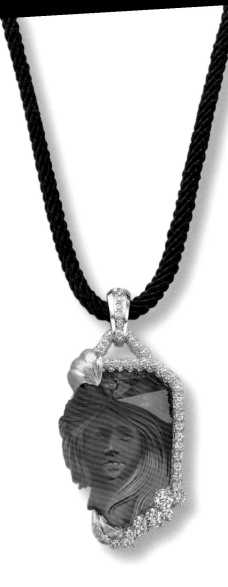

Rock crystal is the crystal-clear colorless variety of quartz that became the empty canvas to shape into eggs sculpted with sensuous surface embellishments to satisfy Henry's love of shape and depth. Carving crystal into eggs and spheres is an ancient art form, so Henry decided to add rippling textures in the quartz eggs and wrap them with gold and pavé to create a new style. Building upon this idea, he frosted the carved crystals so the transparency was muted but not the transmission of light through them. He and Jürgen had to look through many crates of raw Brazilian and Madagascar crystals to find examples of sufficient flawlessness to meet Henry's need for producing a complete suite of fashioned objects.

Crystalline quartz also occurs in colored varieties, and for these Henry's demand for saturation in color comes back into play. Amethyst, the purple variety, comes in many shades and commonly does not have uniform color. Henry is a stickler and so demands those uncommon, large, intensely and evenly colored stones that have traditionally been mined in Rio Grande do Sul, Brazil. More recently Zambia has produced amethyst of similar quality. Citrine, yellow quartz, has similar coloring characteristics as amethyst, so the same aesthetic of seeking the most intensely colored large stones applies. Sometimes citrines verge toward orange, and these are particularly delicious for him.

One of Henry's favorites is red gem coral. His annual pilgrimage to Europe after the year-end holidays includes a trip to Torre del Greco, a small city south of Naples, Italy, with an ancient tradition for working with coral, so it is known as the Coral Capital. Although harvesting of living Mediterranean coral is prohibited, Torre del Greco operates somewhat like Idar-Oberstein, but essentially for coral, bringing together old coral and new examples from around the world where designers like Henry can make selections. Red coral comes in many shades and hues from pink and pastel orange to oxblood red. You guessed correctly that Henry prefers strong orange-red to intense dark crimson. He acknowledges that these colors are not for everyone, but the combination of

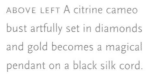

ABOVE LEFT A citrine cameo bust artfully set in diamonds and gold becomes a magical pendant on a black silk cord.

ABOVE RIGHT The bright reds and oranges in an 80-carat citrine at the center of a diamond and gold brooch reminded Henry of a rain-streaked window with the bright city lights shining through. He named it Rainy Night with City Lights.

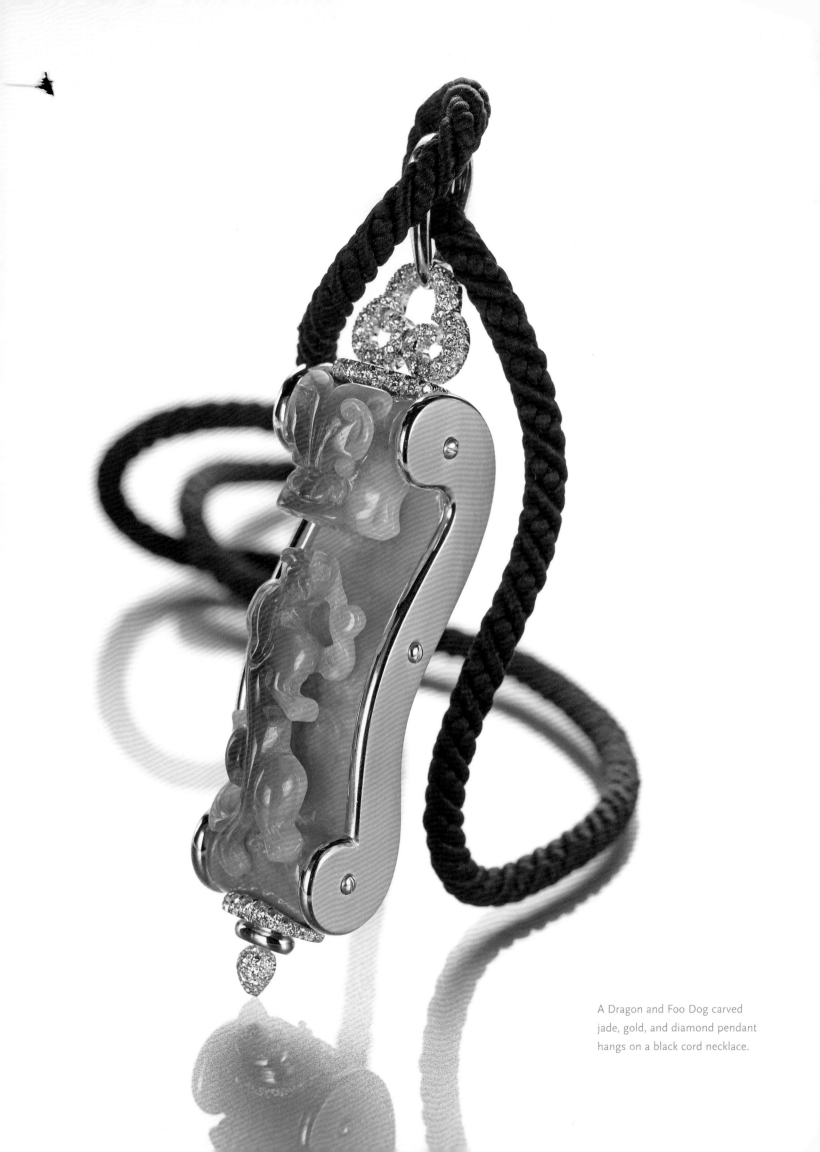

A Dragon and Foo Dog carved
jade, gold, and diamond pendant
hangs on a black cord necklace.

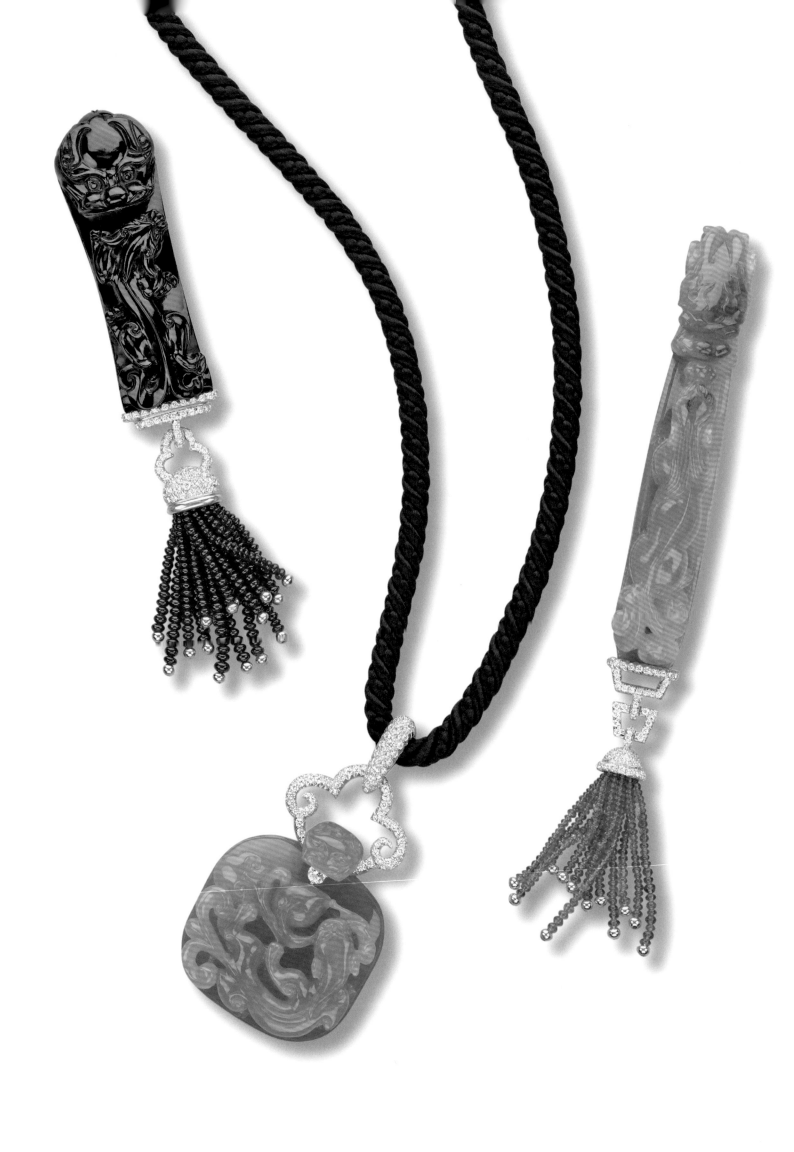

his creativity and developed audience works in his favor. Another problem with coral is size, as coral is more abundant in younger small sprigs than larger thick segments, and he would rather work with fewer larger pieces than build up composites of many small pieces.

Jadeite is the harder form of jade that was the original "prestige stone" of ancient Middle America, used in ornaments and talismans providing both a symbol of power and purported protective powers. Jadeite also became the favored jade for fine carvings and jewelry in China in the eighteenth century, when negotiations permitted the development of the Burmese source. In its most valued form, jadeite jade is emerald green or a translucent mauve or sometimes mixed together with white or black figuring. Henry admires the Asian aesthetic for carving in this beautiful and tactile substance and keeps his eyes open for an appropriate piece he feels can be transformed into something new in jewelry or as an enhanced objet d'art. As jade is among the toughest substances, it does not need protection and can be exposed boldly without risk of damage.

Quite clearly this short presentation of Henry's taste in colored stones demonstrates his love of color, shape, luster, and fineness in the gem kingdom. The stones presented hardly encompass the full encyclopedia of gem Henry— I have left out rubies, tourmalines (a veritable cornucopia of color), garnets, sapphires (he prefers yellows, pinks, and padparadshas to the inky blues now so common)—but I think you get the point. If it has intense color, is fine or just exceptional and a gem, just call Henry to take it off your hands. So, thinking of George F. Kunz upon initiating this examination of Henry Dunay and his use of gem materials was not inappropriate at all—there is a lot of Kunz in Henry.

OPPOSITE (from left to right) A Dragon and Foo Dog carved gray jade and gold brooch has a vibrant ruby tassel; a black silk cord suspends a Dragon and Foo Dog carved lavender jade, diamond, and gold pendant; A Dragon and Foo Dog carved yellow jade and gold brooch has a bright emerald tassel

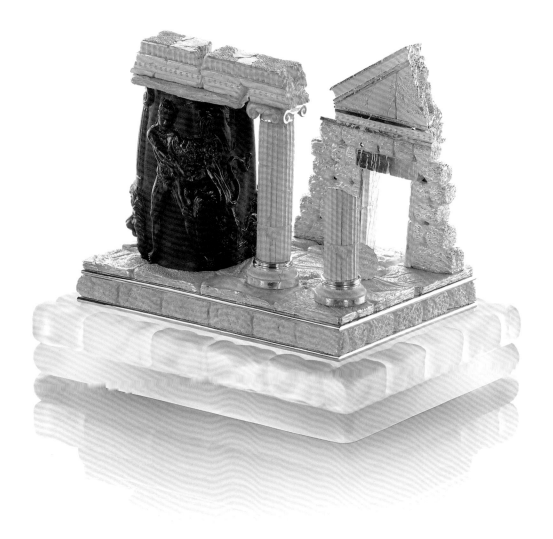

ABOVE A scene of Hercules and the Lion appears on a 783-carat ruby in the gold ruins of the Lost Empire.

OPPOSITE In the Ides of March, Brutus and Caesar are immortalized in an 827-carat aquamarine set in a gold Ionic column.

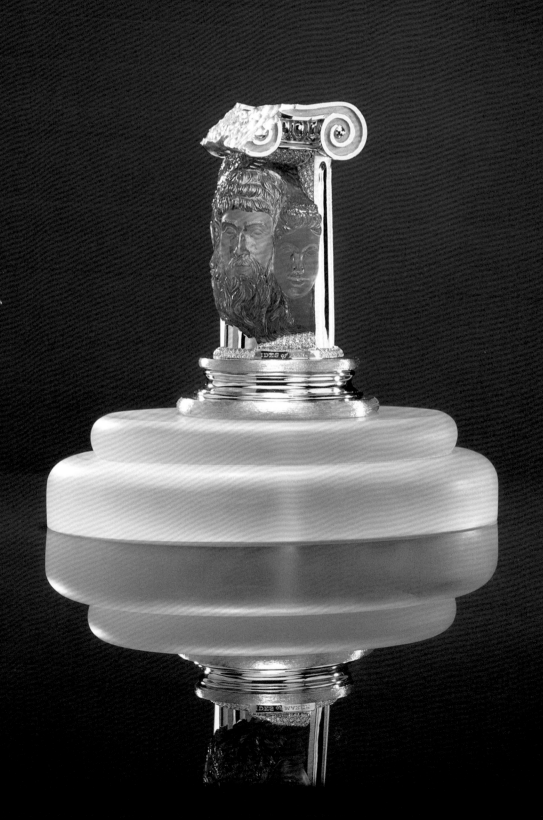

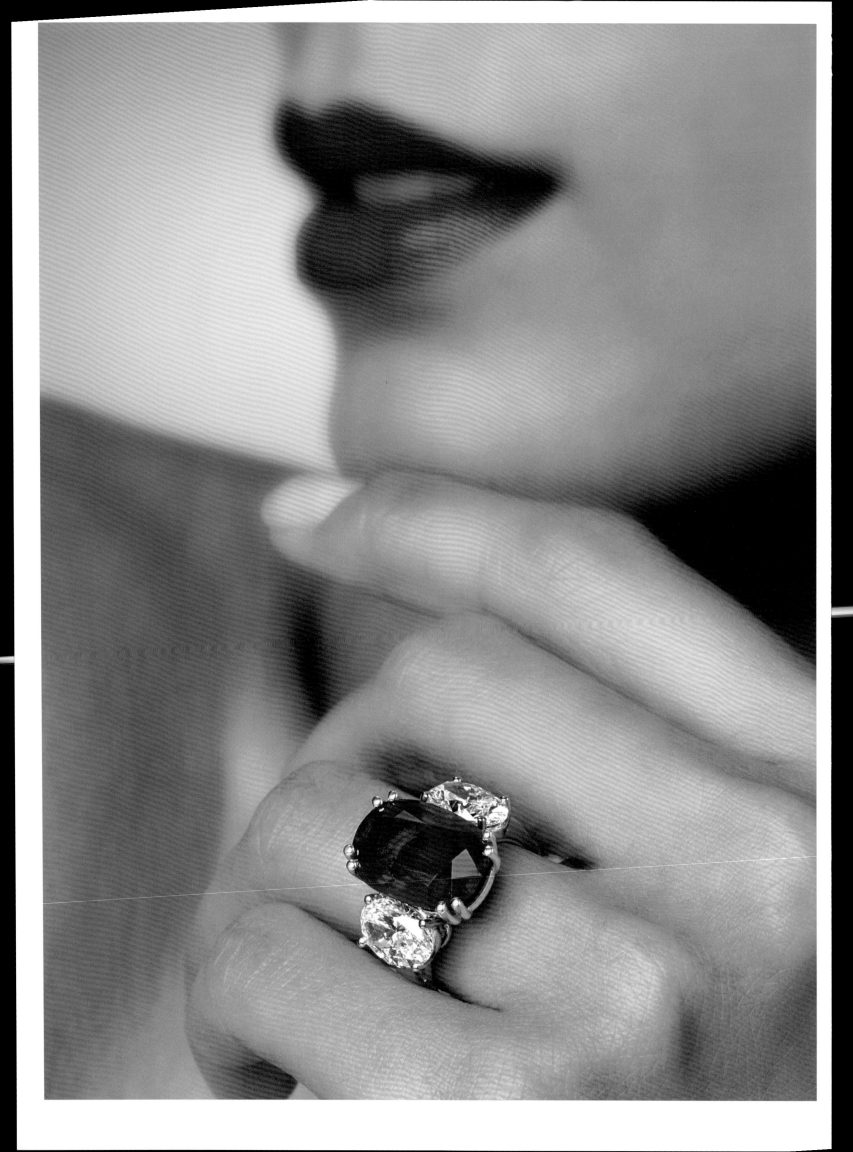

Suntanned Ladies: Henry's Muses Sing a Song of Beauty

Interviews with Louise Ornelas, Mrs. B., and Jane Mitchell By Jeryl Brunner

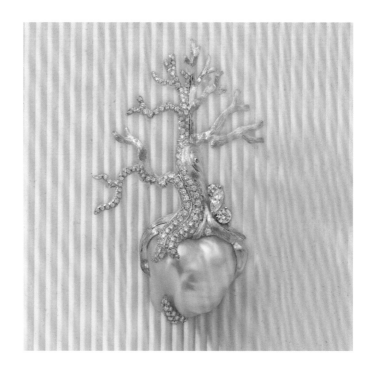

THE VERY DEFINITION OF STYLE IS ELUSIVE. It is a quality the greatest arbiters of fashion have tried to define for ages. "Fashions fade, style is eternal," intoned Yves Saint Laurent. The legendary founding editor of *W* magazine, John Fairchild, proclaimed, "Style is an expression of individualism mixed with charisma." American fashion designer Bill Blass stated that style is "primarily a matter of instinct."

As a young man Henry Dunay tackled the topic of style when he attempted to describe it in relation to his clients and the women he hoped would be his clients. "When she walks into a room, there is an aura about her," explains Dunay. "She is wrapped in sophistication, elegance, and beauty. Everything she wears is well thought out from her makeup down to her shoes and, of course, her jewelry." "Suntanned ladies" was Henry's shorthand way to reference these women of style. "She doesn't have to literally have a suntan," he explains. "What I mean by 'suntanned lady' is someone who works at being beautiful."

Since the early days of his career, Henry has admired and been inspired by his suntanned ladies. Three eternally golden women, metaphorically speaking, turn the tables and explain why Henry Dunay is an essential part of their definition of style.

PREVIOUS A lady considers her 10-carat ruby and diamond ring.

ABOVE The South Sea pearl, diamond, and gold Winter Tree brooch has diamonds on one side, representing where the snow settled after a storm.

LOUISE ORNELAS Nearly every month, Louise Ornelas drives a hundred miles from her Texas home to Neiman Marcus's Dallas store in NorthPark. Her mission? To purchase a Henry Dunay ring, necklace, brooch, or necklace. "I'll drive a hundred miles for Henry Dunay and farther if I have to!" she offers in her sweet Texan drawl. "I just love his pieces—they're works of art."

It all began around 2000 when a saleswoman in the store's precious jewels department introduced her to the designer's line, and she's been enchanted ever since. "Now, if I leave my rings and things at home, I say, 'oh shoot, I'm going back to get them,'" she laughs. "I feel naked without them." During shopping excursions, she only sees Dunay, no other designers interest her. "His jewelry is so well made," says Ornelas. "I've said that I should quit going to Neiman Marcus because every time I go, I buy a piece. I have just about everything they put out!"

To Ornelas, the process of selecting the perfect item happens almost organically. "When I see the right one, it speaks to me," she explains. "I just have to have it." She is particularly fond of her black opal ring. "The opal has every color in the rainbow," says Ornelas. "It has the most beautiful colors you've ever seen." She wears it as often as possible, especially to University of Texas trustee meetings where people always ask: "What kind of ring is that? Do you mind if I look at it?" "The stone is quite large, it picks up the colors of whatever I'm wearing and makes me feel glamorous and gorgeous."

Then there's her black pearl necklace, pendants with giant stones, and her beloved white pearl necklace. "It doesn't have pearls covering the whole strand," says Ornelas. "It has large ones on the bottom." The newest addition to her collection is an "absolutely gorgeous" pin with a row of three pearls, another row beneath it, and diamonds sandwiched in between. "Wearing his creations make me seem like I'm a dressed up lady," she says. "Like a queen."

Her most treasured pieces are Dunay's gold, diamond, and pearl tree brooches. "I have about eight of them," she says. "They're beautiful on the front—and the back." She started buying them for their beauty as well as the memories they brought back.

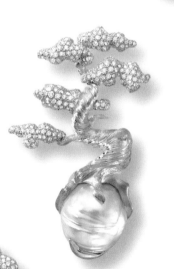

RIGHT Three Lone Cypress Tree brooches with South Sea pearls, diamonds, and gold were inspired by the famous cypresses in California.

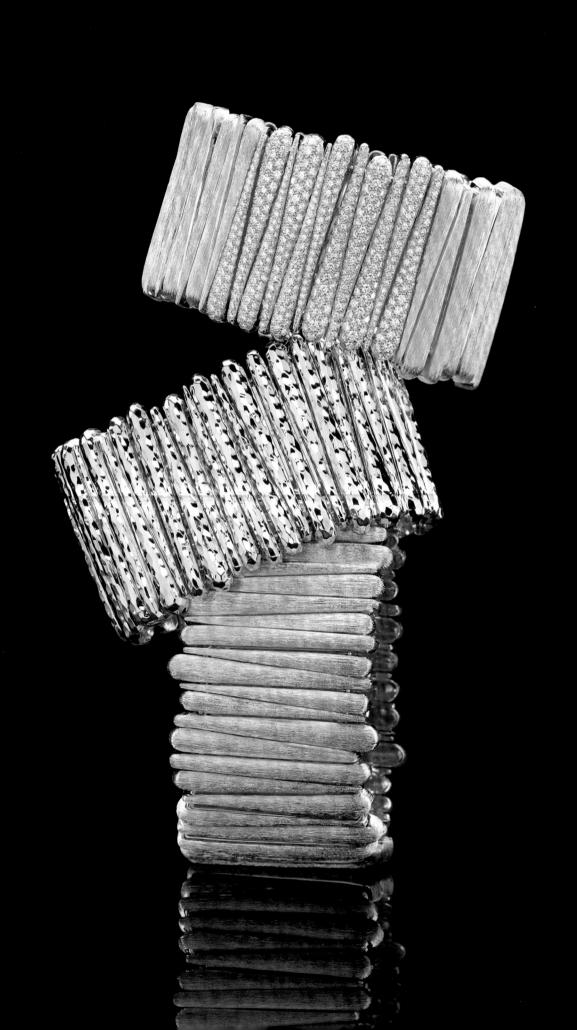

"I'm just an outdoorsy country girl at heart and I've always loved trees," explains Ornelas. When she was a little girl growing up in Arp, Texas, Ornelas and her father frequently went exploring. "He would point to the different trees, tell me all about what kind they were, and talk about them," she recalls. She picked leaves, took them home, and often wrote essays on trees at school.

Ornelas looks forward to the latest piece that Dunay is creating for her. He's resetting a 32-carat emerald that she purchased from another designer. "It was absolutely tacky the way it was originally set and so plain," she says. "We shipped it to New York and he's going to make the ring just like I like it."

A photograph of Dunay and Ornelas at a luncheon in Dallas has its place among photos of friends and family in her office. "My husband asked, 'who is that man you're with?'" Ornelas kids. Joking aside, her meeting with the designer himself proved an unforgettable experience. She learned how he finds stones and figures out what to do with them. "It was so wonderful to know that he's the brains behind the lovely pieces that I have," she explains "He's a gentle soul and I was thrilled to death to meet him." So how did she decide which of his designs to wear to the lunch? "I wore pins and rings and everything that I have of his," laughs Ornelas. "And he had a big smile on his face."

MRS. B. Over the sixteen years that Mrs. B. has worked with precious jewelry at Neiman Marcus, she learned to develop a keen and critical eye—a taste for what is beautiful. "Usually, the first ten minutes that I look at a collection, it seems interesting," she explains. "Then, I'll say 'ooh, everything looks alike or, it's nothing!'" That never happens with Dunay's designs. "His work is absolutely magnificent," purrs Mrs. B. "The more you look at it, the more you love it, and there is always more to discover."

What sets Henry Dunay apart from the rest for Mrs. B. is his craftsmanship, the shape of his stones, and how he creates a design around them. "He uses top, top quality diamonds in his pavé work; his technique is unparalleled," she offers. "You seldom see stones like that in the market in pavé." She is equally enamored with Dunay's playful side. Take the humorous brooches like the rhino with a bird

OPPOSITE Variations in the surface technique demonstrate how three of the same bracelets can look different. Sabi with diamonds is on the top, Faceted in the middle, and Sabi on the bottom.

RIGHT A seagull brooch stretches its golden wings (top). A drawing of a brooch shows a diamond and gold seal sunning itself on top of a large aquamarine iceberg. The design was inspired by the seals that play on the rocks along the shore of the San Francisco Bay (bottom).

on his back and the frogs. "They're like no one else's," she observes. "He has a fun brooch with a dog wearing glasses sitting on *Town & Country* and *W* magazines and now he's gotten into turtles." His prolific flair astonishes her. "I've never seen anyone create so much," says the French-born Mrs. B. "I'll think I know the collection, but I don't. There are always so many new designs."

She first learned about Henry Dunay when she was working in couture. "I am a clothes freak," she laughs. One client came to see her wearing large gold shell-shaped Sabi earrings. Mrs. B. was enchanted by the earrings' organic design and how they illuminated the woman's face. "I said, 'oh, they're breathtaking,'" she recalls. The client replied, "I didn't know the price, I just said, 'I want those, they're glorious.'"

Soon after, when Mrs. B. was working in the precious jewelry department at Neiman Marcus, she found a bracelet that matched the earrings beautifully and invited the same client to lunch. After receiving approval to take the piece to the restaurant, she slipped it into her handbag. When she debuted the creation, the patron exclaimed: "It's beautiful! How much is it?"

"Well, it's fifteen," Mrs. B replied.

"Fifteen hundred?" she asked.

"No. Fifteen thousand," replied Mrs. B.

"Oh mighty, I cannot buy this," was the response.

After two vodkas the client piped up, "Can I see that piece again?"

Mrs. B. slipped it out of her purse, the client placed it on her wrist and cried, "It feels so divine! I'll take it!" To this day, she still adores the Sabi finish bracelet. "That was my first Henry Dunay sale," recalls Mrs. B. "It was exciting to take the initiative and bring the piece out of the store, even though it made me a little nervous."

From there she learned everything she could about precious jewels, especially Henry Dunay's masterpieces, which was no easy task. When she started, she barely knew the difference between a real and fake pearl. She once tried to sell a black pearl necklace, saying, "It's very beautiful," yet couldn't explain why. "I didn't make the sale," says Mrs. B. "To understand pearls and diamonds you have to know what you're looking at. The more you see the more you learn."

ABOVE A gold frog brooch jumps for joy.

OPPOSITE Four bracelets and a cuff show a variety of Henry's work in gold.

Mrs. B. knows Henry Dunay's jewelry has transformed her clients' taste. Many only bought traditional jewelry until they discovered Dunay. "Once you start liking it, you don't stop," she says. Some of her clients have collections that are bigger than the Neiman Marcus inventory. Mrs. B. understands the draw of his work. "It's bold, elegant, striking, and you never get tired of it," she says. "Except for the major pieces, you can wear it from morning to night with blue jeans or a gown," she explains. "At one point he was showing his jewelry worn with jeans and it was fabulous."

What continues to astound Mrs. B. is the consistent "Wow!" factor of the pieces. Consider the spectacular multi-strand coral necklace with a few gold beads or the crystal eggs from his Jeweled Egg Collection. "The lines around the eggs are so sensuous and elegant," offers Mrs. B. "Every egg is unique and special." The brooches designed to resemble cities knocked her out. "His work is so intricate, yet simple at the same time," she observes. "He makes the prettiest, most feminine pearl bracelet that I have ever seen." The pearls are not strung in the usual way. They are on a platinum bracelet and spaced in between gold or platinum. Its clasp is shaped like a pearl and has a tiny heart with pavé diamonds. When he started working with jade, she thought, "nobody knows how to dress jade like Henry Dunay and make it a very rare piece. I don't know jade very well, but I do know when something is very beautiful."

Mrs. B. has a particular knack for guiding her clientele to the right jewels. She instinctively understands what works for the right person. She knows their favorite colors. She enjoys earmarking a humungous ring for a client who will wear it with aplomb. She once saw a Mandarin garnet and thought of a customer and said to herself, "She'll love it." She did.

Mrs. B. works with the pieces all day long at Neiman Marcus and lives with Dunay jewelry at home. Over the years, she has amassed quite a collection of her own. "I look like a billboard for Henry Dunay," she laughs. When she started wearing the designer, she gave most of her other jewelry away to her sisters. "I thought, better to have someone enjoy it than sit in a safe," she reasons.

Mrs. B.'s Dunay pieces vary from gold and coral necklaces, earrings, a deep orange coral ring to assorted gold and diamond bracelets, and a watch. After she

OPPOSITE Gold and diamond beads are randomly scattered through a triple-strand coral bead necklace.

ABOVE A gold Shar Pei wears a platinum Mandarin hat creating a two-tone brooch (top). A gold brooch depicts a literary Shop Hound on a pile of fashion magazines (bottom).

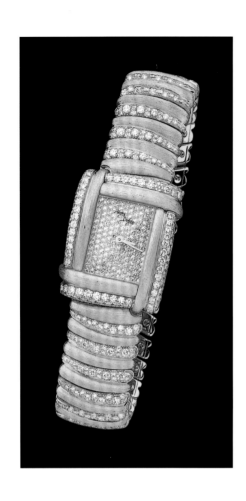

showed a gold seashell brooch to a client, she looked at it again and said to herself, "It's so fabulous, how elegant. That's my next piece!" She has a soft spot for brooches and does not go anywhere without one. "It can be on my waist, on my sleeve, on a skirt, on a jacket pocket," explains Mrs. B. "It just makes an outfit look different."

Every day she wears two gold bracelets on her right wrist. "I never know which one to wear," she says. "So a few years ago I decided, why not wear them both?" One has a bamboo design and the other has more of a wide link. "My husband bought them for me—he loves Henry Dunay, too," offers Mrs. B. She treasures the Praline Collection necklace named after an island in the Seychelles for its soft mood. The gold looks like it has been woven and the gallery inside is covered with hearts. "I get more compliments from men on that piece," she explains. "When they come to shop for their wives, they want that necklace."

Mrs. B.'s absolute favorite piece is her Henry Dunay pavé diamond dial gold bracelet-wide watch with a rectangular face in the Sabi finish. On the closure is a line of diamonds. "I cannot even express how it feels to put it on," she declares. "It's magic." Not only is it a work of art, it's durable. "My watch is so well made and so tightly sealed that I wash it in Mr. Clean and water and rub the hell out of it and it still runs," she explains. If anything happens to it, she can send it off to the Henry Dunay offices and in three weeks she'll get it back polished, with a new inside, looking absolutely exquisite. "Usually when you send an expensive watch for a battery to any other designer, it takes about three to six months to get it back," observes Mrs. B. That would be much too long to live without her cherished everyday timepiece. "It's wonderful," she says of the priceless watch. "It's become a part of me."

JANE MITCHELL When she was a child, Jane Mitchell went through her grandmother's jewelry box all the time. "It wasn't that she had fine things," she remembers. "It was about letting my imagination run free as I took out the pieces and was allowed to try them." As she matured, so did her passion for jewelry. One of her greatest joys was visiting the best jewelry stores in town while on business trips. "Every big city has one or two of the most established ones," she explains. "I'd make a point to see what was available."

ABOVE Diamonds cover this gold Sabi watch.

OPPOSITE Gold and diamonds add sparkling details to a South Sea pearl necklace and earrings.

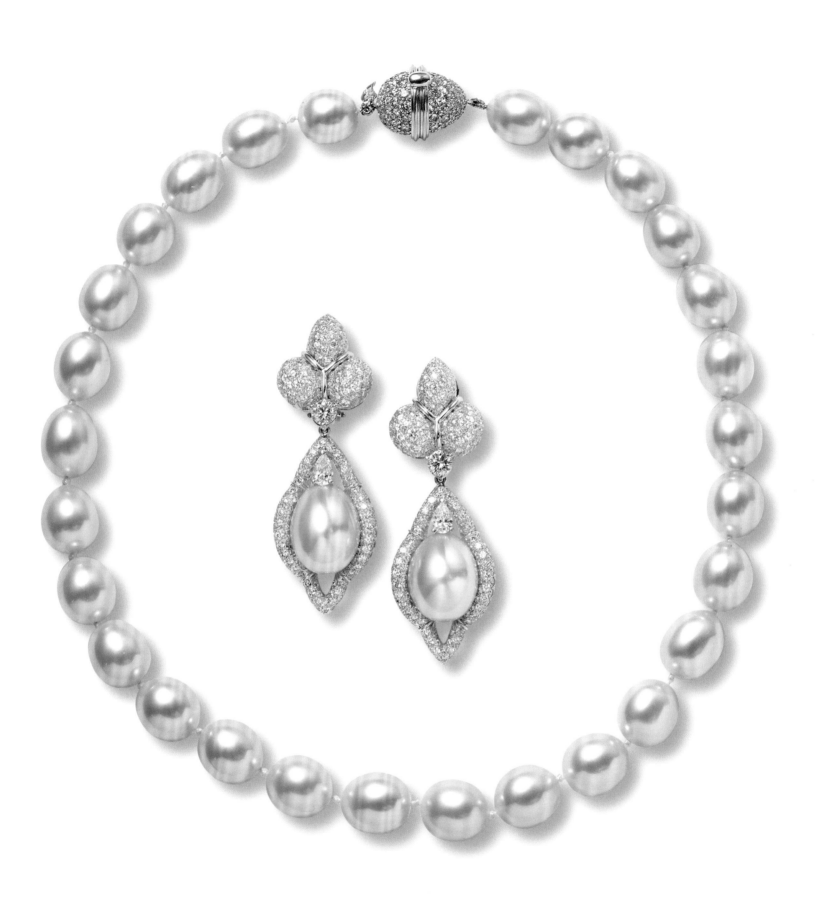

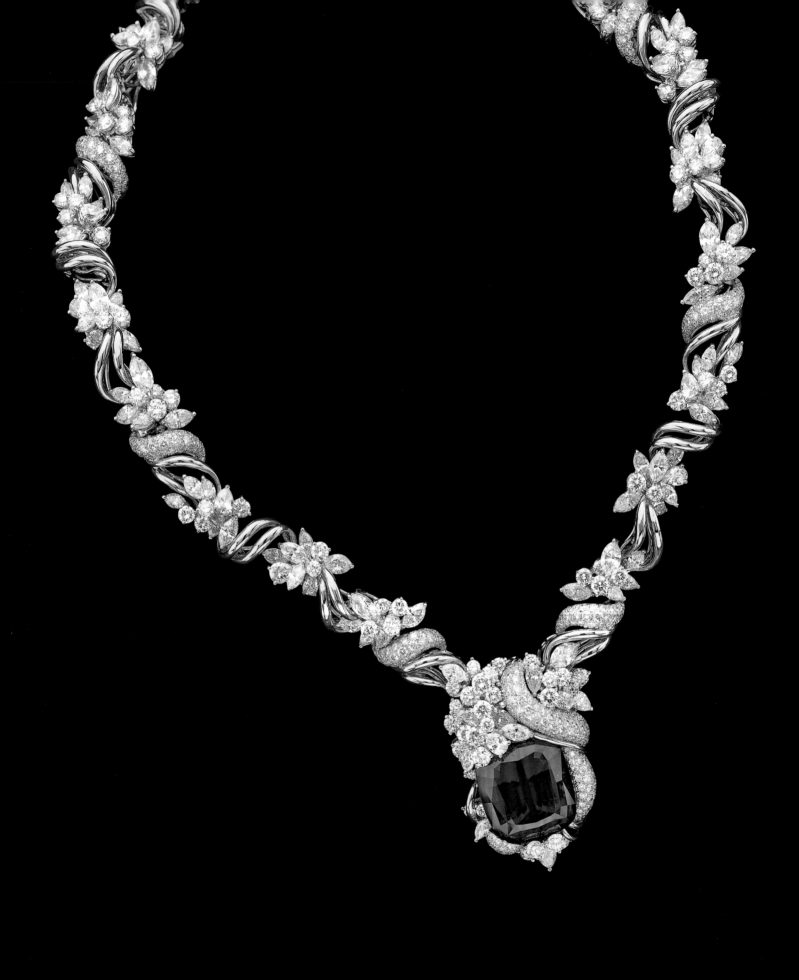

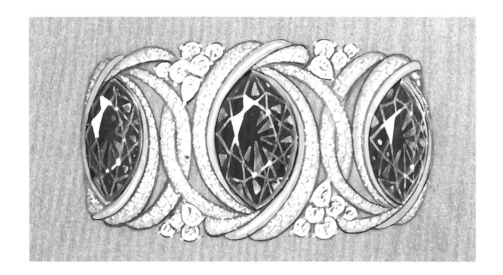

As she became more successful, Mitchell found that she was in a position to acquire better pieces. "I wanted to purchase wisely, have things that I could stay interested in and not discard after a few years," she says. The desire to become a lifelong student of jewelry and her devotion to the craft inspired her to earn her Graduate Gemologist (G.G.) degree at the famed Gemological Institute of America (GIA). "As I studied, I was more and more fascinated," she notes. Mitchell developed a clear sense of what she wanted. "I could always find a bigger diamond, but that was boring and not very original," observes Mitchell. "Anyone can make something that's huge and gaudy; it takes more sophistication to create something complex."

Then she discovered Henry Dunay.

Mitchell's interest was piqued when she read about the designer's work in magazines. "He was known for his gold finishes—he could hammer or brush or engrave to make the metal look more beautiful," she explains. Mitchell sought examples of his craftsmanship finding a jewelry store with a small display case filled with Dunay's work.

She immediately noticed his famous finishes, especially the "amazing" detail of the gold work. "The pieces were deeply engraved and I saw how he used platinum and gold together, which is so unusual," says Mitchell. "It's rare to find someone who makes pieces using the best material, has such original designs, and a unique artistic eye. To put that into one product is exceptional and very leading

OPPOSITE True Blue is the name Henry gave his ornate gold and diamond necklace with an extraordinary tanzanite pendant.

ABOVE Three marquise-shaped tanzanites add audacious color and original shapes to a drawing of a diamond and gold bracelet.

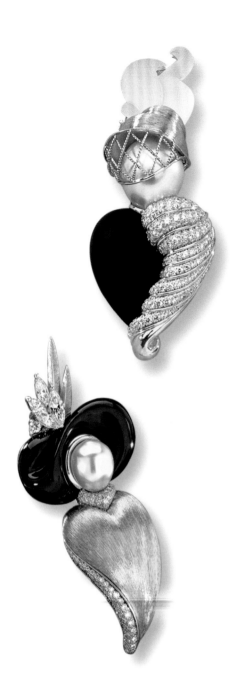

edge." Her first purchase was a pair of gold earrings in his Sabi finish. "I knew that was one of his trademark finishes," she says. "Every time I wear them, I think of how he developed something so special."

Several years later, she met Dunay at the watch and jewelry trade show in Basel, Switzerland. He was exhibiting the Women of the World collection of nearly a dozen pins of women from different cultures. Each lady was displayed in its own beautifully lit small wall case like a little picture window. "Every piece looked so different and yet they were all made from pearl, gold, and diamonds," remembers Mitchell. The Geisha pin was exquisite. Her face was fashioned from beautiful pearl, black onyx created her hair, you could make out the kimono, and she had diamond sticks coming out of her tresses that only a geisha would wear. The French lady sported a beret made out of a carved gemstone. The Persian one wore a beautifully carved thin veil made from the same material.

Mitchell was riveted. She wondered, "How could he put so many combinations together so I would automatically know this woman is French, this one's Japanese, here's the Persian one? What imagination is behind all of this?"

Mitchell spoke with Dunay about the series and remembered feeling overwhelmed. "I didn't want to act like a groupie but I was knocked out by how special the pins were," she says. Mitchell wanted all of them but she knew that she could afford no more than two. "It was a tough decision and I wasn't sure of the prices," explains Mitchell. "I felt that it was better not to ask that way I would pick the ones that most appealed to me." She found the contrast of the old-fashioned Japanese lady from the East with the "very perky looking" French one from the West delightful. "Those pieces help me remember the whole wonderful series," she offers.

The Basel experience was significant for Mitchell on many levels. It was uniquely gratifying to take those pins home. Simply looking at them gives her pleasure and an elegant sense of luxury. "His work makes me feel that I have something fine and rare made by someone who is exceptionally talented," she says. "At Basel, yes, you can find expensive, that's never a problem. What you don't get is the combination that Henry Dunay is able to put together." It was equally thrilling for her to meet the designer. "To hear about his work, what's behind the pins and his thoughts about them, gave the pieces a story," says Mitchell.

ABOVE The French Woman of the World brooch is dressed in black onyx, diamond, and gold. Her South Sea pearl face is covered in the diamond and gold veil of her crystal and gold chapeau.

CENTER The British Woman of the World brooch of gold, diamond, and pearl is dressed for a day at Ascot in a flamboyant black onyx hat with gold and diamond feathers.

A true Dunay devotee, Mitchell always relishes looking at his work, even if she does not buy it. "He makes things that I could never even dream of," she offers. She'll never forget his unusual ruby necklace. The rubies were not faceted in the classic style. Instead, they were large beads. "And I mean large!" remembers Mitchell. "Each one was about an inch and a half long, almost like small logs that were half round." It was solid rubies, one after another set in gold. "It stuck in my mind, who else would use such large rubies, polish them, cut them to match and put them together in such a bold necklace? It belongs on the neck of a queen."

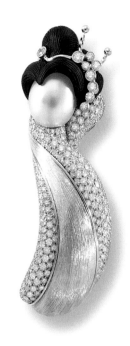

Mitchell believes that Dunay brings a broader picture of jewelry to the public. "People would never know that some of these stones existed in the world if he wasn't making them into beautiful pieces of jewelry," she observes. She remembers a piece of amber that he used. It was giant, the size of a marshmallow and absolutely clear with no marks whatsoever. "Most people have never laid eyes on something like that. I hadn't," says Mitchell. "He's confident enough that he will take whatever appeals to him—where he sees beauty—and will enrich it so it's absolutely stunning."

When Mitchell was ready to have Dunay create a piece for her, she wanted it made from green beryl. She knew that the designer would understand. "It was my one chance to do something extremely special," she says. "Green beryl is in the same family as the emerald. It only lacks one particular little chemical and it's absolutely crystal clear—which I love."

Dunay made a cityscape brooch adorned with tiny, intricate towers, doorways, and windows. Mitchell didn't want to interfere with the specific design. "I would be limiting him if I asked him to make me something specific like a butterfly," she offers. "The stone was going to bring out the inspiration in him. That's what his designs are all about."

Mitchell remembers when she first received the brooch. "It's my masterpiece from Henry," she explains. "I looked at it and thought these fine stones and gold will last a long, long time. They will outlive all of us and will always be protected and cared for—beyond my life, beyond Henry's life, because they're so beautiful. He's a lucky man to create immortality in his pieces. They can't disappear. They're too important."

ABOVE The Geisha Woman of the World brooch made of gold, diamond, and pearl has a sinuous line to her body. Her perfect black onyx hair is arranged with diamond ornaments.

RIGHT Mrs. Mitchell's 70-carat beryl makes verdant ground for her gold, diamond, and platinum Moravian Highlands brooch.

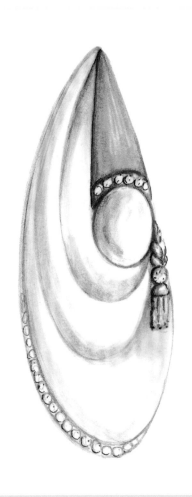

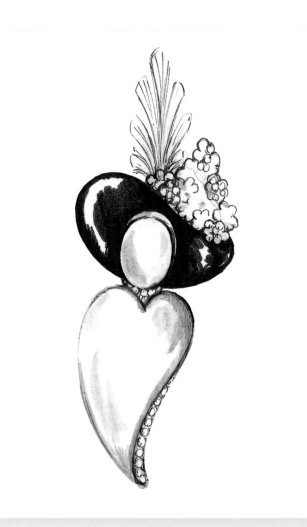

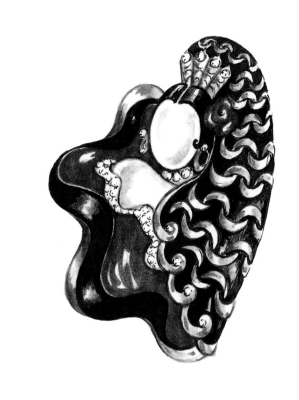

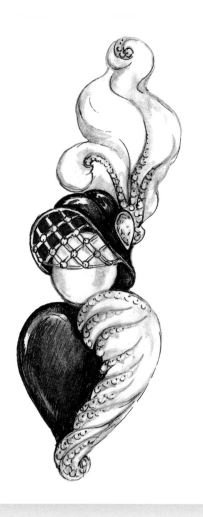

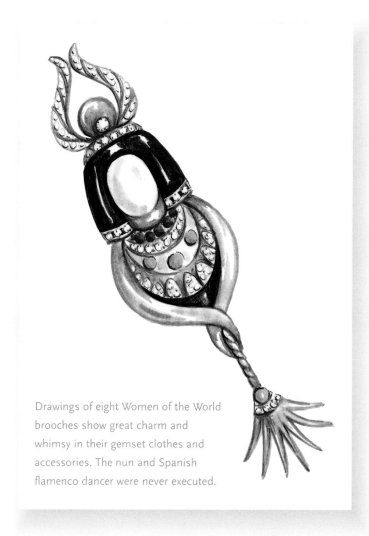

Drawings of eight Women of the World brooches show great charm and whimsy in their gemset clothes and accessories. The nun and Spanish flamenco dancer were never executed.

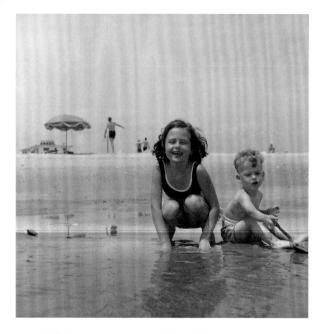

Design for Living

Interviews with Paul Dunay and Valerie Corvin *By Jeryl Brunner*

ASK HENRY DUNAY'S CHILDREN, Valerie Corvin and Paul Dunay, if they ever considered joining their father on the workbench and the answer is a resounding "no." "He's hard to compete with. I didn't want to touch that," says Corvin. "It's tough at his level to go beyond what he did," adds Dunay, "So I had to find my own sandbox." While both children excelled in their own proverbial sandboxes, (Corvin in painting and Dunay in marketing), they each credit their father with giving them certain tools to thrive. It's still such a thrill when they witness all his success. Corvin gets a special joy when her daughter sees a magazine and says, "There's Grandpa's jewelry." She still remembers when her father came to Neiman Marcus where she lives in California to talk about his work. "To me, he's my dad, but people were so impressed and my friends are still talking about that event," she offers. They're in awe of their father's deep-rooted and lifelong passion for his craft and his unwavering devotion to push the limits of his profession. "He taught

PREVIOUS Henry's children, Valerie and Paul, play on the Jersey shore.

ABOVE Henry's children, Valerie and Paul, enjoy a fall day in New Jersey.

me a lot about creativity and about breaking the mold," says Paul Dunay. "My father always found a way to differentiate himself." Life in the Dunay household was a celebration of art, culture, travel, and great food. It was also about working hard for the business, which was truly a family affair. Everyone pitched in, and ultimately, they saw the rewards. "I see my father as the Picasso of jewelry," explains Paul Dunay. "He lives and breathes this craft, and created a niche for himself—he's the American dream."

PAUL DUNAY "At eight years old I learned what the Henry Dunay brand was all about," says Paul Dunay. All it took was a beautifully crafted rust colored double-breasted suit with gold buttons.

"My dad was helping me with my tie and I was very proud of my rust colored suit," recalls the younger Dunay. "He said to me, 'the guy who made your suit is named Pierre Cardin. I want to be the Pierre Cardin of the jewelry industry.'" From that point on, he understood his father's quest to push the limits of what stones and metal could do and be truly distinctive. "My father dreamed to become a great American jewelry designer," explains Paul.

For as long as he can remember, Paul helped nurture that dream by working in the family business in some capacity on weekends and during Christmas. "My first job was delivering jewelry when I was eight or nine," he recalls. In fact, years later from time to time, he was still delivering. At the 24 Karat Club dinner in Dallas, not only did he host a table at the gala, he also dispensed some pieces to clients during the event. "It was a black-tie affair and I had all this jewelry in my tux," remembers Paul.

Then there were the shows. "I got arrested at the New York Jewelry Show at twelve years old," Paul recalls. Although you had to be thirteen to be on the floor, he had been working them for years. While his dad was upstairs in a suite holding a meeting, young Paul was downstairs surveying wares from other designers. A policeman stopped him to ask his age. "I couldn't tell a lie so I said twelve, and he replied 'that's the wrong answer.'" When his father came to get him at the station, he offered, "Don't worry. Next year you'll be thirteen."

HENRY DUNAY'S PASSION for his craft permeated the family's everyday life. Early on, Paul remembers his father spending hours in his home "studio" in the basement, literally under the stairs. It was actually a small cubbyhole with a sliding door and a bench. Henry would either design or fabricate in metal and experiment away. "It was sort of mad scientist kind of stuff and he'd work until one A.M., which to a kid was unbelievably late," remembers Paul. The family would sit around the TV preparing direct mailers. "We'd be watching *The Brady Bunch* and my hands were stuffing and my tongue was licking envelopes that we were putting in the mail to five hundred people to get an appointment," offers Paul. In fact, he credits the experience as priceless in his current career as a branding marketing and advertising executive. "The reason I have any sort of taste level is that I come from that background," he explains. "I know grass-roots guerrilla marketing. That's what my dad used to do."

Henry's marketing genius emerged at home and on the road. For Paul, there was nothing better than joining his dad on business trips as early as twelve years old. "My dad worked all the time, and if I wanted to really spend time with him, I

ABOVE Paul and Henry take a break from a road trip to enjoy dinner.

OPPOSITE The gold owl brooch has wise emerald eyes.

would go on the road with him," he offers. The duo visited Vegas, Dallas, Cleveland, Boston, Florida, and countless other locales. "Those were the best of times," he remembers. "We were from small means and had to be careful what we were spending, but a Caesar salad and a beer with your father at twelve was a very, very cool thing." The pair developed a ritual. "My dad would take a big bag filled with samples and would say 'we're going to have some appointments and find some new accounts,'" notes Paul. They would hop on a plane, usually arrive in town by nighttime, and walk the avenue where all the high-end stores were. They'd go up and down the street, looking into shop windows until they could say, "This place looks right." Then they return the next morning asking to meet the buyer. "Sometimes we'd get thrown out on our ears and sometimes my dad would show the line and get people interested," says Paul.

The great challenge was convincing the stores that Dunay's spectacular square peg designs could easily fit in among the round holes. "They had what I like to describe as the red, white, blue, and green case. They didn't have a designer jewelry section," recalls Paul. "So their question to him was: 'which case does your stuff go in?' Well, it doesn't go in any of them. We want you to show it in its own case!" That was unheard of. Henry would say, "I want you to buy my pieces. I'll give you all the forms and the color. I want it to be shown on black. I'll support it and do advertising."

HENRY WOULD NOT WAVER. As Paul explains, even when he was very young and starting his business, he found a way to differentiate himself setting baguettes (it was also more lucrative work and paid $1.50 a stone). "No one could set them—but everyone could set a round stone. It was undifferentiating," observes Paul. "But if you wanted to make sushi, you needed a Dunay." It was unheard of to design pieces, as Henry did, which integrated wood with metal. When he began working with black pearl, the initial response was, "What is that? Why would I want a black pearl?" Then there were the esoteric stones, like tanzanite. "How many people have ever heard of Padparadscha sapphire?" asks Paul. "He was working with esoteric materials that only now people are saying, I can spell iridium." Or consider his inimitable use of coral. "I'm not saying that no one

used coral before Henry Dunay," he says. "They just didn't do it in the way he did it."

Selling to Neiman Marcus was not just a breakthrough for Henry, but for the entire family. "It was a huge moment in our collective lives," offers Paul. As he remembers his father making that famous trip when he was in high school, he still gets choked up. "He basically said 'I'm not leaving until you buy from me' and Dudley Ramsden finally agreed to give my father a shot," says Paul. "It seemed like it took forever for him to get home, but we knew he finally cracked the code." The family celebrated with a great meal and toasted Henry's major accomplishment. "We didn't talk about the money aspect of it," recalls Paul. "We just knew Dad had a major win, which was a significant life-changing event."

IN 1985, WHEN HE GRADUATED FROM COLLEGE where he was a business major, Paul joined his father's firm. He remembers Henry describing his inventory method: they'd take a $300,000 necklace, put it in a mailing box, walk it around to different jewelers and then write the transaction an index card, "I said, 'it's 1985—did you ever hear of IBM!'" says Paul. So he transformed the office from a manual operation where most of the records were logged with index cards to an advanced digital one with advanced accounting systems in place. The business further grew by leaps and bounds. Paul also ran production and instituted the concept of forecasting their best sellers noting if they sold twenty-five of one item last year, they could sell fifty of them the following year.

But did the son ever contemplate a design career like his father? "I'm creative in the marketing sense but I don't believe that I'm creative in the jewelry sense," he explains. "I did try a few things and my father would say, 'I see that was your inspiration but all these other things that you put around it are just like step-children. You have to really break the mold and try for twelve inspirations.'" Every element had to be key to the piece. The experience of showing his father his work was a bit frightening. "Not that he would be extremely critical," says Paul, "but it's like showing the Ten Commandments to God and saying, 'What do you think?' and he says, 'I said eleven commandments, not ten.'" However,

he's proud of the necklace pendant he made for his wife. The piece includes two hearts bumping up against each other and snuggling.

One of Paul Dunay's most treasured pieces is a ring his father made for him was when he graduated from high school. It resembled a portion or cross section of a tree with a carved D, the same D in the Dunay logo. Henry had a similar ring, so for Paul it was like "our ring." He offers, "he talked about taking the D out and replacing it with some diamonds and I said, 'No, no, no. Don't take it out. I like the D.'"

Paul relishes seeing his father gain inspiration for his designs. Much of it comes from the ocean—especially from his father's scuba diving adventures. But it's not about just recreating a shell, "which may not be as good as mother nature, especially in metal—because mother nature is pretty damn good," notes Paul. "It's more about creating textures—like the feel of coral—how to replicate that in metal or capture the movement of it."

Nature-orientated design patterns are extremely complex to make. The castor would say, "these bumps are too high or this pattern is not ever going to work. But Henry would reply, "Just make it work and we'll figure out how to make it work on the back end." As Paul notes, "Metal has its limitations but during the twelve years that I worked with him, he always pushed the envelope." Henry always considered the customer who wanted something new, their conversation piece. "They were differentiating themselves and he was differentiating himself with metals, stones, and diamonds," offers Paul. "He understood that his customer wanted to be able to say, 'I'm the only person in Boca Raton or in Los Angeles that has this particular piece.'"

TWELVE YEARS AFTER WORKING IN THE FAMILY BUSINESS and helping it thrive, Paul, was ready to move on. "I just ran out of places to go and needed to broaden my horizons somewhere else," he says. It was a scary time but Paul knew that his father gave him the tools to move forward and prosper. "He gave me that stick-to-itiveness—that damn the torpedoes, full speed ahead, we're-going-to-make-this-thing-work kind of fire in my belly which I am hopefully transferring to my children," he offers. The education he gleaned from his father

OPPOSITE Father-and-son gold rings: Paul's has a polished gold D. Henry's sparkles with a diamond H.

ABOVE Three gold inchworm brooches have diamond treads.

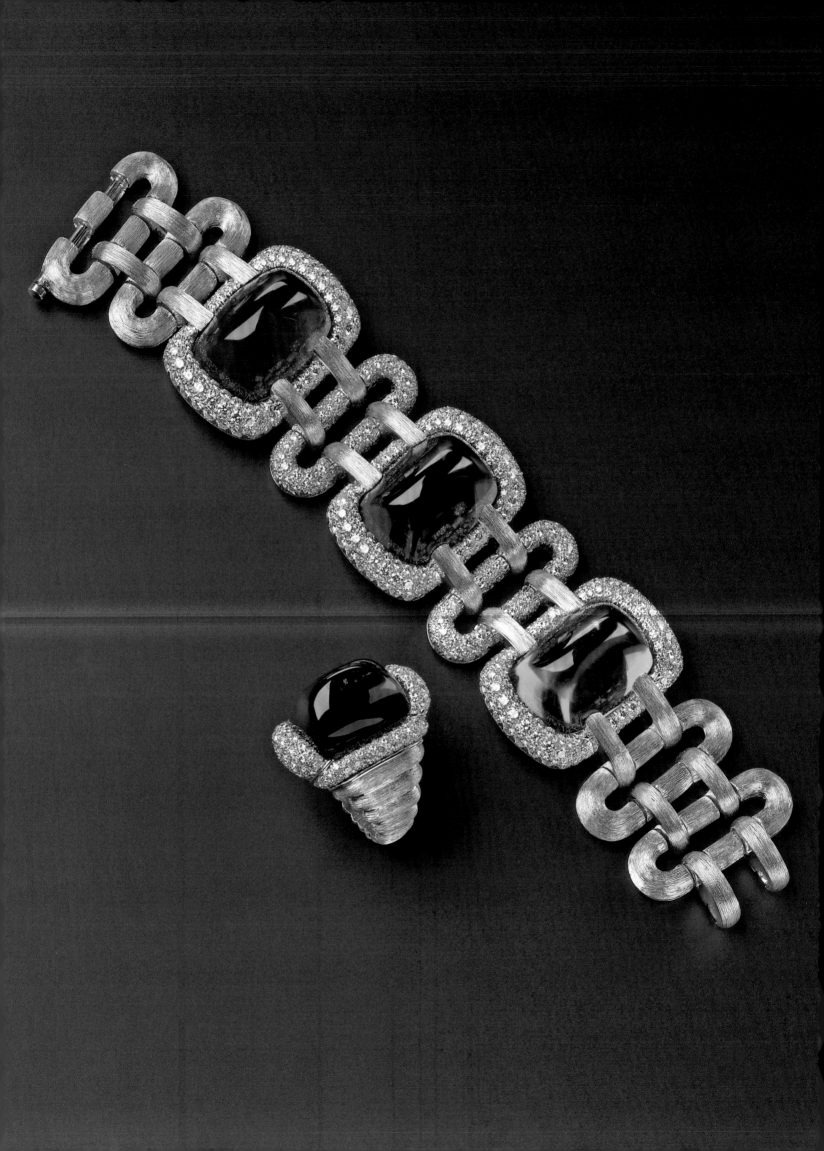

was priceless. "I learned a lot about creativity, about making new markets, breaking the mold, and about new ways to push the limits of things." He'd like to think that his father also learned from him—about computer science, financing, funding, and forecasting.

Ask Paul about the role that his father has played in his life and he'll tell you, "He's been my boss, consigliore, confidant, and best man at my wedding." Then there's the straight dad role and grandfather role with his two boys, who are eleven and seven. Not only do the children treasure going to Yankee games with grandpa, bliss is visiting his office. "He'll give them a sample of a chipped stone, but it's emerald or ruby," says Paul. "When they were young, I made my sons a small plastic box and it contained spodumine, diamond, tourmaline, rhodochrosite, and other obscure gorgeous stones from grandpa's junk pile. They could passionately identify all those stones." In fact, for one of their birthdays the family visited the garnet mines in Connecticut to mine real garnets out of rock, pulling them out with their bare hands. "They loved it and I had grandpa polish a couple of the stones," says Paul.

One time, when Paul's eldest son was just four, Henry was visiting and playing cash register with the boy. "My dad grabbed something from the shelf and said, 'How much is this? I'd like to buy it.' And my son said, 'That will be four thousand dollars,' and my dad said, 'What! Four thousand dollars!' Without missing a heartbeat, my son said, 'I'm sorry Grandpa, I only sell expensive things in my store,'" remembers Paul. "The punch line is that's what I do, too."

But no matter how much success Henry Dunay has achieved, some family rituals that they practiced in the leaner years remain sacred. For example, take Christmas Eve. When Paul was a boy, after they closed the shop, father and son would walk down Fifth Avenue to the post office across from Madison Square Garden to send off the mailers. "My father would always turn to me and say, 'Now we're going to go to Bruno's,' which was an Italian salumeria near Port Authority," recalls Paul. Henry would buy out the place, bringing home bags filled with cheese wheels, prosciutto, and sopressata. "To this day," says Paul, "we still sit down and celebrate over Italian delicacies—that will always be the start of Christmas."

OPPOSITE A trio of high cabochons—rubelite, tanzanite and peridot—decorate a diamond and gold Sabi bracelet. A high cabochon tanzanite towers over a diamond and gold Sabi ring.

ABOVE A golden Toucan brooch with a diamond eye holds a gem in its beak.

VALERIE CORVIN For Henry Dunay, a seashell isn't merely a seashell. It's a revelation. A muse! So it was during their visits to the beach that Valerie Corvin gained great insight into her father's design inspiration. "He'll show me the curve of a seashell, or a wave—there's something about those things that he relates to from within," she explains. "He takes in nature not only with his eyes but with his heart and he has to touch and feel it for it to register." When she was a child, the family had a house on Long Beach Island on the Jersey shore and Valerie remembers their long walks along the water and how her father would spot shells and give them to her. "I have collections that I've picked up with him over the years," she says.

It continues to amaze Valerie how her father's antennae guides him to the most spectacular objects, when most people wouldn't notice them. During a recent trip to the Caribbean, the family went diving together. While exploring a shipwreck, Henry spotted a seashell from out of nowhere hidden in the bottom of the ocean and dove down to retrieve it. "It was gorgeous, perfect, and I couldn't imagine that it could possibly come from nature," recalls Valerie of the brown and white lemon-sized shell. He brushed it all off and gave the treasure to her son. Everyone was

ABOVE Valerie and Henry
celebrate the holidays together.

so smitten, he had to find shells for the rest of family because they all wanted one.

All those organic curves and lines find their way into Henry's work. "It's not mechanical," says Valerie. "Everything that my father designs comes from a deep inner place, from his soul." Even the way he mounts stones in a certain formation reflect things that he's seen somewhere and stored away in the back of his brain. She remembers engaging herself in the process when she was a little girl. She found pinecones and shells for him she placed in his office.

What also intrigues Valerie is how her father gives birth to the jewelry. "I'm fascinated how he assembles the pieces," she says. "I've seen them come to life from something very raw." She remembers how her father's rough pen drawings and sketches came to exist like a butterfly morphing from a caterpillar. "It's so interesting seeing pieces modeled, molded, dirty and unpolished and then watching the diamonds go into them," she says.

One particular piece that continues to intrigue her is the Liberation necklace, for which Henry won the 1982 Diamonds International Award. The elaborate gold masterpiece made with wires extending in all directions is covered with

ABOVE Henry, Carol, Paul, and Valerie relax near their house on the Jersey shore.

RIGHT A starfish brooch glistens in gold.

diamonds. It artfully loops around the neck and hangs down one side of the chest and can even transform into a marvelous, elaborate headband or tiara. "It's absolutely gorgeous and it's beautiful enough to wear any old way," says Valerie. "I always remember the photograph of it on the wall in his office."

Valerie agrees with her brother that the business was always paramount in their lives. Although her father always worked in jewelry, it wasn't until she was about three that he started designing. It took years of hard work to get momentum and exposure and everyone chipped in. "I was aware that things were financially difficult," she explains. "The jewelry market was volatile and I remember when I was ten or eleven when the price of gold took a big dip and my dad was really worried about that." Valerie assisted with marketing—cutting and assembling flyers, photos, and mailers and stuffing envelopes. She also helped man the booth at the jewelry shows in New York. "During summers, I remember sitting in my father's hot, un-air-conditioned office in New York," she sighs. In fact, when she was sixteen and seventeen and her parents traveled on business, Valerie ran the office until she went back to school. "It was a small operation," she recalls. "I'd go in every day, open up, and my dad would call and say, 'Find this piece and send it here and go deliver that to the polisher.'"

On weekends the family cherished going to museums or the ballet. "We were more into cultural events than we were into sporting ones," remembers Valerie. "We'd see what was listed in *The New York Times* and say, 'Let's do that.'" They particularly enjoyed the Egyptian, Roman, and Greek antiquities at the Metropolitan Museum of Art. Henry had such reverence for the forms and textures of the pieces and why they endured so long. In fact, both of her parents painted and in their house was a big wall with all their art. Valerie herself developed a great passion for drawing and painting in a high school after studying art history with a spectacular teacher. Yet she found the wall intimidating because she thought that she was destined to have natural talent when she picked up paintbrush or pencil. "It took me a while to understand that I had to keep working on this to develop it myself," she recalls. "I was so in awe of my dad and his jewelry and his design ability that I thought I was supposed to be this prodigy, but I realized that he had to work at it, too."

ABOVE A turquoise, diamond, and gold pin give a little vignette of Anguilla.

OPPOSITE A gold shell brooch unfurls in graceful whorls.

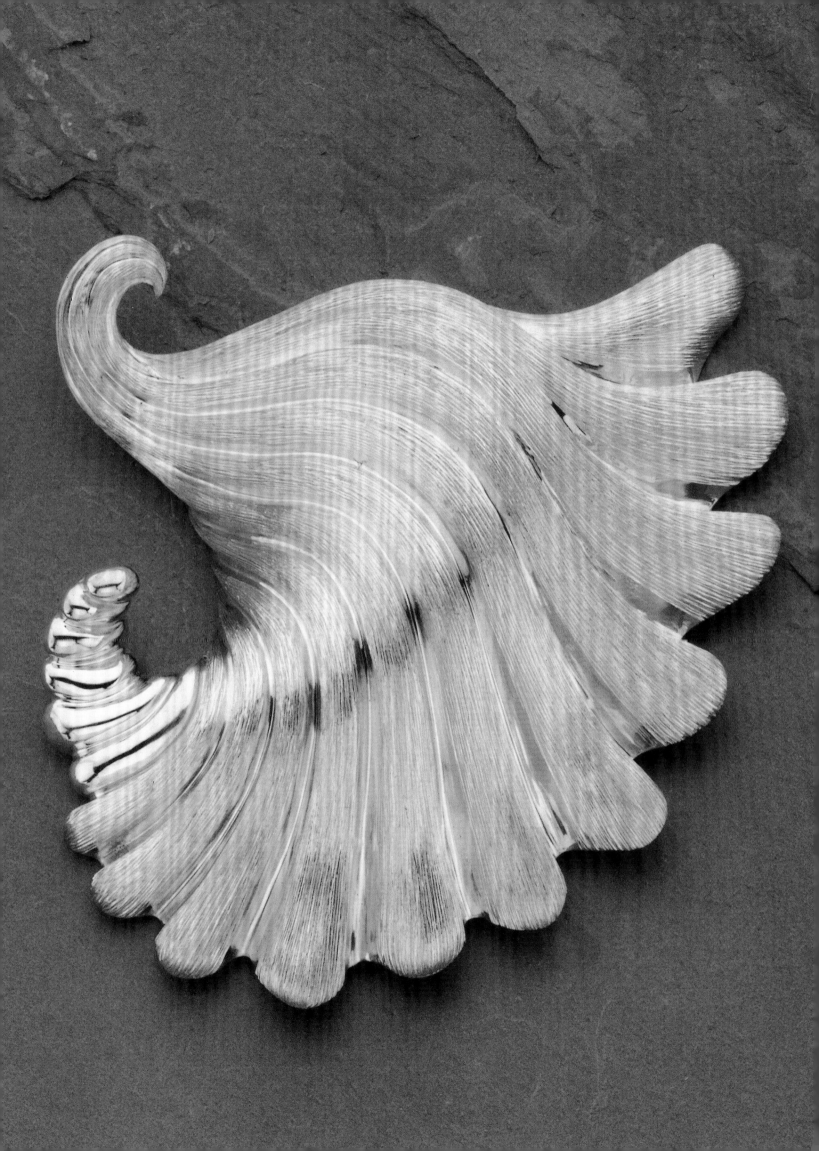

Valerie, who lives with her husband and three children in California, continues to work with oils. She is mostly drawn to still lifes. Like her father whose work is so tied to nature, she is inspired by the California landscape. No doubt Henry genetically passed his eye for finding magic in smaller details and physical beauty to his daughter. In middle and high school, her zeal for nature led Valerie to become a keen equestrian and she competed in horse shows. She fondly recalls how her father was so supportive of her riding. "It wasn't that he liked horses, but he knew that I loved them and wanted me to go for it," says Valerie. She remembers the thirty-minute drive the two of them made each way to the barn for her lessons. "That's something I'll always treasure," she recalls. "We had all kinds of wonderful discussions about everything."

Now her children treasure time with their grandpa. "My kids adore him," says Valerie of her seventeen-year-old daughter and eleven-year-old twin boy and girl. "They're fascinated by him and feel he's larger than life." Indeed, grandpa is full of fun. He'll do exotic things like go scuba diving in Anguilla, hunt for shells and come home with bags full of them. "Or they love just hanging out, jumping on him, and dunking him in the water. He loves to tickle," she laughs. When they were born, each child received one of Henry's beautifully crafted and etched eggs from the Jeweled Egg collection. Over the years he has given them various pieces, like a little necklace with a star pendant with a diamond that he gave to Valerie's youngest daughter, his little star. Her older daughter has a bracelet with charms he designed to reflect things she loved. To celebrate her two adorable cats who loved to sleep together, he created a charm of a pair of little felines cuddled up together.

As proud as she is of her father's ability to make such unique and magnificent jewels, Valerie is in awe of her father's intrepid persistence. "He is in his seventies and he's not slowing down," she observes. "The daughter in me says, 'Hello, Dad. Stop and smell the roses a little bit more.'" But chances are that he will always be designing and creating so much beauty. "I don't think he could face retirement," says Valerie. "Oh, God no."

ABOVE A rough piece of turquoise is the water in the gold and diamond Fish Pin.

OPPOSITE Family beach vacations inspired gold shell jewelry.

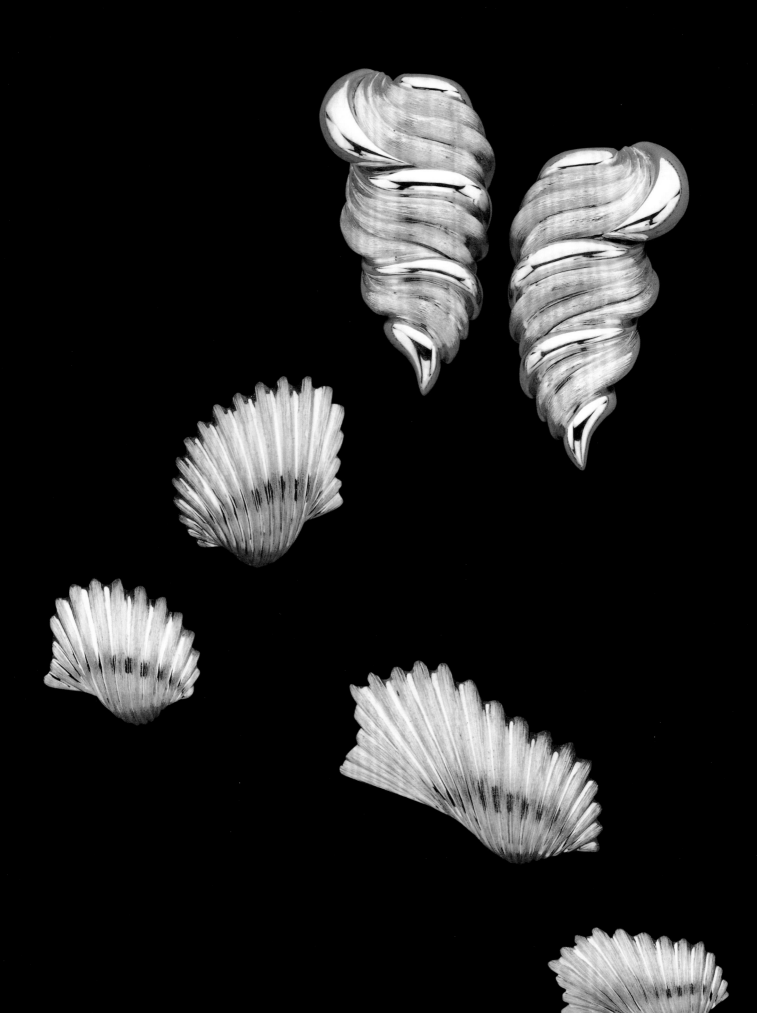

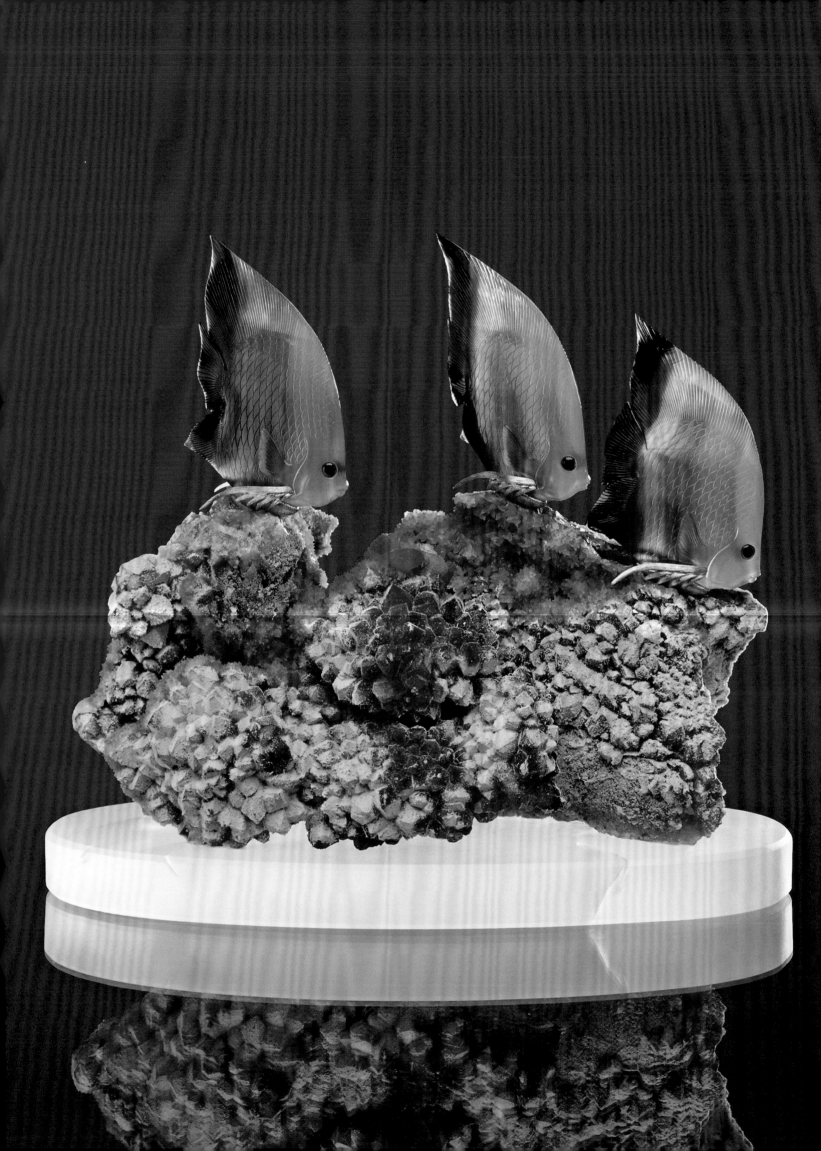

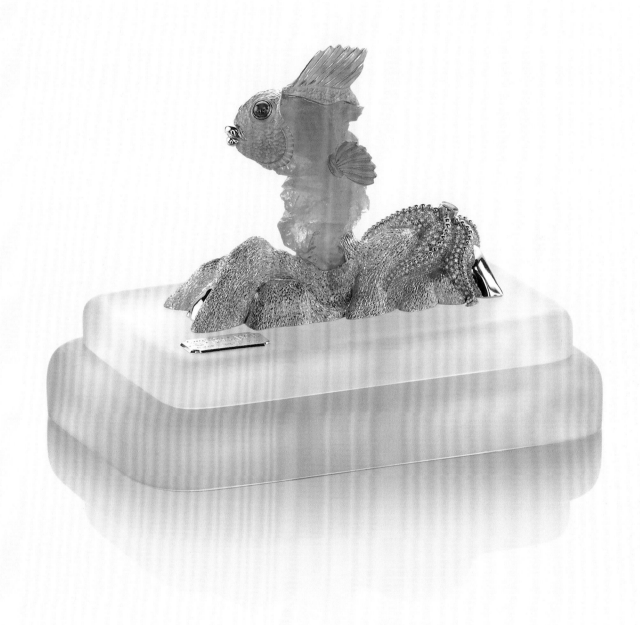

OPPOSITE Three agate fish swim
along mineral rocks in Lazy
Afternoon.

ABOVE A rough piece of aquamarine
becomes the body of the gold Lone
Blue Angel with emerald eyes
swimming on a quartz base.

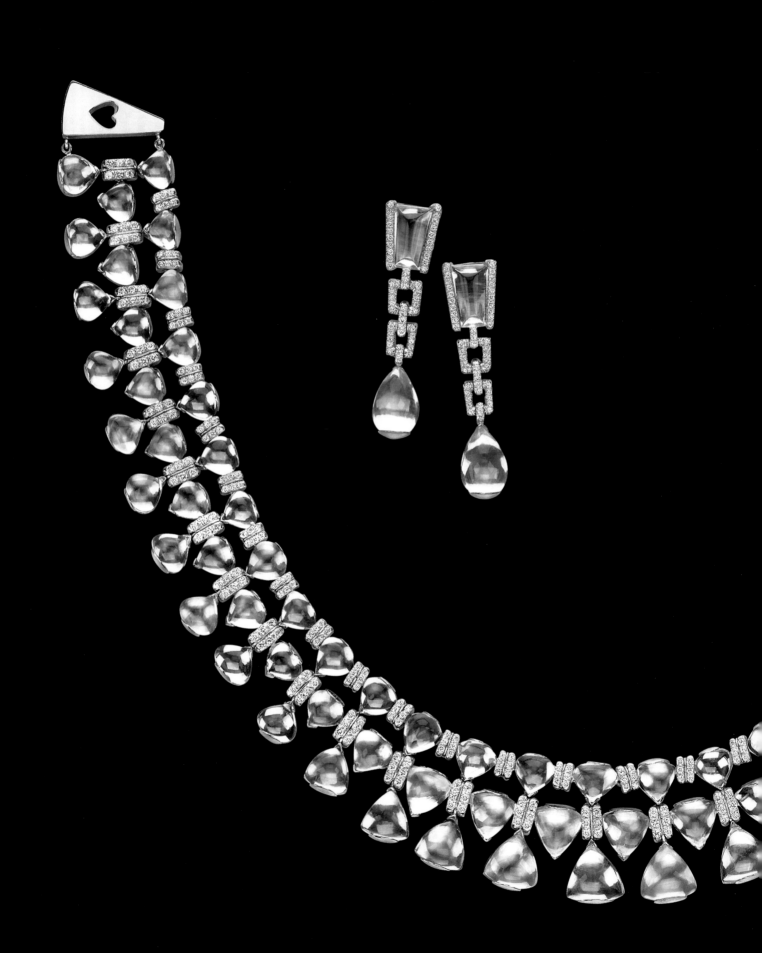

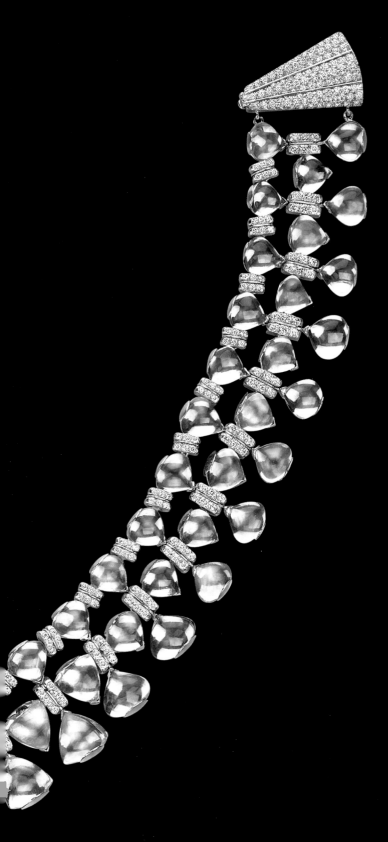

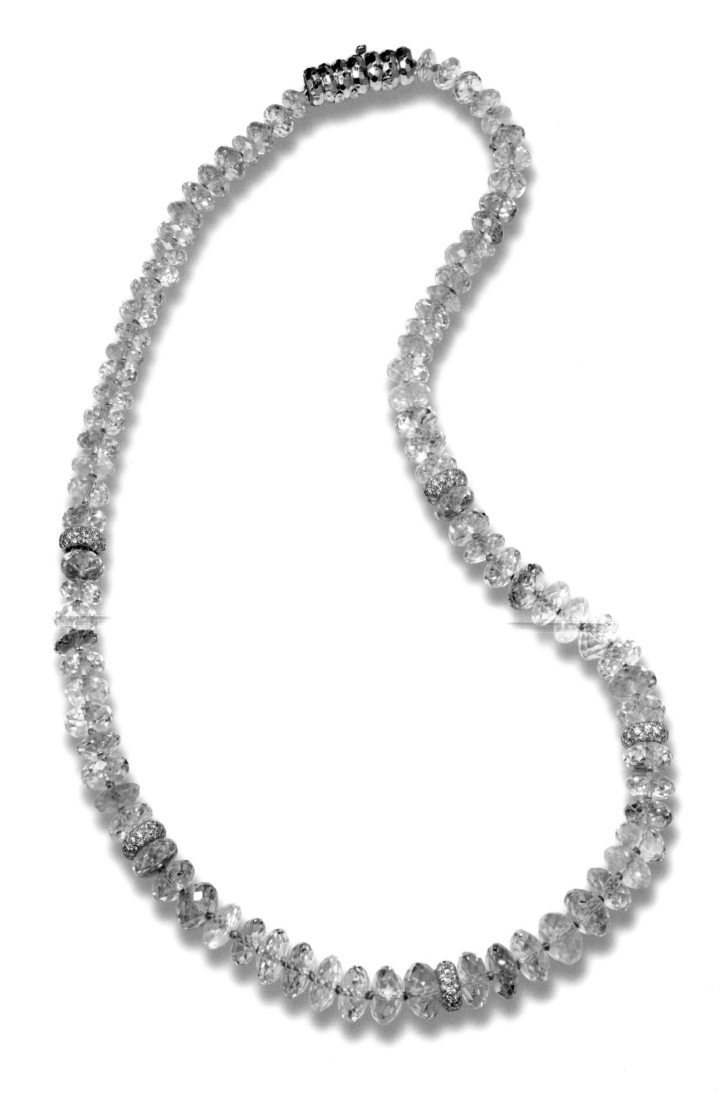

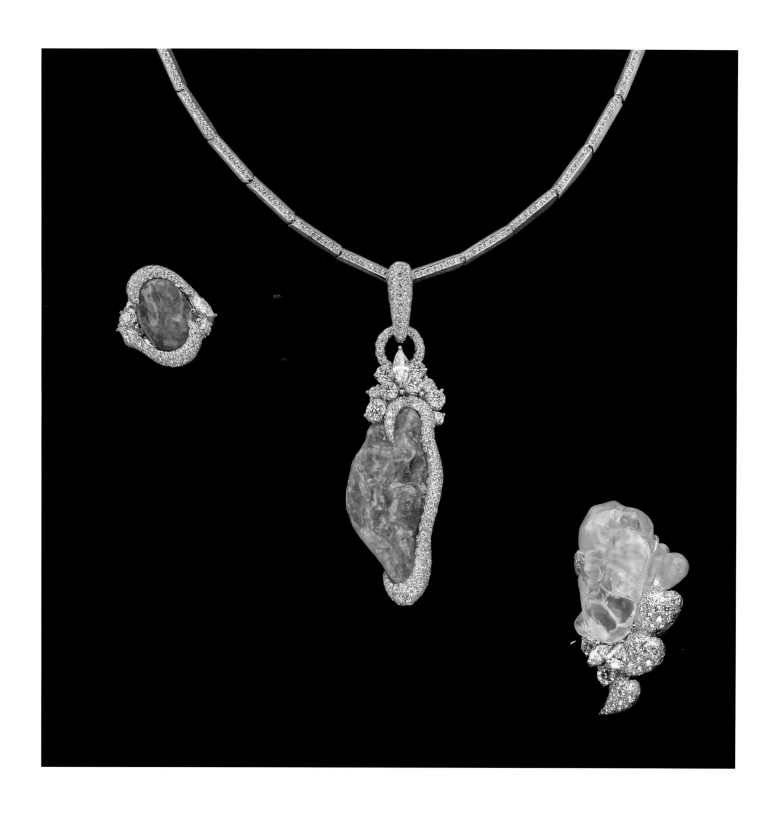

PREVIOUS Moonstones shimmer in a diamond and platinum bib necklace and earrings.

OPPOSITE A simply stunning beryl necklace shows the variety of color possible in the semi-precious gem. Diamonds and platinum accent the clasp.

ABOVE Black opals produce a rainbow on a diamond and gold necklace and ring. Lower right, a jelly opal in a diamond and gold brooch inspired Henry to name it the Light of Love.

ABOVE The fall colors of a black opal in the trunk of a diamond and gold tree brooch prompted the name Autumn.

OPPOSITE Three styles of bonsai tree cultivation appear in this trio of diamond and gold brooches: Moyogi (top), Kenagi (middle), and Shidare (bottom). Moyogi emphasizes a curvaceous and sturdy trunk. Kenagi reveals the beauty of a bending branch. Shidare exudes a contemplative mood.

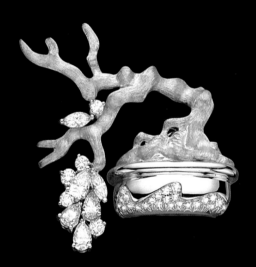

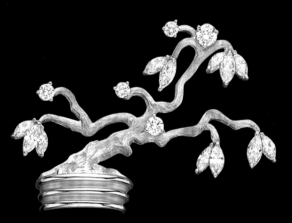

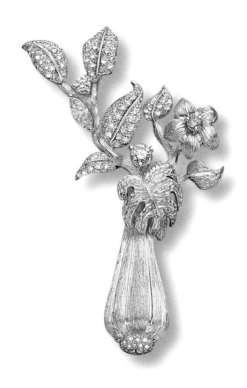

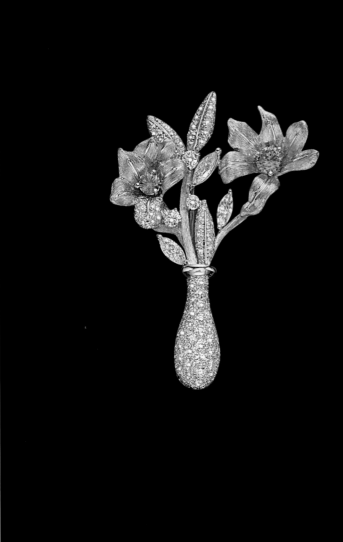

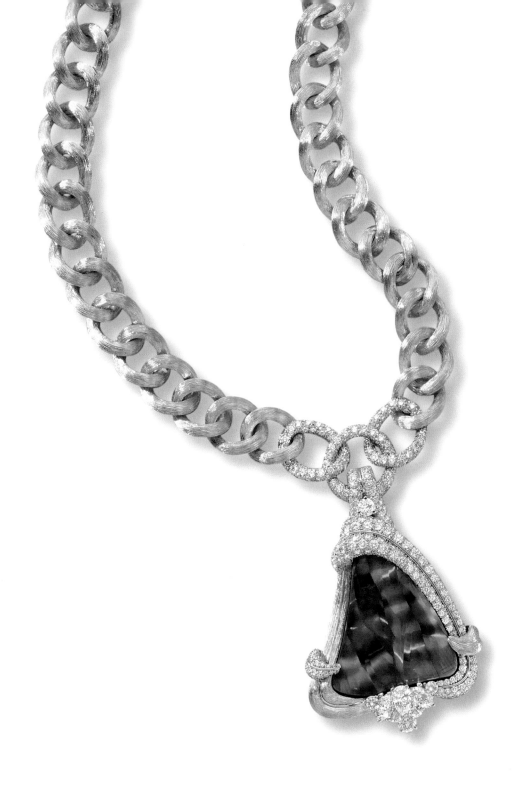

OPPOSITE, CLOCKWISE FROM TOP LEFT A diamond and gold flower rises from a beryl flowerpot in the Sunshine brooch. A gold brooch of an Amaryllis has diamond flowers and leaves. Orange diamonds highlight the stigma of another Amaryllis gold brooch. A King's Cup also has diamond flowers and leaves.

ABOVE A black opal and diamond pendant glimmers mysteriously at the end of gold and diamond Sabi necklace.

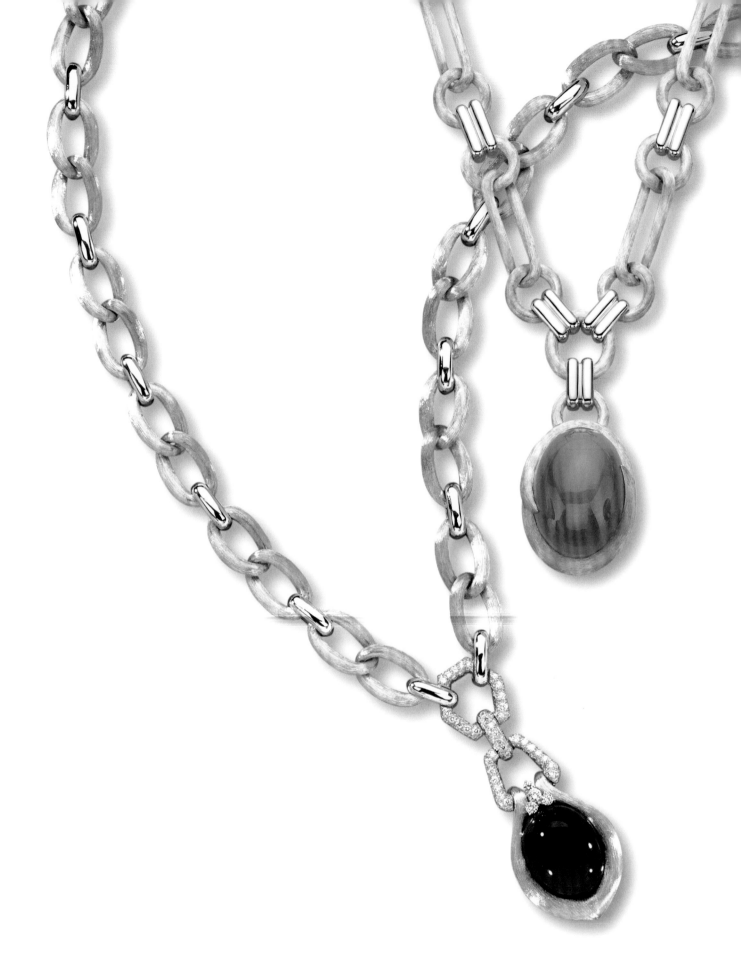

An amethyst, a peach
moonstone, and a morganite
make pretty pendants on the
end of shiny and matte gold
Sabi chainlink necklaces.

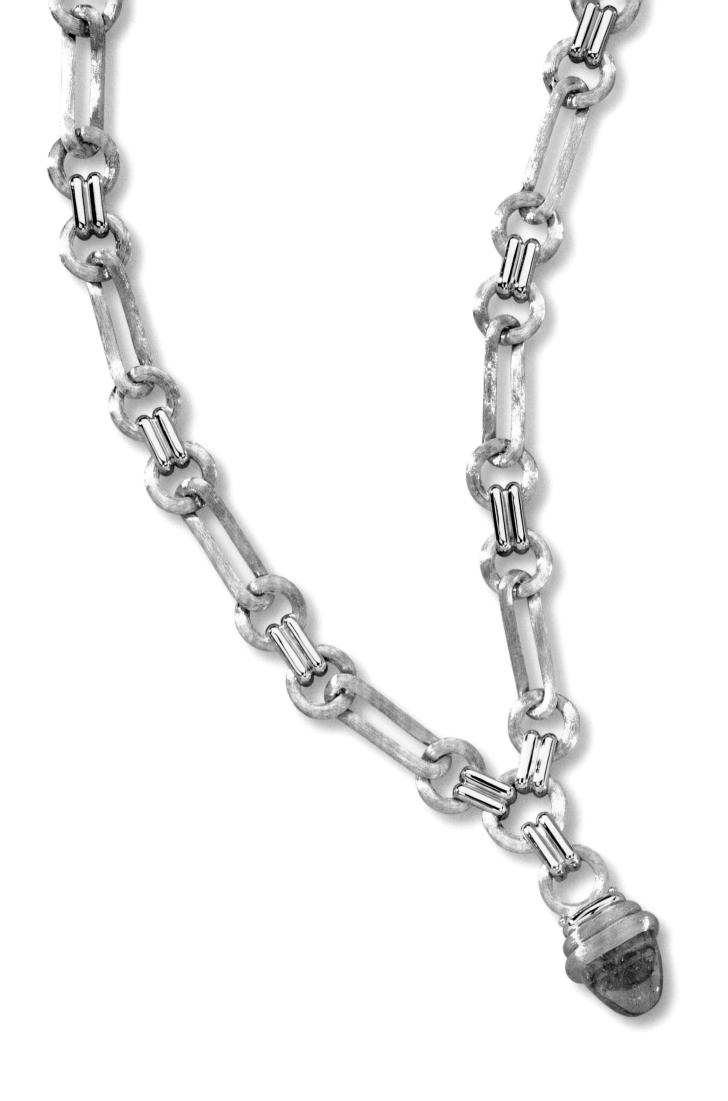

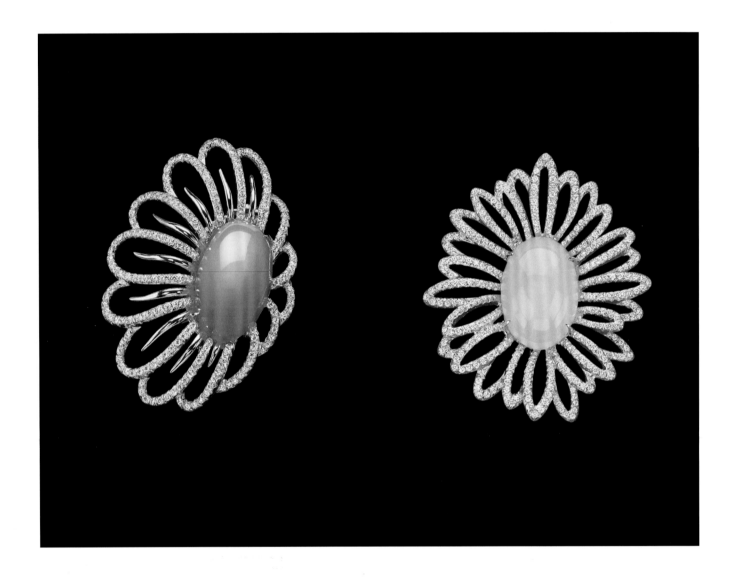

ABOVE The petals of the flower are turned to meet the rays of the morning sun in Bashful, a peach moonstone, diamond, and gold brooch (left). Vanilla moonstone, diamonds, and gold make up the Frozen Rain brooch (right).

OPPOSITE A variety of moonstones—white, olive, peach, and spearmint—make Henry's gold and diamond jewelry dreamy.

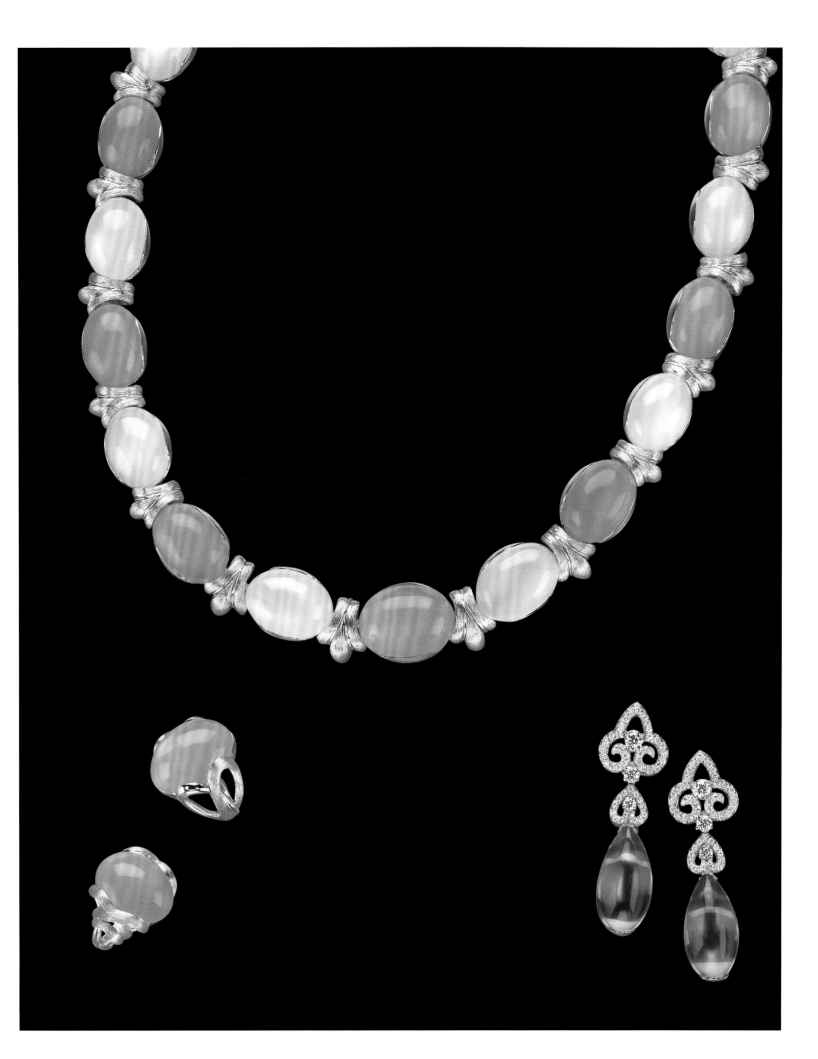

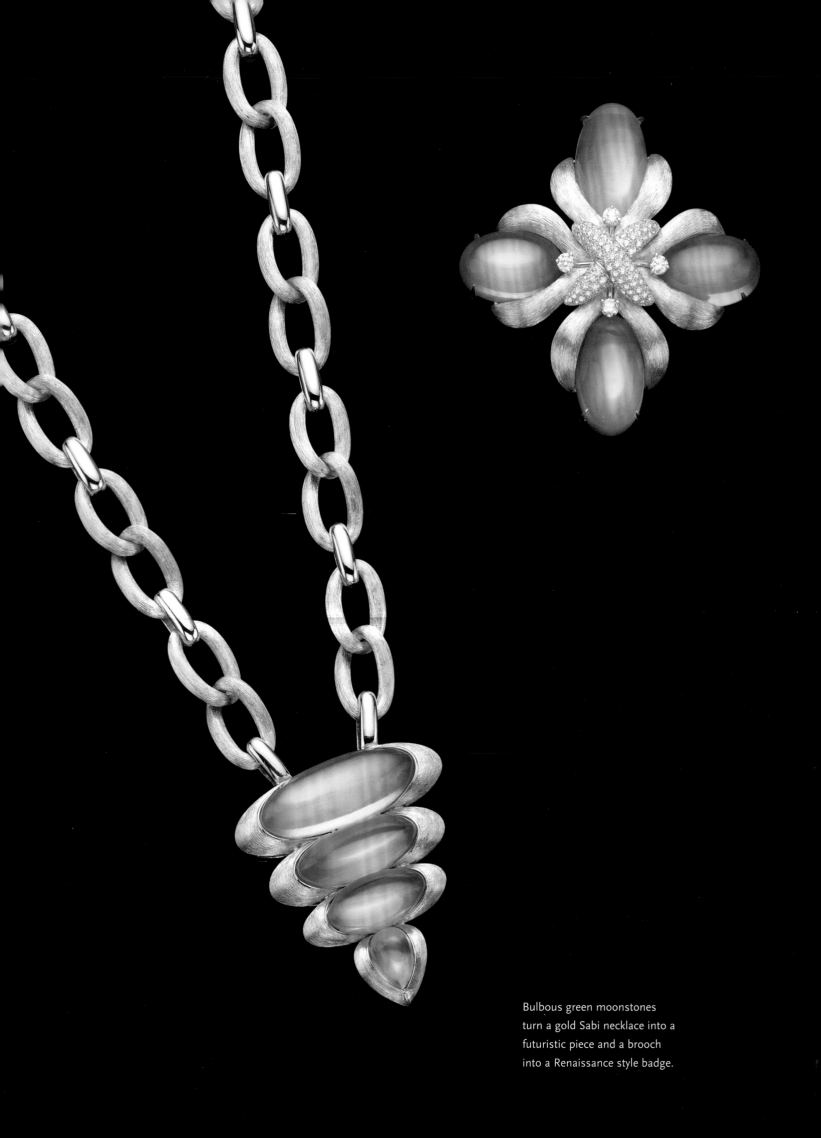

Bulbous green moonstones
turn a gold Sabi necklace into a
futuristic piece and a brooch
into a Renaissance style badge.

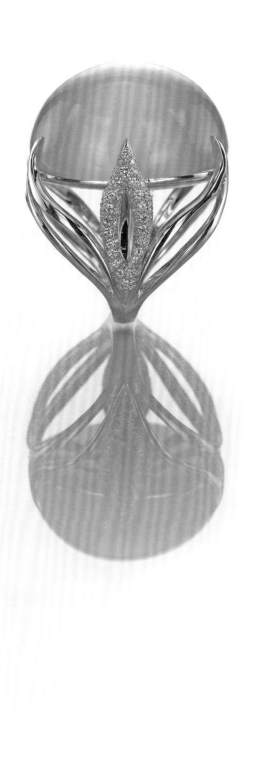

Coral and moonstone
cabochons add height to
diamond and gold rings.

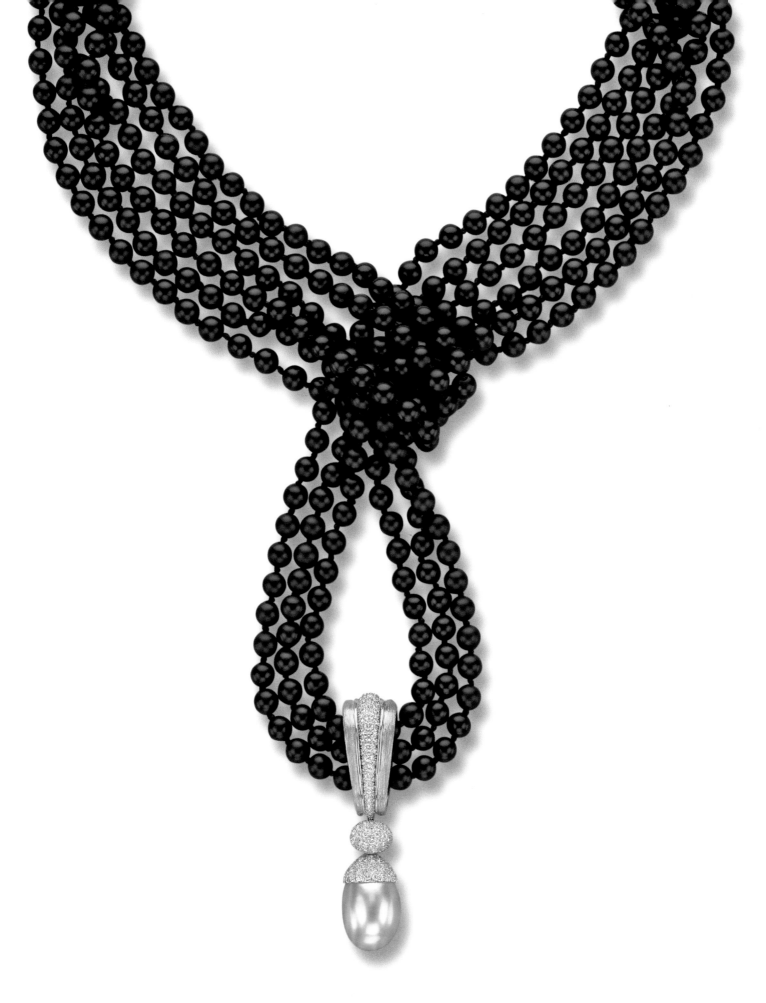

OPPOSITE Gold ties four amethysts into an elegant cross pendant. The piece hangs from a woven gold necklace that echoes the design.

ABOVE A swath of onyx beads holds a South Sea pearl, gold, and diamond pendant in a giant loop.

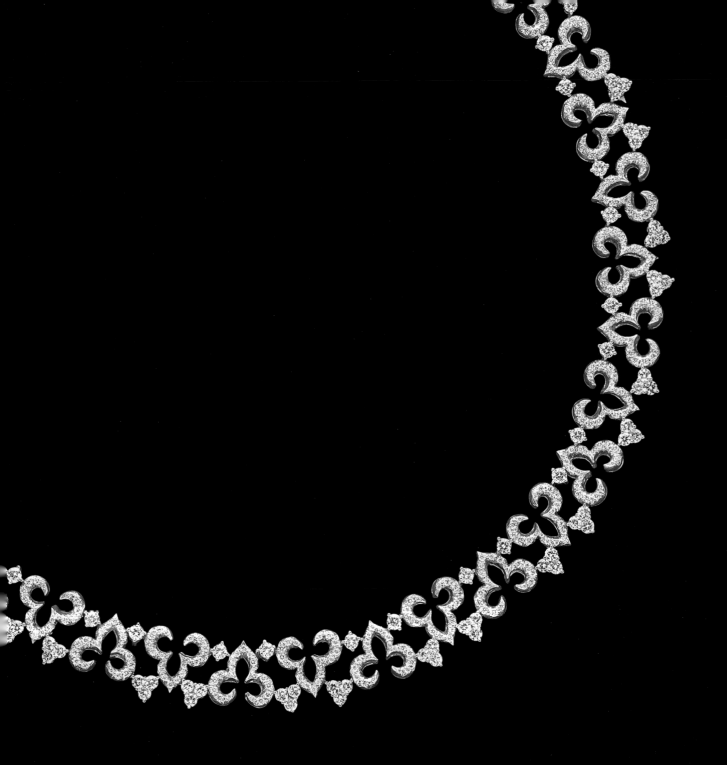

Fleur-de-lys motifs fit together
like a puzzle in a diamond and
platinum choker.

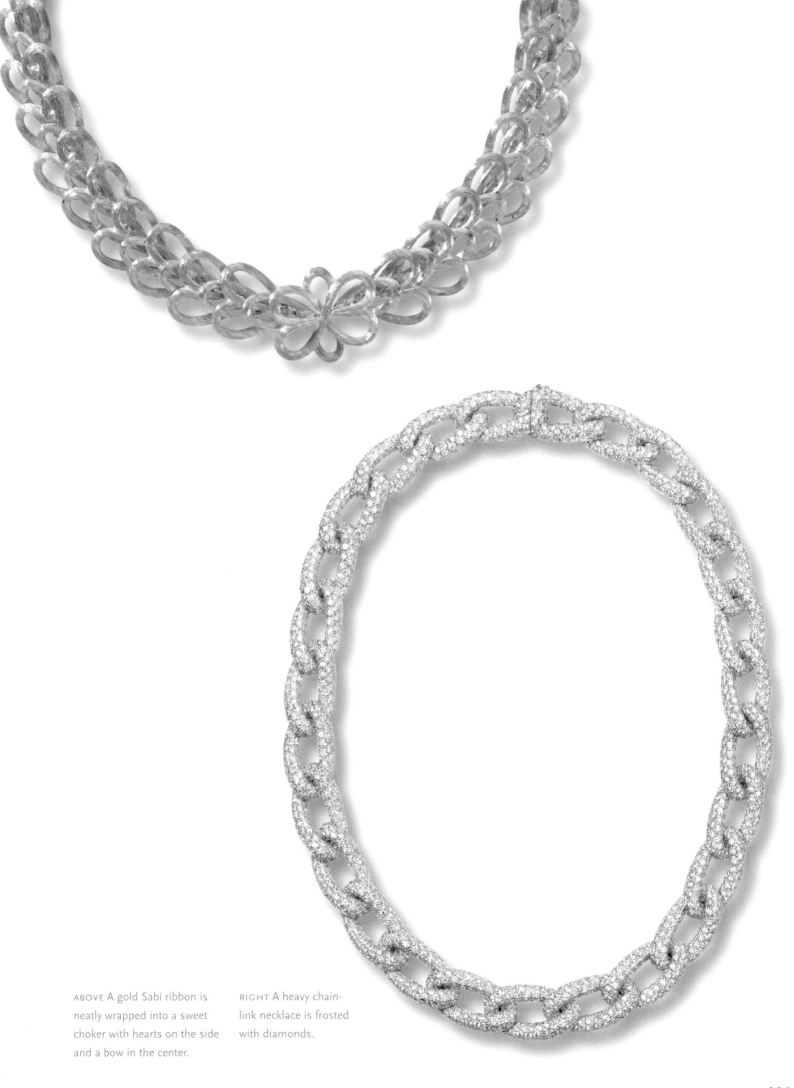

ABOVE A gold Sabi ribbon is neatly wrapped into a sweet choker with hearts on the side and a bow in the center.

RIGHT A heavy chain-link necklace is frosted with diamonds.

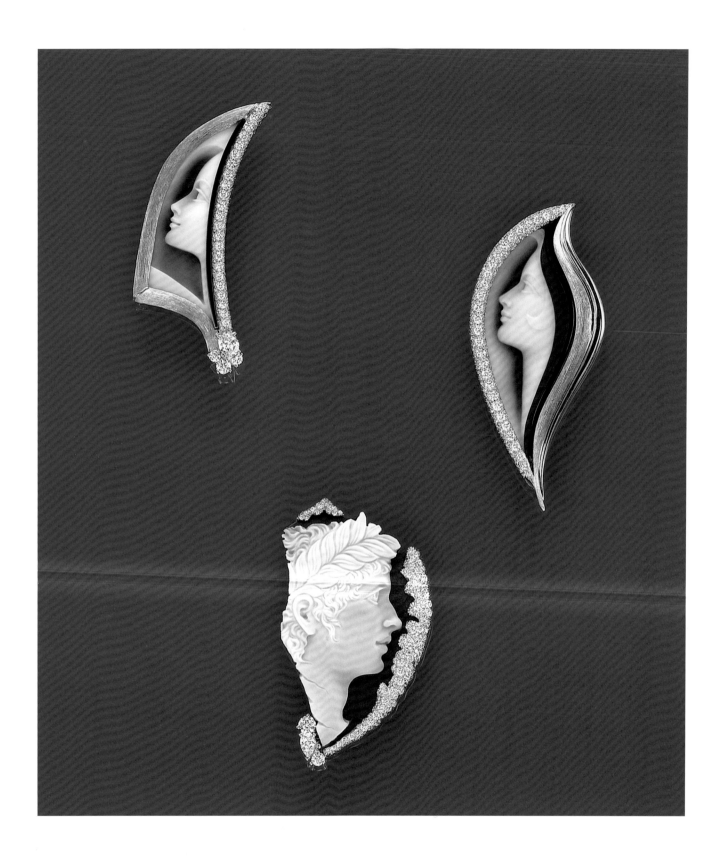

ABOVE Gold and diamond
brooches frame two black and
white agate cameo fragments of
women in profile (top). A black-
and-white agate cameo fragment
of a Roman emperor becomes
lost treasure in a diamond and
gold brooch (bottom).

OPPOSITE Two fantastical black-
and-white agate water nymph
cameos study their reflections
in pools of diamonds on top of
gold brooches.

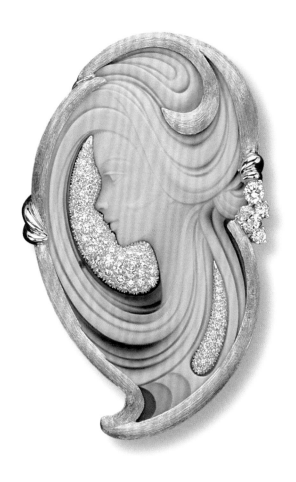

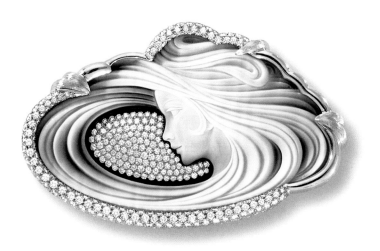

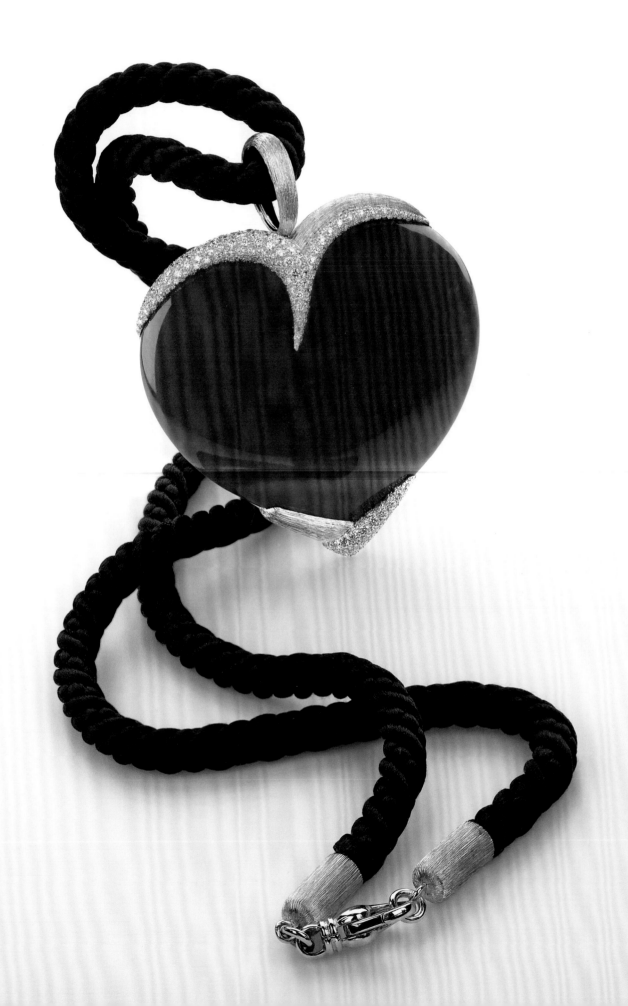

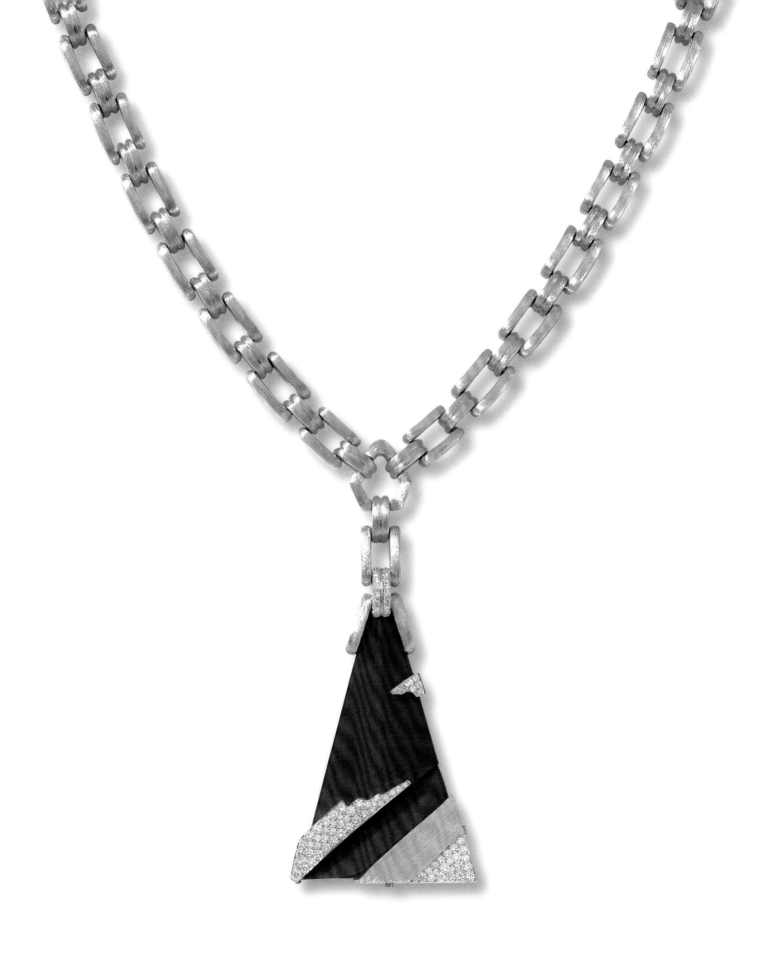

OPPOSITE A big heart pendant made of coral, diamonds and gold hangs from a black silk cord necklace.

ABOVE A gold Sabi necklace ends in a unique pyramid pendant of coral, diamonds, and gold.

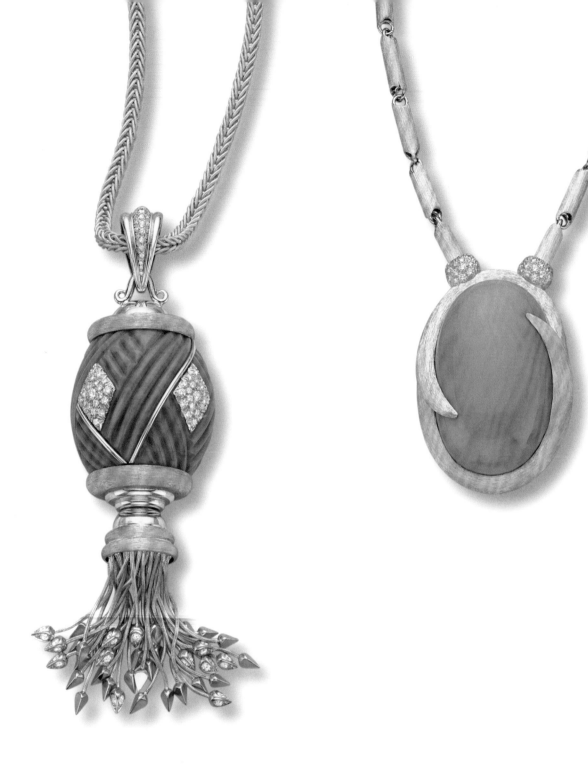

ABOVE LEFT A Chinese lantern prompted Henry to make a carved coral, diamond, and gold tassel pendant for a long gold necklace.

ABOVE RIGHT Light coral makes a necklace super feminine.

OPPOSITE Coral, black onyx, and emerald create a necklace with a vivid color scheme.

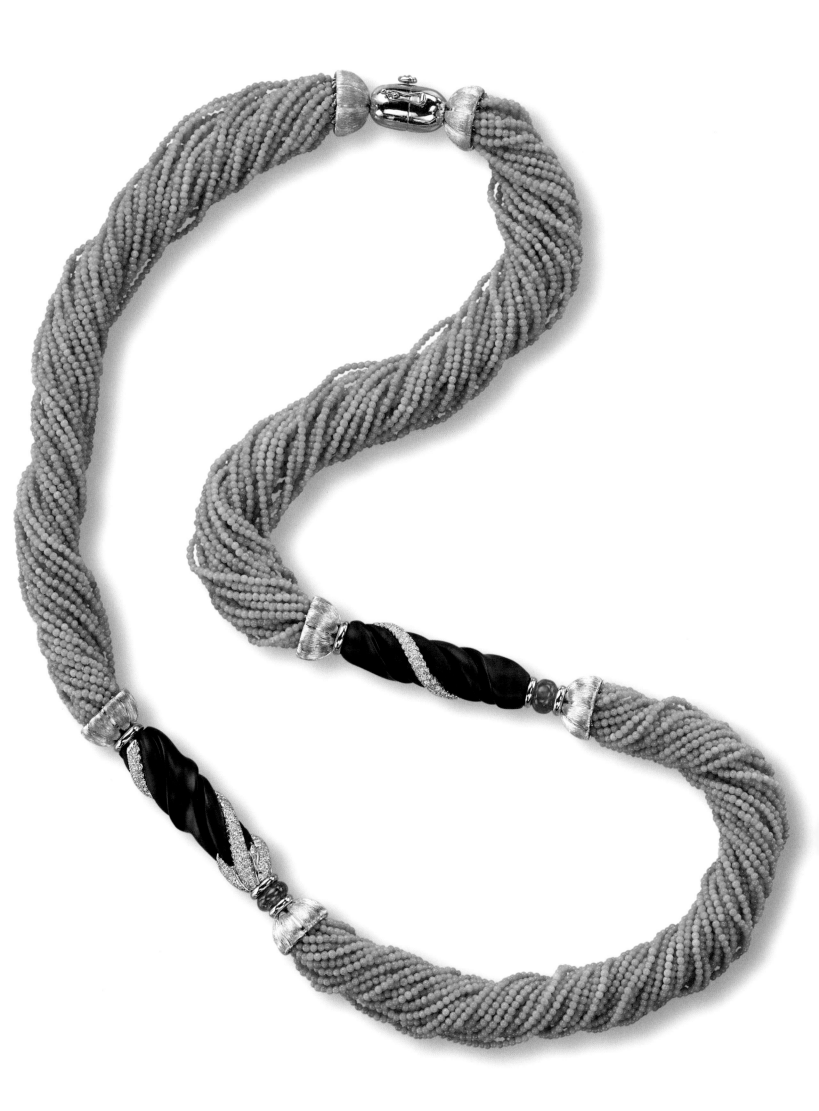

A gorgeous clasp of Ching
Dynasty ornamentation closes
an emerald bead necklace.

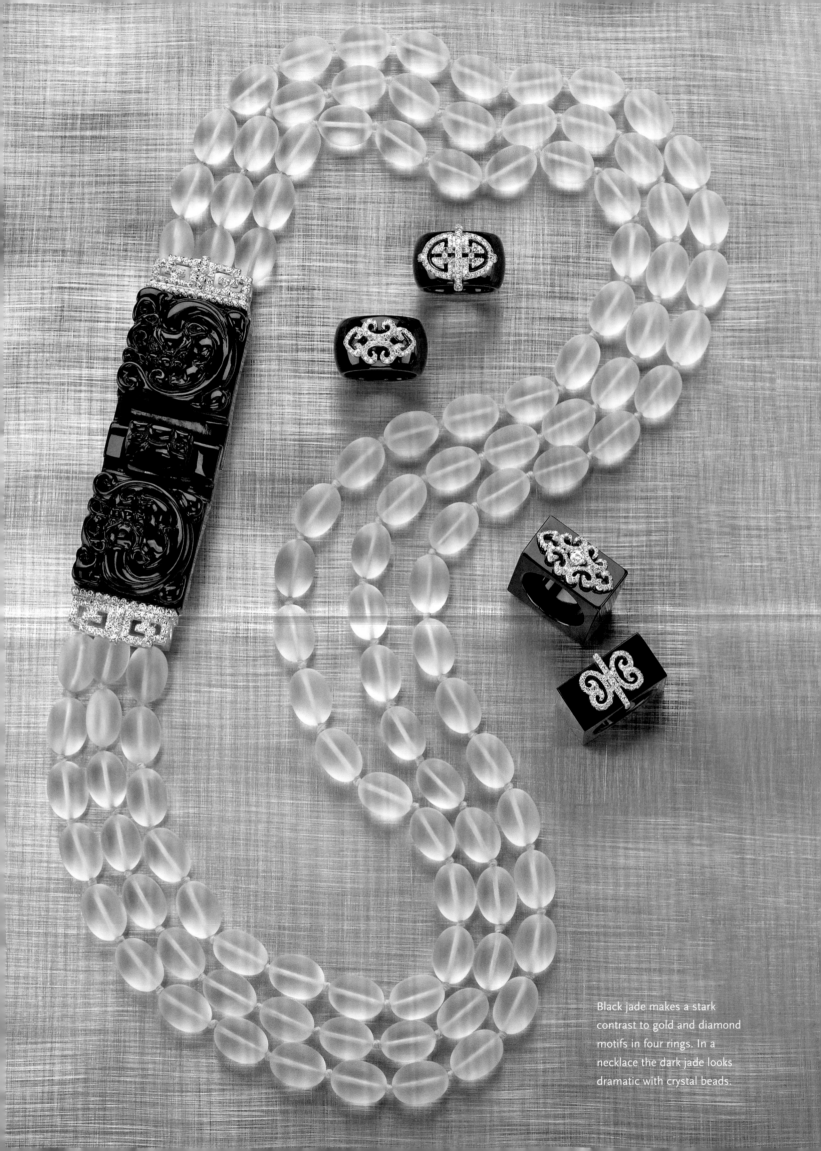

Black jade makes a stark
contrast to gold and diamond
motifs in four rings. In a
necklace the dark jade looks
dramatic with crystal beads.

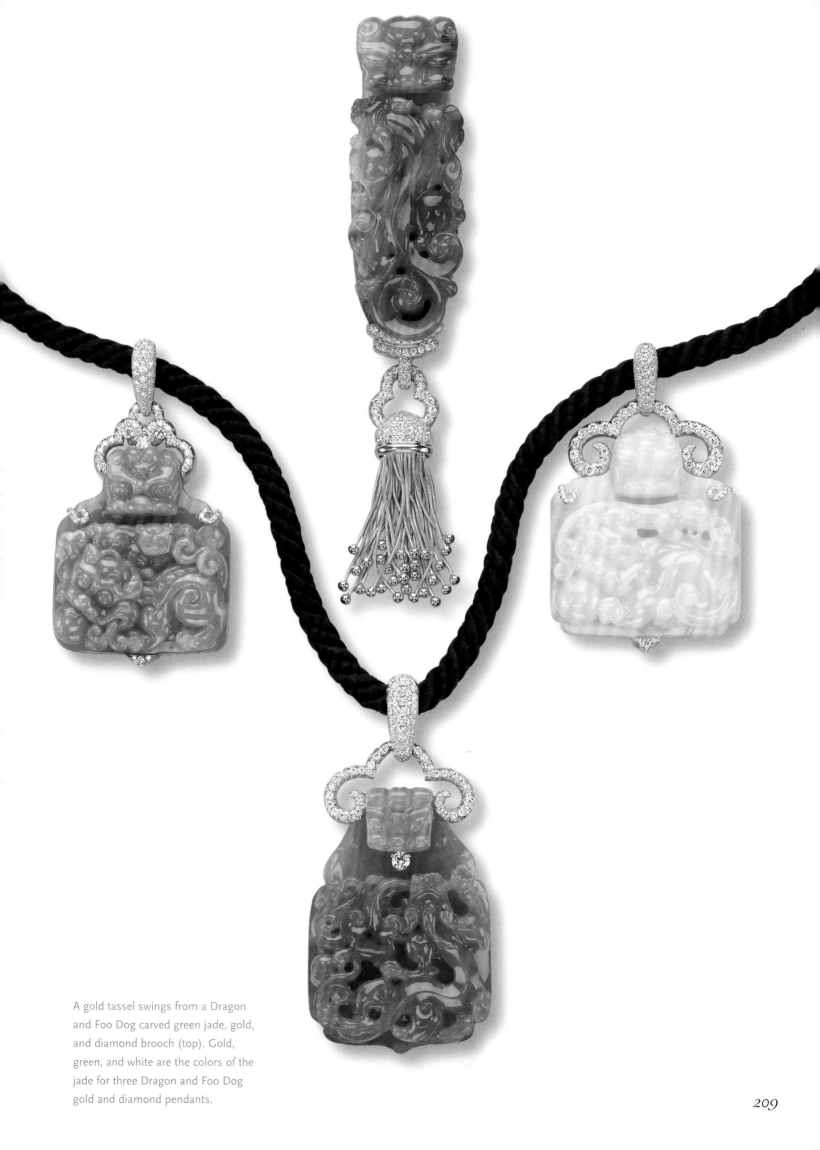

A gold tassel swings from a Dragon and Foo Dog carved green jade, gold, and diamond brooch (top). Gold, green, and white are the colors of the jade for three Dragon and Foo Dog gold and diamond pendants.

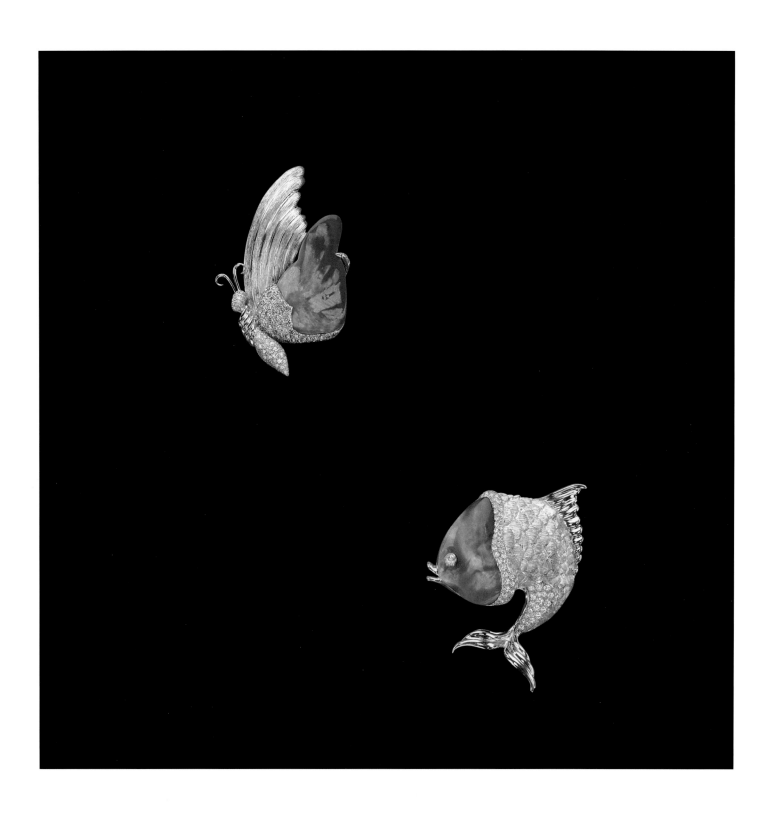

OPPOSITE Blowing in the Wind gold and diamond brooches represent wheat sheafs fluttering in the breeze.

ABOVE Black opals, diamonds, and gold animate the Tinkerbelle (top) and Leaping for the Sun (bottom) brooches.

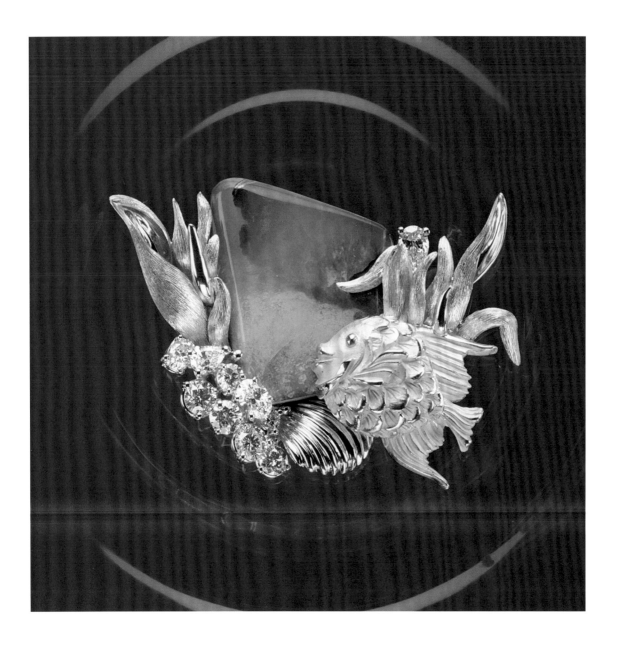

ABOVE The gradation of blues
on an opal reminded Henry of
what it was like diving in the
Seychelles. He used the gem
in an underwater scene for a
gold and diamond brooch.

OPPOSITE, CLOCKWISE FROM TOP
LEFT The leaves on the Mum's
gold flower pin are all diamond. A
bright turquoise grounds a gold
and diamond Amazon Orchid pin.
Flowers grow all over turquoise in
the gold and diamond Forbidden
Garden pin. In Silver Ghost a gold
and diamond flower blooms on a
turquoise rock.

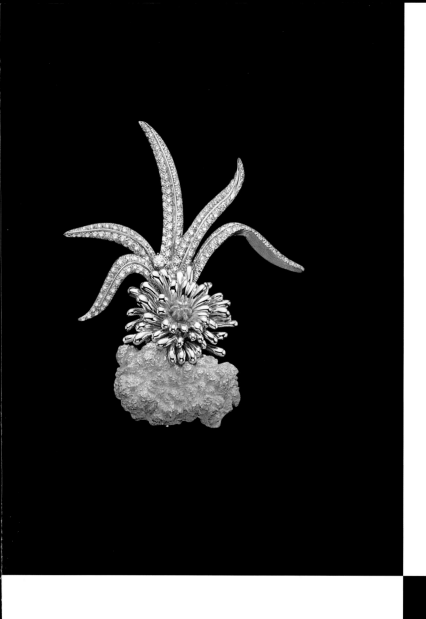

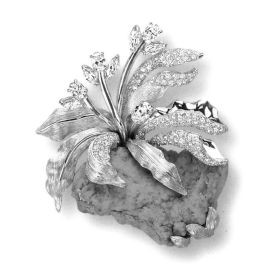

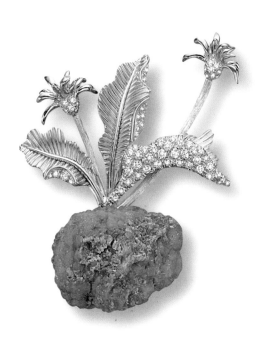

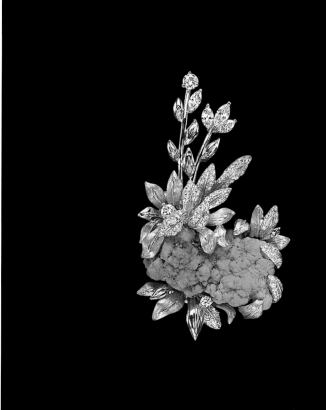

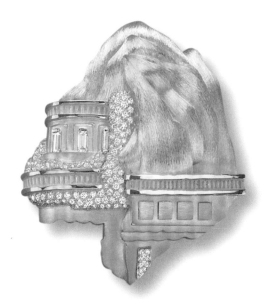

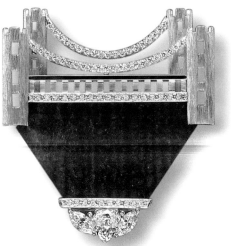

ABOVE LEFT Platinum and
diamonds form the windowpanes
in the buildings of the gold and
diamond Red City brooch.

ABOVE RIGHT For Henry, the
Bridge—a rhodochrosite, diamond,
and gold brooch—ensures steadfast
and fearless crossings even over
troubled waters.

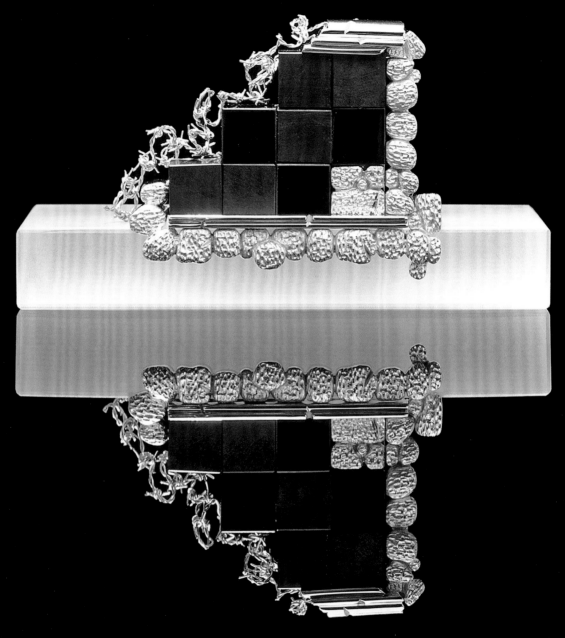

ABOVE The building blocks
of The Wall are black coral
reinforced by golden rocks
and platinum barbed wire.

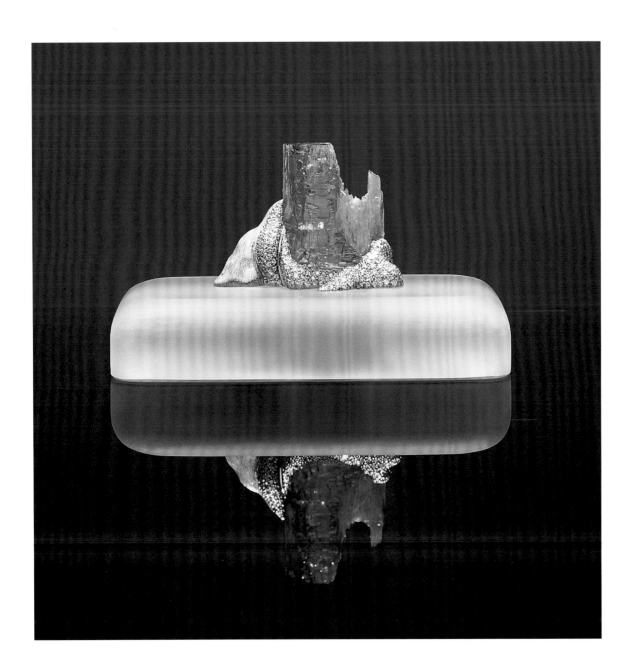

ABOVE LEFT An aquamarine, diamond, and platinum ice cap looks chilly in Somewhere Cold in Between.

ABOVE RIGHT A polar bear stays cool in a platinum Sabi brooch.

OPPOSITE In Trilogy of Bears, platinum polar bears romp on an 827-carat aquamarine, diamond, and platinum iceberg.

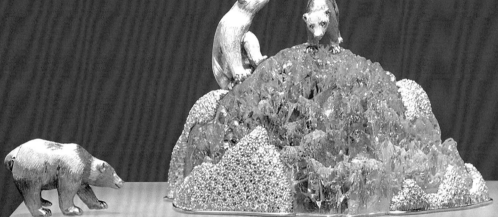

TRILOGY of BEARS

PT950 D3833 Dudu

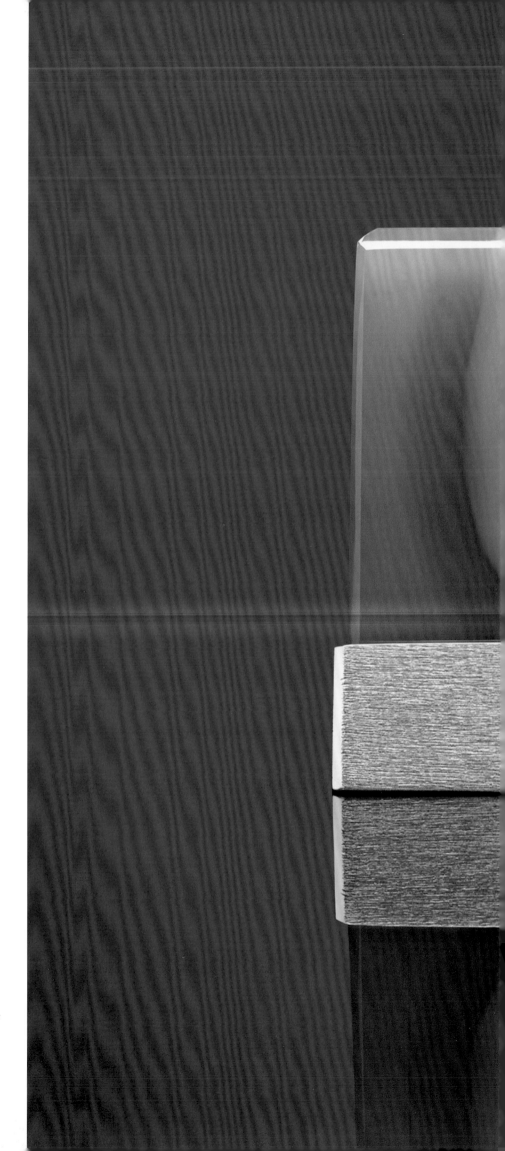

The gap in a meditative piece of blue agate is repeated in the pattern of diamonds on the gold base of Silent Crevice.

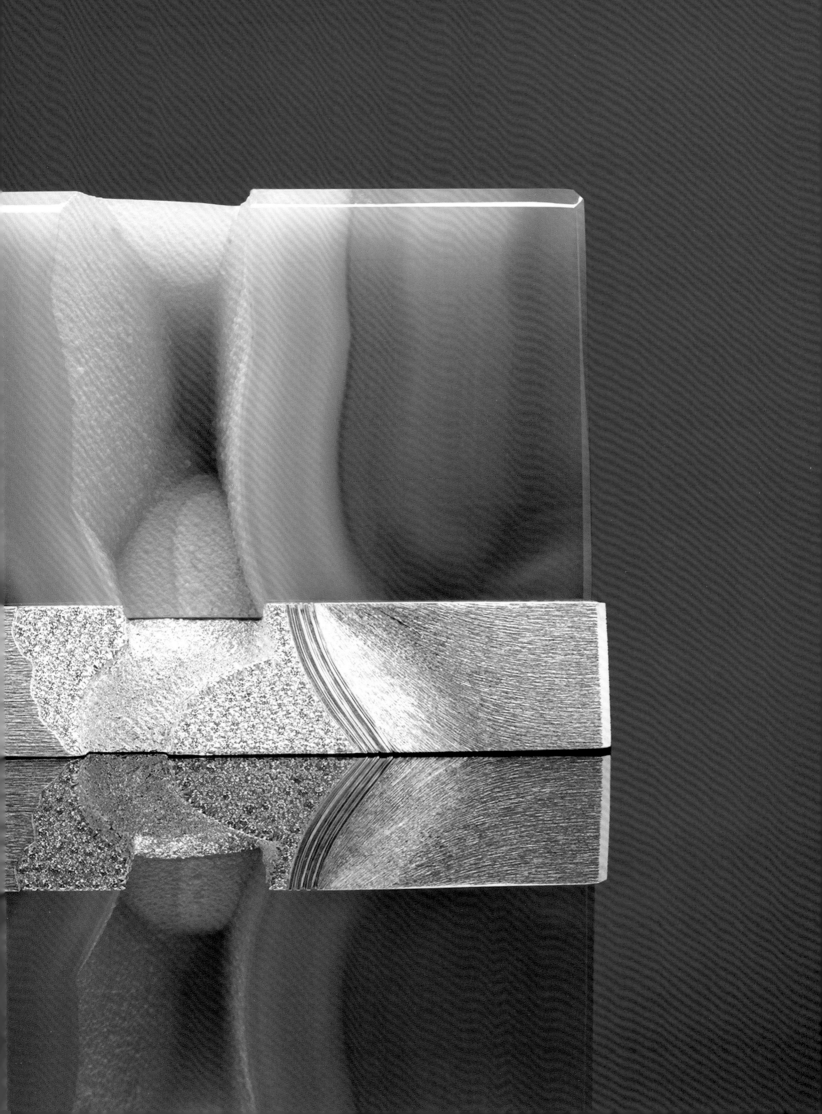

List of Awards

2003 Couture Jewelry Collection & Conference
Couture Design Award
Outstanding Achievement in Public Relations

2001 Couture Jewelry Collection & Conference
Couture Design Award
Best in Design: Pearls

2000 *Robb Report Magazine*
Annual Best of the Best—
Jewelry Designer in the World

1999 *Robb Report Magazine*
Annual Best of the Best—
Jewelry Designer in the World

Robb Report Magazine
Annual Best of the Best—
Best American Jewelry Designer

1997 Kent State University School of
Fashion Design
Hall of Fame

Contemporary Design Group
Hall of Fame

Watch & Clock Review
First Prize

1995 *Watch & Clock Review*
Citation for Excellence

Watch & Clock Review
Display Award

1994 *Watch & Clock Review*
Display Award

Diamonds International Award

1993 *Modern Jeweler Magazine*
Lifetime Achievement Award

Diamond Today Award

1989 American Gem Trade Association
Spectrum Award
Gemstone/Jewelry Design Competition

1988 Intergold Competition
Honorable Mention

American Gem Trade Association
Spectrum Award
Gemstone/Jewelry Design Competition

1987 De Beer's Men's Collection Award

1985 Platinum Award
Japan

Diamonds Today Award

1984 American Gem Trade Association
Spectrum Award
Gemstone/Jewelry Design Competition

1983 Johnson Matthey Platinum Design Award

Award for Outstanding Achievement
Cultured Pearl Jewelry Design

1982 Johnson Matthey Platinum Design Award

Diamonds International Academy Induction

Diamonds International Award

1981 Cultured Pearl Association of Japan
Judge's Prize

International Gold Corporation
Grand Prize Winner of Gold Competition

ABOVE Henry accepts an award
for excellence in jewelry design
(top). In 1973 Henry won an
Award for Diamond Jewelry
(bottom).

OPPOSITE *Modern Jeweler* magazine celebrated
Henry's career with a Lifetime Achievement Award in
1993 (top). In 1970 Henry received the Highest
Award for Cultured Pearl Jewelry (center). A model
poses in Henry's 1971 Cultured Pearl Association
award-winning belt (bottom).

1980 Cultured Pearl Association of Japan
Silver Medal Award

Cultured Pearl Association of Japan
Award of Honor

1978 Cultured Pearl Association of Japan
Graphic Award

1977 Cultured Pearl Association of Japan
Graphic Award

Diamonds Today Award

1975 American Manufacturing Jewelers &
Silversmiths Award

Diamonds Today Award

1974 American Manufacturing Jewelers &
Silversmiths Award

Diamonds for Christmas Award/Diamonds
Today Competition

1973 Diamonds for Christmas Award/Diamonds
Today Competition

1971 Cultured Pearl Associations of America
and Japan
Award of Honor

1970 Diamonds for Christmas Award

Cultured Pearl Associations of America
and Japan
Highest Award for Creation of the Most
Outstanding Design

Cultured Pearl Associations of America
and Japan
Special Award for Excellence in Design

Cultured Pearl Associations of America
and Japan
Award of Honor

Diamonds International Award

1969 Prix de Ville de Geneve de la Bijouterie, del
Joailolerie, de l'Horlogerie et de l'Emaillerie

Cultured Pearl Associations of America
and Japan
Award of Honor

Cultured Pearl Associations of America
and Japan
Special Award for Excellence in Design

1968 Cultured Pearl Associations of America
Special Award

Cultured Pearl Associations of America
Honor's Award

1967 Cultured Pearl Associations of America
and Japan
Award of Honor

Diamonds International Award

Index

Page numbers in *italics* refer to illustrations.

Designer: Russell Hassell
Production Manager: Anet Sirna-Bruder

Cataloging-in-Publication data has been applied for and may be obtained from the Library of Congress.
ISBN 13: 978-0-8109-9395-2
ISBN 10: 0-8109-9395-3

Henry Dunay: A Precious Life © 2007
 Penny Proddow and Marion Fasel
Coloring Henry © 2007 George E. Harlow
Suntanned Ladies and Design for Living © 2007
 Jeryl Brunner
Foreword © 2007 Henry Dunay
Introduction © 2007 Stephen Magner

Printed and bound in China
10 9 8 7 6 5 4 3 2 1

HNA ▪▪▪▪▪
harry n. abrams, inc.
a subsidiary of La Martinière Groupe
115 West 18th Street
New York, NY 10011
www.hnabooks.com

PHOTOGRAPHY CREDITS
Every effort has been made to contact copyright holders for individual images. In the event a copyright holder has been missed, Henry Dunay and the publisher would be glad to rectify the situation.

AmfAR, 96; De Beers, 12; Dunay archive, 16–18, 20, 22, 25–27, 33, 64, 71, 108, 151 (bottom), 162, 163, cover; Gold Corp. Ltd., 58; Janet Gough/ Celebrity, 105; Carol Dunay Kriet, 164, 166, 168, 174, 175, 220; John Parrish, 1, 2, 4–6, 8, 10, 11, 14, 31, 32, 34–48, 51–53, 55, 61–63, 65–69, 72–82, 84–89, 93–95, 100, 102–107, 109, 111–114, 116–120, 122–142, 144–146, 148–150, 151 (top), 152–158, 160, 161, 169, 171–173, 175 (bottom), 176–181, 185–199 (top), 200–205, 208–218, back cover, spine, flaps; Remy Martin, 56; Carl Scheffel, 19, 23, 28, 29, 83, 99, 110, 159, 170, 184, 199 (bottom), 206, 220 (bottom), 221; Robert Sherbow/Time Life Pictures/Getty Images, 90 (top); *Time* magazine, 59; Erica & Harold Van Pelt Photography, 97; Jeff Vespa/Wireimage.com, 98

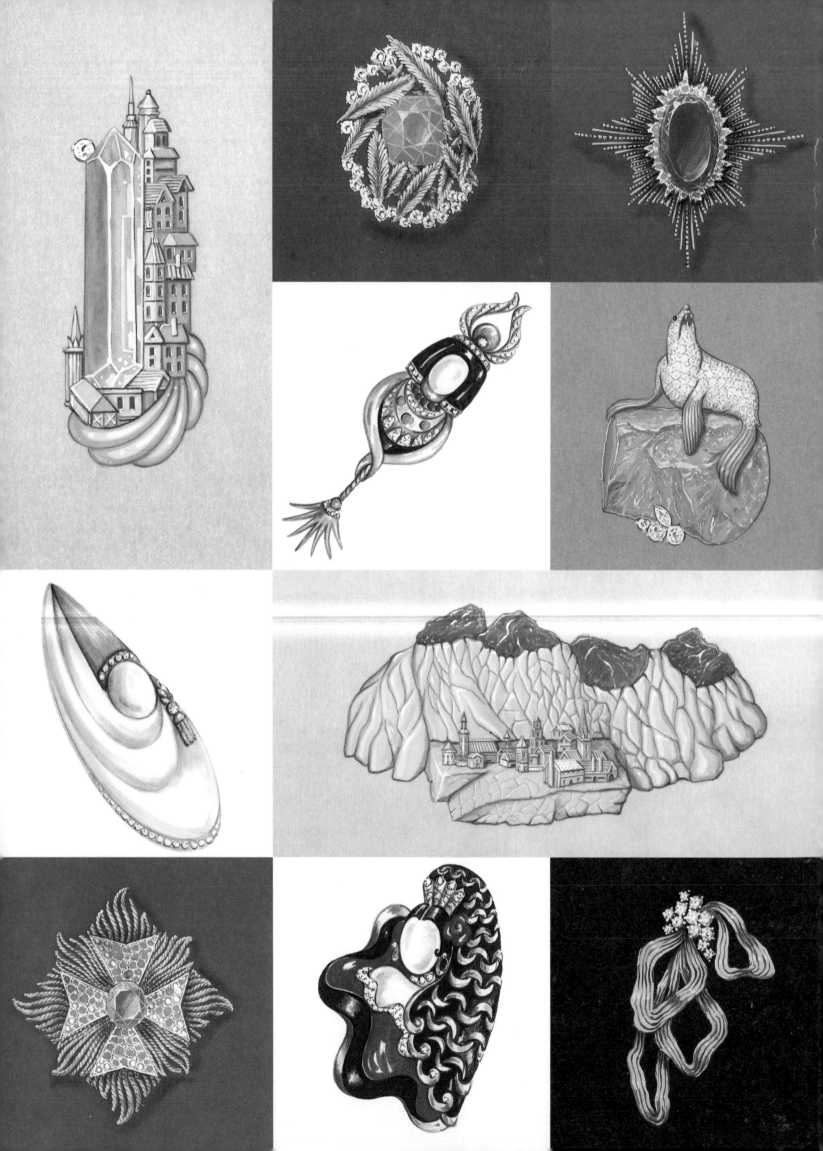